FOUNDATIONS OF
European Art

FOUNDATIONS OF
European Art

P. A. Tomory

WITHDRAWN

Thames and Hudson

Contents

Foreword 7

I Classical Antiquity: Greece and Rome, *c.* 650 B C–A D 350 9
 Greek Art 9
 Roman Art 28

II Early Christian – Byzantine – Romanesque,
 c. A D 380–1150 47
 Early Christian and Byzantine 47
 Romanesque 60

III Gothic Art: Northern Europe and Italy, *c.* 1150–1530 73
 Northern Architecture and Sculpture 73
 Northern Painting 91
 Italian Gothic Art 98

IV Italian Renaissance – Northern Renaissance
 Italian Mannerism, *c.* 1400–1590 105
 Italian Renaissance 105
 Northern Renaissance 134
 Italian Mannerism 144

V Italian Baroque – Spanish Baroque – Northern Baroque
 Rococo, *c.* 1600–1770 155
 Italian Baroque Art 155
 Spanish Baroque Painting 176
 Northern Baroque 184
 Rococo 192

VI Neo-Classicism and Romanticism, *c.* 1770–1850 207

VII European Art, *c.* 1850–1930 231

Bibliography 264

List and Sources of Illustrations 268

Index 283

Foreword

The aim of this book is to introduce the reader to the study of European Art History, through an examination of the major styles. In such a brief space it is impossible to mention every notable artist, let alone every notable work. Examples are chosen simply to epitomize important styles, and I have deliberately refrained from mentioning works that could not be illustrated. Most of the points that I have tried to make, therefore, can only be understood by constantly turning from one picture to another; the reader will have to look more than read, and to make this easy copious marginal references have been inserted throughout the book.

I must issue the usual warning against trusting any generalization too far. Artists rebel against being fitted into historical categories, and those proposed in this book are no more than a rough framework – which may be useful in relating styles and periods but which remain ultimately subjective. It must not be thought that all artists working at a particular time shared the same values, nor that the artists represented here adhered exclusively to the style of the works illustrated.

Finally I must record my debt to the many art historians, whose articles and books have helped me to write this book, which, however, should be read as representing my own point of view of European Art. My deepest gratitude goes to my wife, who has not only produced the hundreds of photo-copies from which the plates were selected, but has assisted me in correcting the script and the proofs.

1 Archaic Greek *kore* found at Auxerre, known as the *Auxerre Goddess*

2 Archaic Greek *kouros*, known as the *Argive Twin*

Classical Antiquity : Greece and Rome c. 650 BC–AD 350

GREEK ART

Greek sculpture is divided into three types – Free-standing – Pedimental – Relief.

Free-standing sculpture erected on a pedestal could be viewed from any angle, and was intended for devotional or commemorative use.

Pedimental sculpture was mounted in the pediment of a temple, the triangular section at the top of each end of the building. These groups generally describe the power or the qualities of the god or goddess to whom the temple was dedicated.

Relief sculpture was either high or low, indicating the depth to which the sculpture was cut into the block. Relief was widely used for altars or sacred places, on the metopes and friezes of temples and on commemorative monuments. They were used to depict legendary battles or events of the people to whom monuments were set up. In general, therefore, Greek sculpture was intended for public use.

In the long period from about 650 BC to about 50 BC illustrated here, different treatments may be seen, but the human figure, draped or undraped, is the only subject and, even in the narrative relief *The Apotheosis of Homer*, there are only slight indications of a natural background.

Ill. 19

We may assume, then, that the Greeks expressed in the human figure, either still or in action, most of their ideas of art and religion. Gods and humans are interchangeable in their forms, but may be distinguished by their positions or their actions. Thus any analysis of style must rely on the postures, actions and modelling of the figures or on the character of the drapery. The varieties of treatment that occur throughout

9

Greek art stem mainly from a new idea or attitude towards the subject, not from an increase in technical mastery or a decrease in artistic taste. The *kore* (maiden) shows how strong Egyptian influence was on early Greek sculpture. Note the proportions of the figure and the hairstyle. Although free-standing, all the sculptural interest is concentrated on the front, as is generally the case with sacred images. This early style is called 'Archaic'. Some of its features are similar to African or Oceanic tribal carvings; only an approximate human figure is intended; features like the hair, fingers and toes are 'stylized', i.e. the forms are simplified and seen as a repeated pattern and the figure is made so symmetrical that the artist must have had no interest in making it life-like.

Ill. 1

A hundred years later the *kouros* (youth) shows a dawning interest in life – the left leg is advanced and a 'smile' enlivens the face. Apart from the smile, however, Egyptian influence is still present in the proportions, the hairstyle and hands held by the sides. An important change may be seen in the carving. In the *kore*, the fingers have been produced by cutting channels *in* the soft limestone; in the *Argive Twin* the rounded forms of the muscles have been carved *out* of the stone. This new method implies that the artist has begun to see his figure in the round, but not yet as life-like, since the young man looks like an assembled doll. For the artist, still intent on symmetry, carved each side of the figure independently from the others. The movement of the left leg does not carry through to the side or to the back. The frontal view, therefore, is still all important.

Ill. 2

These type figures were to continue in Greek art until about 490 BC. The female – *kore* and the male – *kouros*, did not represent deities. They seem to have been ancestors or watchful spirits. By the end of the sixth century, the old tribal system was replaced by a more free urban society. In a similar way, due to European settlement, Africans and Polynesians have changed their way of life and their attitude to their old tribal images.

10

3 *Charioteer*, bronze figure from
the Apollo Sanctuary in Delphi

The *Charioteer* marks a similar change in attitude. The *Ill. 3*
medium is hollow cast bronze, indicating another kind of
sculptural method. For a bronze is cast from a wax or clay
figure. The work is modelled, by *applying* wax or clay on to
a rough skeleton called an armature. In the carving of marble,
unwanted stone is *cut away* to reveal the figure. Because of its
weight, marble can break if it is not supported or counter-
balanced. Bronze is proof against this, so the artist had much
greater freedom in deciding the posture of his figure. This
Charioteer is all that survives of a large group consisting of a
chariot drawn by four horses and erected near Delphi to
honour a victory at the Olympic Games.

The artist has now a new patron, the State, which permits
him, in a more liberal fashion, to make works other than
religious images. But Church or Temple and State were very

4 *Apollo* as judge over the battle of Lapiths and Centaurs. Pediment group from Olympia

Ill. 4

close together in Ancient Greece and this had a significant influence on art, as may be seen in the *pediment group from Olympia*. In the centre stands Apollo, acting as judge over the legendary battle of Lapiths and Centaurs. In religious terms, the Centaurs represent evil since they were the aggressors and the Lapiths stand for virtue. Apollo, the god, therefore guards virtue against evil, but since his followers also consider themselves virtuous, then this scene shows the god aiding the city against its real-life enemies. The artist benefited from this idea since he could introduce all kinds of legendary events as double-edged parables or allegories to illustrate religious principles or contemporary events.

These two works represent the Early Classical style. Its main characteristics are: a close observation of natural forms; a feeling for balance, restrained action and expression. These points are exemplified even more in the body of Venus from *Ill. 5* the *Ludovisi Throne*, in the texture and weight of the hand-maidens' garments and the towel they hold; in the balanced arrangement of the three figures; in the 'timing' of the action

12

to coincide with the 'still' moment between two movements; in the calm expression on Venus' face. Even in the battle scene *Ill. 4* there are no violent actions, no over-agonized expressions, and physical action does not disturb the even rhythm and balance of the composition. It is also clear that real people are not being represented, there is no personal character evident in either Apollo or Venus, for the artists constructed their whole figures from carefully selected parts. While they wished to create figures close to nature, they did not want to make them real but ideal. Possibly to prevent their marbles and bronzes becoming too cold and remote from life, the Greeks painted them in various colours, even the eyes in bronzes were filled with silver or enamel and the Charioteer had copper wire eyebrows. Colour also helps to identify figures or scenes – 'royal' colours like blue and red symbolize the god-like character. Such distinctions are necessary, for in classical periods gods are seen as men and men are seen as gods.

5 Venus and two handmaidens, relief from the front of the so-called *Ludovisi throne*

The next three works represent the High Classical period (*c.* 450–400 BC). The difference between Early and High Classical may be explained by saying that in Early Classical gods and men share similar appearances, whereas High Classical goes further and suggests that man equals god, that men and gods share the same *powers*. Artistically this may be achieved by making human figures over life-size. Even where gods and goddesses are represented as over life-size humans this suggests that humans are superhuman beings. Look, for instance, at the

Ill. 7 *Doryphorus* (Spear Bearer). For such a superhuman, the artist, Polyclitus, invented an ideal scale of proportions. No ordinary man looks like this. Unfortunately, we have to rely on a rather ponderous Roman marble version of the original bronze. The Spear Bearer, while of similar rank, belongs to another

Ill. 3 world from that of the Charioteer. Another factor in High Classical art is the 'split second' timing of action. The action of a man walking is composed of two major movements, of the left and right legs making a pace. The action here is a momentary pause between these two movements. The Spear Bearer's left leg is about to move forward and the swing of the body directs this movement.

6 Three goddesses. Part of a pediment group from the Parthenon

8 *Centaur and Lapith*, metope
relief from the Parthenon

◀ 7 Roman copy after
POLYCLITUS *Doryphorus* (Spear
Bearer)

In High Classical art emphasis is given to symbolic gesture,
as may be seen by comparing these Centaurs and Lapiths. The
Parthenon relief and the others of this series depict the endless
struggle between virtue and vice. The natural actions of the
Olympia pediment are replaced by superhuman or ideal
gestures. High Classical art is always associated with perfection
of technique since the artist sets out to achieve a perfect ideal art.
The artist, therefore, matches technique with idea. For instance,
the carving of the drapery of the Ludovisi Throne is entirely
consistent with the quiet mood and balance of the composition,
while in the Parthenon pediment group the handling of the
garments is dramatically matched to the action – the seated
goddesses turning about to receive the messenger goddess,

Ill. 8

Ill. 4

Ill. 5

Ill. 6

15

9, 10, 11 The Parthenon, Athens. Above, the west front. Below left, plan. Below right, detail showing Doric column, capital, architrave, triglyph, metope and cornice

Iris. The full folds of the drapery add a majestic symbol to these immortal beings. High Classical idealism as represented by the sculpture of the Parthenon shows an extraordinary balance of form, action, emotion, technique and symbolism equal to the balance effected at the same time in the social, political, economic and intellectual state of Athens. Since such a balance is not only rare but necessarily short-lived, these periods, and particularly fifth-century Athens, are seen as almost unattainable levels of artistic idealism.

The same degree of perfection may be observed in the *Parthenon* itself, perhaps more easily, since architecture deals in abstract forms. From the plan, the love of balance and harmony of proportion is evident. Light and shade created by the surrounding columns is similar to the use of the drapery in the sculpture. The variety in the surface treatment is similarly employed to give life to the forms. Both temple and human figure have the same monumental look. Since the Greek temple

Ill. 9
Ill. 10

16

did not have to house a congregation as a Christian cathedral had to, the Parthenon can even be looked upon as a sculpture.

But the two arts are not quite the same. Many features of the early temples are derived from even earlier wooden constructions which have not survived. The architect has to be artist, craftsman and engineer. His problem and the Greek solution can be examined in the detail of one of the corners of the temple. The parts, from bottom to top, are: the fluted column; the *Ill. 11* Doric capital (which gives its name to this style); the architrave or main beam; a triglyph on the corner with a metope relief space beside, together making up the frieze. The Doric rule was that triglyphs had to meet at each corner of the temple and also stand over the centre of each column and each space between columns. This could only be done if the front to back measurement of the main beam was the same as the width of the triglyph, but the main beam would have to be reduced in size to do this, and, therefore, unable to support the weight

12, 13 The Erechtheion, Athens. Left, east and west elevations; right, view of the west side showing Caryatid porch on the right

above it. If the triglyph was enlarged then its proportions would not be in harmony with the rest of the building. Since there was no physical solution there had to be an optical one, namely by slightly reducing the distance between those columns nearest each corner. The artist thus overcomes an engineering problem and the reluctance of the craftsman to make changes in style. The perfection of the Parthenon depends on a great many other artistic corrections.

Ills. 12, 13 The *Erechtheion*, which stands near the Parthenon on the Athenian Acropolis, is built in the other great style, Ionic (characterized by the scroll-like capital). The existence of a number of sacred places on the Acropolis probably dictated the split-level plan, but its small scale, the open airy porches, in one of which carved female figures (caryatids) replace columns, makes it immediately attractive. Columns and beams are reduced in size since they no longer have to carry the great

18

weight of the pediments and their sculpture, and the Doric problem discussed above does not exist since a continuous frieze of relief sculpture is used. And whereas all the Doric features appear to have a structural reason for their presence, a comparison of details reveals a more decorative attitude in the Erechtheion. While the Parthenon is like some great sculptured block of marble, the Erechtheion suggests an assembled structure containing both open and enclosed space.

In the fourth century a new Athenian style appeared. Compared to the sculpture of the Parthenon, it is softer in form and outline, the proportions are no longer on the heroic scale, but suggest instead an individual personality – that the artist has worked from a model before him rather than from an over life-size image in his head. Art now represents life and not some superior world. It is moreover to be seen at eye level (notice the low pedestals on which these sculptures are placed),

Ills. 14–16
Ills. 6, 8

whereas the art of the fifth century had to be looked up to in both senses of the word. Strangely, one learns a great deal about the life of a people by examining its tombstones. The *Stele of Hegeso* is a grave monument, one of many discovered. While the composition and rectangular format is similar to the metope reliefs of the past, the subject is a domestic one. The girl, who has recently died, chooses jewellery from a box held by her servant. Details of gesture, furniture and hairstyles are personal and contemporary. Since the figures project slightly outside the stone framework, the onlooker, because of this physical nearness, may become personally and emotionally moved by the thought that a young woman, so beautiful, should die so young. Indeed, at this time interest in the female figure seems to have been increasing as enthusiasm for the heroic male diminished. Compare, for instance, the draped goddesses and the girl here, whose drapery (the so-called 'wet' look) clings to parts of her body, although it is the fine folds

Ill. 14

Ills. 6, 14

14 Greek tomb monument, the *Stele of Hegeso*

15 Roman copy after PRAXITELES
Cnidian Venus

16 PRAXITELES
Hermes with the Infant Dionysus

of the garment which gives the figure its elegance. By the
latter half of the fourth century, drapery, in relation to the nude,
played merely a decorative role or served to cover up the
support required for the off-balance marble figure.

The *Cnidian Venus*, by Praxiteles, is also a Roman version *Ill. 15*
of the lost original. The goddess is about to bathe, but it might
be any woman about to bathe, for a comparison with the
Ludovisi relief shows that the once serious ritual or religious *Ill. 5*
association of the goddess with the sea had now become a
commonplace occurrence. For the model for this work, accord-
ing to Arthenaeus, a Roman writer, was Phryne, the mistress
of the artist.

21

Ill. 16 In another – original – marble by Praxiteles, the once heroic,
 Ill. 7 harmonic treatment of the nude male is replaced by the new
idea of throwing the weight of the body on to one leg, so that
the torso adopts a graceful line to preserve the balance. Coupled
with the refining of all the parts of the body, an extreme of
elegance is created. So, in every way, the notion of the heroic
is rejected. But idealism of a kind is still present, for Praxiteles
Ill. 15 gives his mistress a legendary beauty by posing her as Venus.
Phryne, in real life, like many film stars, may have been much
less beautifully proportioned. But not all Greek art in the fourth
century was like this, for on the Asia Minor coast, new city-
states were arising due to the energy of dictator-like leaders.
These men had to make history in their own lifetimes. They
had no tradition to lean on nor could any of them, with much
confidence, foresee their regimes continuing after their deaths.
The art that they encouraged was a highly personal one, and
while it extols the heroic, it was the desperate heroism of real
Ill. 17 life. In the relief from the *Tomb of Mausolus* by Scopas, Greeks
and Amazons fight, literally for survival. The dynamic poses

17 SCOPAS *Battle between Greeks and Amazons*, from the Tomb of Mausolus

18 Statues of *Mausolus and his consort Artemesa*, from the Tomb of Mausolus

of the Greeks, their muscles taut, portray men fighting ruth-
lessly for their lives. Contrasted with the Parthenon metope *Ill. 8*
and the Olympia pediment, this art is strained and tense (notice *Ill. 4*
the modelling of the calf muscles in the fallen Lapith and the
Greek on the left). Instead of a rolling rhythm used at Olympia,
Scopas introduces a violent zig-zag composition. These reliefs
of the Mausoleum were also at eye level, so that they made an
exciting impact on the spectator. Although this was a legendary
battle, its meaning was contemporary. Survival depended on
the suppression of one's enemies.

Mausolus, the leader of Halicarnassus, built his pyramid-like *Ill. 18*
tomb before his death and the over life-size sculpture of himself
and his consort was placed in a four-horse chariot on the top
of it. Not only has man replaced the gods, but since he stands
at the apex of the pyramid, he becomes his own symbol of
the all-powerful judge, ruler and divinity, greater even than
Apollo at Olympia who stands on the same level as the con- *Ill. 4*
testants. Understandably, factual portraiture became popular
at this time, although one must allow for a little 'touching up'

23

in the portraits of great men. Most rulers prefer to be shown as they *should* look and not as they *do* look. Nevertheless, Mausolus appears as an individual personality, while his drapery shows a similar strain and tension to Scopas' relief, for it is cumbersome, trapping almost all movement. The great swathe, across the stomach, pulled out into artificial folds, cuts the figure in two. Compared to the Parthenon drapery, it is rather ornate and over conscious.

Ill. 6

In the third century, Greek artists worked in many places other than Greece and they tended to move to those cities which could give them the greatest patronage. Amongst the most important at this time were Pergamon in Asia Minor, Alexandria in Egypt and the island of Rhodes. All three maintained stable governments for long periods, thus enabling distinctive styles to emerge. Greek art from this time is called 'Hellenistic'. Attalus I of Pergamon is credited with putting together the first collection of Greek sculpture including both Archaic and Classical works, and the influence of this collection is shown by some Pergamene artists adopting an 'archaic' style. Ptolemy IV of Alexandria, not only encouraged the study of Homer started by his predecessor, Ptolemy II, but erected a temple in honour of the poet. The relief known as the *Apotheosis of Homer*, which probably dates from his reign, shows the continuation of the 'personality cult', for the carving depicts the deification of the poet in the lowest zone. He is being crowned by a king and queen, possibly Ptolemy and his consort. While Zeus, Apollo and the Muses are shown in the zones above, it is the real-life patron and ruler who bestows the crown. In style the relief reflects the influence of Greek painting, of which nothing survives, for it is composed in a narrative form and the background is carved to give the impression of the figures moving or standing in space. Compared to the relief of Scopas, which is a frieze, the figures appearing like 'cut outs' on a uniform surface, the Homer relief is clearly 'pictorial', even though the handling of figures and groups remind us of early Greek reliefs.

Ill. 19

Ill. 17

24

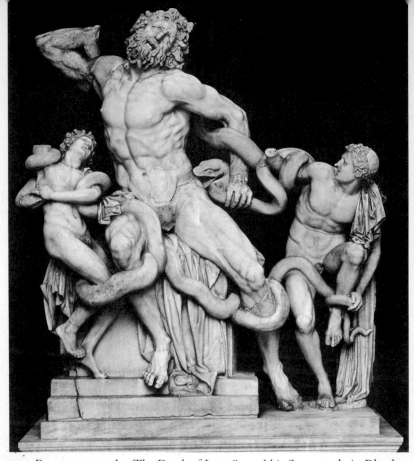

20 Pergamene style. *The Death of Laocoön and his Sons*, made in Rhodes

Ill. 20 The *Laocoön* group, sculpted by Rhodian artists, is a first-century example of the Pergamene style. It is also 'pictorial', since it was designed to be seen only from the front. The forms within the composition, starting from the furthest away (Laocoön's right elbow), advance in a series of planes to the nearest, his right knee; in the same way the painter distinguishes background, middleground and foreground. There is also a painterly interest in the use of light and shade and the variety of textures, to increase the emotional impact of the work. For the intention of this art is to engulf the onlooker in the drama, not only emotionally but almost physically, since

26

by moving close up, Laocoön's right knee will almost project beyond one. It should be noted that the figures of the Stele of Hegeso, while they project from the frame, occupy only a single plane. *Ill. 14*

Greek architecture from 200 B C becomes more grandiose in conception and mixed in style, as can be seen here in the entrance to the *Sanctuary of Athena at Pergamon*. It is, in fact, *Ill. 22* a Doric and Ionic temple façade all in one, but it still obeys the earlier Greek attitude to natural laws, for the 'heavier' style supports the 'lighter' style.

Dating from about 50 B C is the octagonal tower, called the *Tower of the Winds*; its function was to house a water clock and *Ill. 21* act as a sundial. The octagon shape was probably derived from the Near East. Its conical slab roof (not visible) was made with triangular sheets of marble. Inside and outside there are Doric, Ionic and Corinthian (the last of the Greek styles) columns and capitals, while the reliefs at the top represent the eight compass

21 The Tower of the Winds, Athens

22 The *Propylon*, or entrance to the Sanctuary of Athena at Pergamon

points of the winds. It must be recalled that Greece had been occupied by the Romans since 147 BC, which helps to account for this curious building, for it is not quite Greek nor is it quite Roman, since it shows the adaptation of Greek styles to a building whose shape and construction are largely determined by its function.

ROMAN ART

The Romans are often considered as 'copyists' of the Greeks, although in reviving certain styles of Greek art, they did no more than the Italians did in the fifteenth century and the French and the English in the eighteenth century. Rome was just the first society in the history of Europe to look back to the fifth and fourth centuries of Greek art as a 'Golden Age'. The Roman Empire saw the creation of a new class of patron, a professional middle class of civil servants, magistrates and teachers, who indulged their varying taste in works of art. The *Ills. 23, 24,* three portraits on this page and the next illustrate not only differ-*25* ent social levels but the three artistic levels on which Roman art

23 Roman funerary portraits, so-called *Cato and Portia*

28

24 *Augustus* (27 BC–AD 14)

evolved. Unlike the Greeks, well-to-do Romans preferred
straightforward realistic images of their dead, and the couple *Ill. 23*
here originally surmounted their own tomb. The style, known
as 'verist' is derived from an old practice of taking wax masks
of the recently dead, used by the Etruscans, the people who
dominated northern Italy before the Romans. This style not
only served Roman artistic interest in everyday life but also
reflected its love of the practical, which comes out particularly
in its architecture. For Roman imperial art preserved the same
'personality cult' that occurred in Greece. *Augustus*, indeed, *Ill. 24*
was the first Roman emperor to inspire a Neo-classical revival.
He encouraged artists to follow the style of the Greek fifth
century. In the statue shown here, he is seen haranguing his

29

troops. Round his hips is the same bulky swathe of drapery observed in Mausolus, but by this time, tradition has turned it into an attribute or sign of authority, while the figures on his breastplate illustrate his divine powers, and the child on a dolphin by his leg, his Genius. This lavish use of symbols not only indicated the divine and legendary origin and authority of the ruler, but coupled with grandiose architectural schemes and ornate decoration is characteristic of Roman court art.

The third portrait is of *Octavia*, the sister of Augustus. The stone used is basalt, which is extremely hard and shiny when polished. This is a green basalt and the way the forms of the face are cut into flattish planes is due to the difficulty of working it. Nevertheless, it was quite popular with the Romans, who also favoured all kinds of coloured hard stone like marble, not only for architectural decoration but in their sculpture, which might be made up of pieces of different colours. This became an alternative method to the Greek one of painting marble. The head of Octavia also is of rather higher quality than the

Roman matron on the tomb relief. The simple yet effective way the form and texture of the hair sets off the smooth planes and bone structure of the face, point to a well developed artistic taste. It was this informed opinion which encouraged the best of Roman art.

The relief from the *Ara Pacis* (Altar of Peace), which Augustus had built, represents the peace and plenty which victory brings, and most Roman emperors stressed this aspect of strong government. Here the Earth Goddess, Tellus, nurtures children and all the fruits of the earth. The figure and drapery of the goddess shows the influence of early fourth-century Greek sculpture, but the carving of the relief is a Roman innovation, for the Greeks used a uniform depth of relief throughout the composition. The Romans, with the pictorial idea in mind, employed various depths as can be seen here, from the high relief of Tellus' head to the very low carving of the plants in the background, in the same way as painters use thin paint for distant forms and thick paint for near forms. The subject too

25 Head of *Octavia*, sister of Augustus

26 Detail from the *Ara Pacis* (Altar of Peace), showing Tellus, children and the fruits of the earth

shows the Roman love of the countryside, which their poets like Virgil and Horace helped to encourage.

Ill. 27 The Roman temple, of which the *Maison Carrée* is a good example, while it adopted the Greek rectangular plan and general appearance, was in many ways different. A much higher podium or platform was used and approached by a steep flight of steps. Two ideas provide the basis for this treatment. There is the artistic conception of elevating what is fine above the commonplace level of, in this case, domestic housing; for where Greek temples were generally associated with sacred sites, the Roman temple, like our own churches, was more often a building within the town plan. The other idea was the equating of religion with imperial authority, since most Roman emperors claimed a divinity equal to the gods or at least to that of a high priest. The porch is also deeper and the walls of the inside room (*cella*), are moved out to 'engage'

27 Maison Carrée of Agrippa, Nîmes

28, 29 The Arch of Titus, Rome. Below, detail of the reliefs inside the arch showing the spoils of Jerusalem being brought to Rome

with the columns, which, nearly thirty feet high, are topped by Corinthian capitals. A frieze of figures is replaced by a decorative scroll pattern. It is typical of the Romans to favour the ornamental Corinthian capital, to which they often added the scroll-type volutes of the Ionic capital.

A separate mark of imperial authority was the *triumphal arch*. The one illustrated here was erected by Titus about AD 80; others had three or more arches. The arch had a purpose, for as the returning victors and their prisoners passed through it, the former saw it as an emblem of triumph and the latter as a symbolic yoke of slavery. To make this idea more emphatic, reliefs were set, at eye level, into the insides of the arch showing, as here, the army about to pass through an arch with their spoils; while high above, an inscription proclaimed the name and honour of the emperor. Architecturally, too, the arch form is very important. The Romans developed it from clay-brick

Ill. 28
Ill. 40

Ill. 29

types they had seen in Egypt. The Greeks did not use the arch very much, largely because it did not fit into their idea of an architecture where forms were based on the natural formation of the material, i.e. a vertical block supporting a horizontal block, known as 'post and beam' construction.

The arch is straight engineering, for the centre 'keystone' locks the other stones into an 'unnatural' but powerful form, capable of holding up a considerable weight. In engineering terms, the arch tends to 'thrust upward'. Too heavy a load on *Ill. 30* it, however, would make it 'thrust outwards'. In the *Colosseum*, this 'upward thrust' of the arch is used to support an immense structure, for the open arch has little weight but great strength. However, the 'outward thrust' of the arch has to be stopped by buttresses (the thick side walls); to lessen the weight of these, important in a high building, the Romans made a brick casing and then filled it with rubble and cement (coarse concrete). The continuous open arches (arcading), also make the building look lighter, and in the hot Roman summers allowed cool air to circulate into the corridors and rooms under the banked seating. To be noted is that Doric, Ionic and Corinthian columns are now used ornamentally, since they no longer play any part as 'supports'. Although the exterior has a certain monotony, the Romans were primarily intent on creating *internal* space. Any sports stadium today becomes exciting only when one gets inside it.

It was the arch, brick and concrete which enabled the Romans to build not only amphitheatres but bridges and aqueducts *Ill. 239* (such as the *Pont du Gard*) of which many still stand. This gift for the practical and its connection with human needs probably enabled sculptors and painters to put into their art the gestures *Ill. 29* and postures of ordinary people. The soldiers on the Arch of Titus striding forward, a little bent under the weight of the seven-branch candlestick, convey an extraordinary feeling of actuality, of watching real people pass by. Even in a Roman *Ill. 31* painting, like the *Aldobrandini Wedding*, both immortals and mortals, lean, sit, lounge and make gestures common to us all.

34

30 The Colosseum, Rome, begun by Vespasian, finished by Titus

While the figures are set across the picture area like a sculptured frieze, there is more empty space between them, which helps to create a feeling of a 'real-life' scene. (The technique here is called fresco, and will be explained in Chapter Three.) This, in turn, shows how far the Romans had moved from the Greeks in this intimate and domestic view they held of their gods. One rarely sees this matter-of-fact observation in Greek art. The girl chooses her jewels with an action selected by the artist, from his experience and feeling for the ideal, not directly from observation.

Ill. 14

This feeling of sharing the artist's immediate response to
something he has seen and felt about, is present in the *Landscape*
and it is there because like most Romans, the artist not only
enjoyed the countryside, but found this enjoyment absolutely
necessary for his well-being and happiness. The way in which
the paint is applied briskly and how few strokes are used to
give the form of each object and the colour tone it would have
on a summer afternoon, makes it possible for us to share this
immediate impression of the artist. At the same time, the
technique helps to form the artist's style, for the method is
painting with hot wax, known as 'encaustic', where colour
mixed with wax was literally 'ironed' into the wall. It required,
therefore, very quick handling.

Ill. 32

36

31　*Aldobrandini Wedding*, fresco from a mansion in Rome

Another imperial monument was the column: two famous ones survive, those of Trajan and Antoninus. *Trajan's Column* *Ill. 33* is a hundred feet high and its surface is covered with a spiral relief which winds its way up to the top. The relief, a detail of which is seen here, provided a continuous narrative, not unlike an endless 'comic strip', for the first and second Dacian Wars. All the qualities of the Roman artist noted so far come out. The gift for catching 'life' as it is, is not just to be observed in the general naturalism of men and horses, but in the particular observation like the balled-up calf muscles of soldiers who have been marching for months in steep country; the technical mastery of the pictorial relief system is tested here, since the sculptor could not cut too deeply into the drums of the column.

37

32 Wall-painting of an idyllic landscape from Pompeii

33 Detail of soldiers from Trajan's Column, Rome

It is for this reason that the artist used natural or architectural raised backgrounds, since to render too great a distance was impossible, without employing the full range of high to low relief. Today it is impossible to see all the relief from the ground, but when erected in AD 114 high buildings stood fairly close to the column, so that it could be viewed from the windows; colour and metal details also helped to make the forms clearer. Reference can be made to the *Apotheosis of Homer*, to see that although a narrative 'strip' was attempted, the story is separated into three main zones and fails to achieve the continuity of Trajan's Column.

Ill. 19

The dome and the so-called barrel vault cannot be constructed without the knowledge of the arch, so the Greeks could employ only flat ceilings, and the width of their buildings was largely determined by the length of a block of marble or wooden beam, which could bear its own weight and anything above it without breaking in the middle. Across the centre of the Parthenon plan, outer columns, walls and inner columns provide essential supports. As the Romans required interior space, such columns and walls would take up too much room. If one arch requires buttressing, one can imagine that the *Pantheon* dome (diameter 142 ft 6 in.), representing numerous

Ill. 10

Ill. 35

34, 35 Plan and portico of the Pantheon, Rome

36 Temple
of Diana,
Nîmes

Ill. 34 criss-crossing arches, would exert enormous outward pressure;
thus the eight shaded blocks on the plan are the massive
buttresses or 'piers'. The circular wall or drum of the building
Ill. 30 is built up in a series of arches, which, as in the Colosseum,
'thrust upwards' to support the weight of the dome, and filled
with light brick. The interior is lit by the 'eye' or porthole
(the dotted circle), which pours an even light over the space
Ill. 36 below. For smaller buildings like the *Temple of Diana*, the
barrel vault was constructed using a series of arches as supports
or 'ribs', as can be seen running up on the right, for a few
arches can carry an immensely greater weight than their
appearance would suggest. The Pantheon and the Temple of
Diana make it clear that the Roman idea of architecture is
quite different from the Greek; it develops a sensation of

40

spreading and soaring internal space unequalled in natural surroundings; it forces stone into unnatural forms to accomplish this. Consequently, the column, which is the major vertical support in Greek architecture, becomes, in many Roman buildings, a decorative item.

Ills. 9, 11
Ills. 28, 30,
36

This idea of outdoing nature in art runs parallel to the superhuman ambitions of the emperors and the unlimited extent of the Roman Empire. Even the Roman road ran as straight as a die, ignoring any obstacles that nature might put in its way.

The Emperors *Marcus Aurelius* and *Caracalla*, although men of very different personalities, shared similar ambitions as the civic heads of the State and leaders of the army in foreign conquest. These imperial characteristics might have led to a rather uniform and dull kind of official portrait, but the Roman 'verist' tradition ensured a lively portrait art – from Augustus' slightly idealized head and Praxitelean stance to the equestrian Marcus Aurelius, whose somewhat 'withdrawn' look, more evident in other portraits of him, points to his interest in philosophy; and the frowning, wary, ruthless gaze of Caracalla. In whatever type, full length, equestrian or bust, the Roman sculptors produced some of their best work in portraiture. The hollow cast bronze horseman, Marcus Aurelius, is a technical achievement, since so large a cast causes many problems, particularly in planning the mould so that the molten bronze will flow evenly into the narrow gap between it and the inflammable 'core'. The 'core' ensures a thin bronze 'skin' for the sculpture. A solid cast would be both very expensive and very heavy. The bronze in this work was originally gilded with gold leaf, but time has removed most of it now. To be noticed also is the horse's stance and that horse and rider are balanced on only three legs, which would have required additional care, since the horse's raised leg and the emperor's outstretched arm, being on the same side, would have to be counterbalanced on the other.

Ills. 37, 38

Ill. 24
Ill. 16
Ill. 37

Ill. 38

In the marble bust of Caracalla, the forceful turn of the head to the left is counterbalanced by the severe folds of the drapery

Ill. 38

37 Bronze equestrian statue
of *Marcus Aurelius*
in the Piazza
del Campidoglio, Rome

38 Bust of *Caracalla*

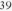 39 Temple of Venus, Baalbek

running up to the clasp on the right. Caracalla was assassinated at Edessa in Syria before he could extend the empire further east, but wherever the Romans created a province from conquered territory, there they built temples, amphitheatres and fine villas. The little *Temple of Venus* at Baalbek and the earlier Maison Carrée at Nîmes in France show there was no lessening in quality, however far from Rome the architect might be. The round temple shows very clearly that the Romans considered architecture as a 'plastic' art, in the way that the sculptor models a clay figure, adding lumps, squeezing or pushing them into the shapes he wants. In fact, as the Etruscans were in the habit of making clay models of their architecture, we may assume that the Romans did the same. The Temple of Venus, in plan, is much like the Pantheon, but its exterior is more interesting, due to the wave-like rhythm which is set up by the concave shape of the highly ornamental cornice; the rolling motion is assisted by the convex drum of the wall and also by the columns. This rhythm is stopped by the flat fronted porch (not visible). The bright sun of Syria would also create a dramatic play of light and shade over these opposed forms,

Ill. 39
Ill. 27

Ill. 34

43

40 Arch of Constantine, Rome

41 Bronze head, possibly of *Constantine*

for even the outward round of the wall is punctured by con-
cave niches. The cup form of the dome (now caved in) would
also have made a further contrast.

Although Baalbek could boast of two other great temples
and buildings, the great scheme that had been planned was
never finished. For the outlying provinces were the first to
rebel or fall to the increasing number of invasions of the
empire. However, Rome was to have one last great emperor,
Ill. 41 *Constantine the Great*, who not only unified the empire again,
giving it a second capital, Constantinople, but set up Christianity
as a State religion. It is not certain that this bronze bust really
represents Constantine, but it shows in the upward-turned eyes
and much reduced emphasis on personality (note the uniform
eyes and eyebrows and the regular pattern of the hair), that
Christian belief in the salvation of the soul and the life hereafter
was causing a growing indifference to individual appearance
Ill. 40 and 'life' as it is. The *Arch of Constantine* contains reliefs in the
same style as the Constantine head, but it also served as a museum
to the past glories of Roman emperors, for there are also reliefs
dating from the reigns of Trajan and Hadrian, amongst others.
Architecture, however, as an 'abstract' art, was less affected by

44

the onset of Christianity than sculpture, as this demonstrates.

Roman sarcophagi survive in large numbers, representing all periods of Roman art. They are best described as semi-portable tombs, since they were placed in open view in burial chambers (mausolea). Some were very large, like this one from Sidamara in Asia Minor which is twelve feet long. Some had elaborate reliefs of mythological scenes, battles, hunting scenes and similar subjects. The type here is derived from earlier versions which displayed individual figures set in niches, flanked by columns. In the centre the dead man is represented as a philosopher or poet like Homer; to the right, his wife gazes at him; but the other figures, including the nude protective gods, look upwards, like the so-called Constantine. There is also an artistic indifference to a uniform style. The nude gods combine the heavy-weight anatomy of Polyclitus with the graceful stance of Praxiteles, while the seated figure in profile throws the centre of the composition off balance. These signs of artistic uncertainty indicate the transition from a pagan to a Christian conception of life and art.

Ill. 42

Ill. 19

Ill. 41

Ill. 7

Ill. 16

Early Christian art, in fact, preserved a great many features of Roman art, but the Christian artist re-worked them with a different spirit.

42 Sarcophagus from Sidamara, with the dead man as a philosopher

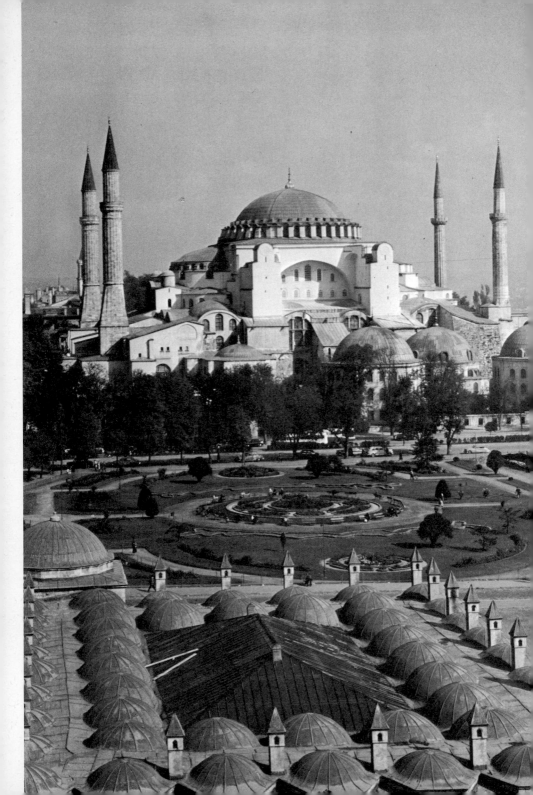

Early Christian – Byzantine – Romanesque c. AD 380–1150

EARLY CHRISTIAN AND BYZANTINE

It was not unnatural that the early Christians should base their churches on a Roman building, the basilica. The two plans on the next page represent a three-aisle and a five-aisle *basilica* respectively. The Roman version was akin to a town hall, used for civic purposes, including the hearing of cases by magistrates at the apse end of the building. Since Christian worship probably originated in small underground chapels, because of persecutions, Christians required interior space, and this had to be shaped to the needs of service and ceremony, known as the liturgy. However, by the middle of the fourth century Christianity had two main divisions, the Roman and the Greek. In the West the basilica was adopted, in the East a domed octagon, but it, too, required an apse (top of plan) to contain the altar. Whereas the attention of the Western congregation was in one way or another directed towards the altar, the Eastern service was conducted by the priest, hidden from his listeners by a wall or screen (iconostasis). The Eastern central plan, while it gave no particular direction, encouraged the worshipper, listening to the service being intoned, to look *about* and *up*. And on the walls scenes from the life of Christ, saints and bishops of the Church were depicted in mosaic.

The basilica, although like a Greek or Roman temple in plan, reverses the Classical structure, bringing the columns inside to form the wide central nave and the two or four aisles on each side. To light the nave, windowed walls were extended up from the arcading to make a clerestory (a clear story). In comparison to the interior, the exterior of a basilica was very plain. On the other hand, the Eastern central plan offered a much more interesting appearance. Even the massive bulk of

Ills. 45, 46

Ill. 44

Ill. 48

Ill. 47

Ills. 45, 46

Ill. 49

Ill. 44

◀ 43 Cathedral of Hagia Sophia, Istanbul (minarets later additions) 47

44, 45, 46 The Early Christian basilica. Left, sketch of a typical exterior, showing clerestory, aisles and eastern apse. Below left, the simple basilican plan, S. Apollinaire Nuovo, Ravenna. Below right, basilica with transept and double aisles, S. Paolo fuori le Mura, Rome

Ill. 43 *Hagia Sophia* suggests a 'mushrooming' of forms, from the way the half-domes and smaller domes cluster round the main one
Ill. 48 (the minarets are later Turkish additions). The plan of *S. Vitale* in Ravenna also has this aspect of a natural growth, compared
Ill. 21 to the severe, geometrical shape of the Tower of the Winds. The low, saucer-shaped dome appears from the outside to push downwards and outwards towards the ground, as the clustered forms around it descend in height. One may think, therefore, of the idea of 'hollowing out' a series of caves under the slopes and crown of a hill. Indeed, some of the small Byzantine churches of Greece look like part of the mountain landscape.
Ill. 53 The Emperor Justinian (527–65), a successful general and
Ill. 48 important lawmaker, who ordered the building of S. Vitale
Ills. 43, 47 in Ravenna and Hagia Sophia in his capital, Byzantium (Constantinople-Istanbul), was well aware that the church not only enshrined the presence of God, but provided shelter and security for the Christian. Although the western part of the

47 Interior of
Hagia Sophia,
Istanbul,
looking south-east

48 Plan of S. Vitale, Ravenna

Roman Empire had collapsed about AD 400, the planning of Hagia Sophia was based on both the basilica and central plans

Ill. 47 giving it the form of a Greek cross (†). The two half-domes that support the central dome give it a lozenge shape, thus indicating direction, but this is still not as forceful as the columns of

Ill. 49 the basilican *Sta Sabina* which 'march' the eye towards the altar. The central plan did set technical problems for the architect, however, for instead of the dome being built up over a

Ill. 34 solid circular drum as in the Pantheon, it now was supported, on a square consisting of four open arches, by 'pendentives' (the wedge-like forms at each corner of the square). A very exact balance was required between the weight of the dome and the upward thrust exerted by the arches on each pendentive. Even so, massive piers (just beyond the four columns on the right) had to buttress each pendentive.

49 Interior of
Sta Sabina,
Rome,
looking east

50　Detail of columns and capitals in Hagia Sophia, Istanbul

The Eastern Roman Empire, its political ties with the Western section broken, assumed more and more the characteristic Eastern mysticism. This, combined with the Christian emphasis on the spiritual, produced figures and images which only approximate to nature. Eastern stress on flat pattern and decoration made them assume a linear quality, the forms being described by outlines and the details of their character by other varieties of lines. Inevitably, through his devotion to flat surface description, the artist ceased to care about the solid nature of his subject, as though, in fact, he was more interested in the shadow that man cast than man himself. The capitals in Hagia *Ill. 50* Sophia are examples of the new trend, for when they are compared to the Corinthian capitals at Baalbek, one can almost see *Ill. 39* that the craftsman of Byzantium has transformed Classical sculptural solidity into an almost flat network pattern. Using the

drill, he has, in the way a stencil is made, cut out his pattern. It was said at the time that angels helped to build Hagia Sophia, a not surprising opinion, since only an intense spirituality could conceive such a fragile lace-like appearance for such an important structural member as the capital. It is also a notion totally opposed to ancient Greek architecture.

Ill. 51 Turning to the ivory relief ($13\frac{1}{2}$ in. high) of the *Emperor Anastasius*, made in Byzantium (Constantinople), one is made very much aware that the Roman tradition is still strong enough to counter Eastern ideas. The style and scale should be com-

Ill. 42 pared to that of the Sidamara sarcophagus, for here, in miniature, are represented many large-scale Roman works – from

Ill. 21 top to bottom – the angels, reliefs of the Tower of the Winds;

51 Byzantine ivory panel showing the *Emperor Anastasius*

52

52　*Christ among the Apostles*, mosaic in the apse of Sta Pudenziana, Rome

the Emperor Anastasius (*c.* AD 430–518), Marcus Aurelius; the
Asiatics and Indians, the reliefs of the Arch of Titus. The artist
adopts a symbolic proportion and scale. The emperor is a
colossus to the small woman at his foot. It is line which imparts
rhythm and liveliness to each section and dominates the artist's
interpretation of texture and form (note the sandal, toes and
horse's tail in the centre panel, and that drapery folds are
incised not modelled). The artist also displays a '*horror vacui*'
(a horror of unfilled space), but this is the natural result when an
artist is concerned principally with an overall, rhythmic pattern.

In contrast is the early Christian apse mosaic in the church
of *Sta Pudenziana*, made eighty years earlier in Rome. Closer

Ill. 37
Ill. 29

Ill. 52

53

to Roman art, the mosaicist has adopted a triangular composition for Christ and the Apostles, similar to a Greek pedimental group; expressions and gestures are naturalistic and there is a feeling of space behind the figures. Although Christ is shown beardless in the top zone of the ivory, he is here bearded, an Eastern tradition in Early Christian art. In the background is the New Jerusalem, with churches built by Constantine. In the clouds float the winged symbols of the four Evangelists, taken from *Revelations* 4:7. From left to right, the Man – St Matthew; the Lion – St Mark; the Ox – St Luke; the Eagle (partly obscured) – St John. This use of symbols and signs had been essential in the years of persecution, to protect Christians from discovery, but they, too, form part of the mystery or magic associated with most religions. The mosaic here has been much altered; the surround was narrowed down in the sixteenth century and since damp often causes the tesserae (the marble and glass chips) to fall out, parts of the composition have been restored. The technique used here is Roman, in so far that the tesserae, cut into regular sized cubes of varieties of tone, are set into wet cement, as the painter brushes in his tones. The advantage of using mosaic in this painterly manner is that it has a translucent quality so long as glass tesserae are used. The making of glass mosaic is identical to stained glass (colour is fused between two sheets of glass in a high-temperature oven), except that the mosaic workshops of this period often fused gold or silver leaf between the glass.

The next example, a detail from one of the flat wall compositions in *S. Vitale* in Ravenna, demonstrates the Byzantine style of the sixth century. Here the tesserae are not only larger, but vary greatly in size and shape, noticeably in the brooch on the Emperor Justinian's shoulder (left) and the cross held by the bishop Maximian (right). The tesserae forming the background are all of gold leaf, so that the flat planes of the figures are projected forward from this gleaming surface, causing the figures to 'float' in front of the solid wall, so that a person standing below could look up and see a 'vision' of the majesty

Ill. 53

54

53 *Emperor Justinian and his Retinue*, mosaic in the chancel of S. Vitale, Ravenna

of State and Church. This flat linear method is best shown by Justinian's crown, for its shape is indicated by flattened curves alone, while Maximian's garments at the level of the sleeve are seen as overlapping planes. This thoroughly Eastern style is offset by the heads, which, in the tradition of Roman portraiture, are lively and convincing likenesses. Despite this characterizing of the heads, the emphasis on the vertical (the crossed-over arms providing about the only strong horizontal line) gives each figure an elongated form, which is not only 'unnatural' but stresses the mystical atmosphere desired by the Eastern Church.

The course of Byzantine art was interrupted by the so-called 'Iconoclast' period (AD 726–843), during which no figural art

55

was made. It was held that the making of images had been forbidden by Moses and that to use them in worship was idolatrous. Only in the eleventh and twelfth centuries did Byzantine mosaic art regain its mastery, in Greece itself, in Venice and in Sicily.

Ill. 54 *Daphni* lies on the old classical Sacred Way between Athens and Eleusis and this location is significant, for the mosaic style practised in the monastery church has a graceful rhythm reminiscent of fourth-century BC Greek sculpture: St John on

Ill. 16 the right, with his weight on one leg, is not unlike Hermes. There is, too, less emphasis on the strong verticals used at

Ill. 53 Ravenna, and the proportions of the figures are more natural,

54 *Crucifixion*, mosaic in the monastery church of Daphni, Greece

55 *Christ Pantocrator*, the Virgin, angels and saints, mosaic in the apse of Monreale cathedral, Sicily

but forms and textures are still described by line. The overlaps in St John's drapery are still seen as planes, while the diagonal folds on his outplaced leg deny the presence of the shin and calf beneath. However, the tilted board below Christ's feet, the skull and flowers indicate a very shallow space *within* the composition, and the duller lustre of the gold background restrains that projection of the figures, so marked at Ravenna.

The mosaic technique involves small regular tesserae, but they are laid in with the distinctive Eastern love of linear decoration, as one may observe on the torso of Christ. Compared to the Daphni style, *Monreale* in Sicily presents a much *Ill. 55* more awesome conception. The twelfth- and thirteenth-century Byzantine art there was due to a historical accident, for Roger, a Norman knight diverted from a Crusade, captured

57

Sicily from the Arabs in the latter part of the eleventh century and founded a dynasty of Norman kings in this island that already had a long Byzantine tradition and had been ruled by Arabs for two centuries. The Islamic influence may be seen in the slightly pointed arch, framing the apse of the cathedral, which contains approximately 64,800 square feet of wall area

Ill. 50 covered with mosaics. Like the ornament on the Hagia Sophia capital, the mosaics cover the architecture to the extent of hiding its structural form. The great bust of Christ represents him both as Pantocrator (the Universal Judge), and as Teacher, since the Bible is open. Below him, in a descending order of rank, referred to as 'hieratic order,' are the Virgin and Child enthroned with the four Archangels, followed by the four Fathers of the Greek Church. This hieratic order may be com-

Ill. 19 pared with that in the *Apotheosis of Homer.*

Ill. 56 The portative mosaic ($21\frac{1}{4}$ in. high) of Christ as 'the Light of the World' is an icon, i.e. a painting or small mosaic picture

56 Portative Byzantine mosaic of *Christ* as the 'Light of the World'

57 Initial XPI (Monogram page) from the *Book of Kells* ▶

which could be carried by the traveller or set up in a private house. The icon, indeed, is the forerunner or prototype of the painting as we know it. For practical purposes, painted icons soon replaced mosaic. While this is a gentler Christ than at Monreale, the symmetrical linear outlining and detailing of the face and beard indicates a similar attitude to the sacred image *Ills. 1, 2* as that of Archaic Greece. While these early periods of Christian art appear to consist only of monumental or very small-scale works, it is this latter 'miniature' art which carries and spreads artistic styles across the length and breadth of Europe.

ROMANESQUE

While the Romans spread their art through conquest, the Christians spread theirs through faith. For Christianity had few territorial boundaries, and priests, monks and craftsmen all moved freely and frequently. When the diffusion or spreading of an art style is considered in this period, account must be taken principally of the portable art that these travellers carried – icons, ivories and manuscripts. Manuscripts were not only hand-lettered but were also illustrated and decorated (or 'illuminated' since much gold leaf was used). Besides, the medium – glair, dry colour mixed with egg white – produced brilliant colour. The pages were of vellum (prepared goat or *Ill. 57* sheepskin). The initial page illustrated, demonstrates the long labour, craftsmanship and use of rich materials, which make up one of the principles of the medieval attitude to art – the work was to be valued for the cost of labour and materials, in addition to its artistic merit.

Romanesque art is the Western equivalent of Byzantine, and its greatest flowering was in Northern Europe. Northern art tends to reflect the character of Northern life, the hard struggle to survive in a hard climate, the anxieties which this creates; the loneliness of the small isolated settlement, which creates self-dependence; the long winters which create the need for absorbing and time-consuming work indoors. The artist monk *Ill. 57* who made the page from the *Book of Kells*, lived on the island

60

of Iona, Scotland or in a monastery in southern Ireland. Hardness is seen in the initial, as though it had been cut out of tin; anxiety in the restless and sometimes rapid abrupt changes in the linear pattern; self-dependence, in the personal 'doodling' of the artist, filling in the space with similar shapes, but none of them quite the same as another; and isolation is evident in the never-ending line of the pattern, beginning nowhere and ending nowhere. However, the Northern artist tended to use regular geometric arcs for his *irregular* patterns.

This extreme form of Northern art is not to be found in France or Germany, since both these countries had had longer physical contact with the Romans and continued to be included in the Holy Roman Empire, founded by Charlemagne at his coronation in Rome in AD 800. However, these Northern characteristics direct the artists even when they are at their most Roman, that is, Romanesque.

The Abbey Church of *St Denis* and the character of the *Ill. 58*
oratory or small chapel at *Germigny-des-Prés* show the adoption *Ill. 59*

58 Plan of the Carolingian church of St Denis

59 Interior of Theodulf's Oratory, Germigny-des-Prés

61

of the basilica plan and the practical brick arch and square pier the Romans had used for bridges and aqueducts. But the plan of St Denis reveals two distinct changes from the Italian basilica: the apse is now deeper and the east end of the nave extends out in two arms, in the form of the Latin cross (†)

Ill. 61 which eventually led to the plan of the *Abbey at Cluny* (1088–1130). It is to be noticed also that the rather meagre capitals on the piers form a horizontal line which keeps the eye down to the level of the altar in the distance, similar in intention to that

Ill. 49 of Sta Sabina.

However, the idea that moved the Romanesque architect to create new forms was the church as a symbol. Already the plan resembled the crucifix, but the need for self-expression

Ill. 57 regardless of practical considerations (see the initial page), enabled the Northerner to conceive the whole church as a symbol. For if the central-domed plan of Byzantium was designed to provide visions on earth, the Northern church was

Ill. 60 to be a heaven on earth. In *St Cyriakus at Gernrode*, Germany, this desire is expressed in the addition of a middle storey (blind or triforium) and twin towers, capped with short spires, to the original basilica form. However, despite this vertical direction an almost equally strong horizontal direction is maintained by the roof line of each storey on the outside, and

60 Exterior of St Cyriakus, Gernrode, from the north-east

61 Plan of the third abbey church of Cluny

62 Façade of S. Miniato al Monte, Florence

63 Interior of Durham cathedral, looking west

on the inside (the *nave of Durham*) by capitals on columns and *Ill. 63*
piers, the rounded moulding at the triforium level, and high
up, just below the clerestory windows, by capitals supporting
the roof arches.

The west front (façade) of St Cyriakus, although much higher,
expressed the same balance between vertical and horizontal as
can be seen in the Italian Romanesque façade of *S. Miniato* *Ill. 62*
outside Florence, where the proportions and features resemble
those of Classical buildings. The Roman solidity in this arch *Ills. 22, 40*
is also reflected in St Cyriakus – thick walls and small windows.
The 'mushroom' growth noted in Hagia Sophia occurs also *Ill. 43*
in Romanesque, as may be seen in the east end of *St Sernin* at *Ill. 67*
Toulouse in southern France and the plan of the Abbey at Cluny. *Ill. 61*
The original basilica end and apse, just below the tower, have
been extended outwards to make the arms of the 'cross' (the
transepts) and outwards and downwards to a series of clustered

63

chapels. But the similarity to the Byzantine idea ends, because of the stress on the vertical in the Northern church.

Ill. 64 The Roman spirit evident in the architecture is to be detected also in illuminated manuscripts. The Master of the *Registrum Gregorii* is thought to have been an Italian (monks often travelled far from their original homes; there were, for instance, Irish monks at St Gall, Switzerland). Where four human faces

Ill. 57 peer out of the curvilinear maze of the Book of Kells page, here Gabriel and the Virgin are depicted in a natural way, standing on a slope at a distance from the walled city of Nazareth. The weight of the drapery, the lively gestures and the setting are

Ill. 52 like those in the apse mosaic of Sta Pudenziana, but the North is represented by the repetition of U curves made by Gabriel's face, halo and wings (see this repeat pattern in the Kells page). It is interesting to relate this kind of repetition to Northern poetry – the sixth-century poem *Beowulf*, for instance, is made up of linked alliterative lines (for example, '*The grim guest Grendel*'), which illustrates that the Northern 'stylized' repeats are the *same* but *different*, contrary to the Greek preference for a regular pattern.

64 MASTER OF THE REGISTRUM GREGORII
Annunciation from the *Egbert Codex*

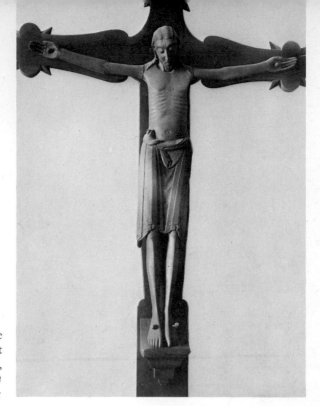

65 Bronze figure
of Christ
on the Cross,
the *Werden
Crucifix*

The thin, rather pitiful image of *Christ on the Cross* also *Ill. 65*
reflects the realities of Northern life, and the ordinary man
would have no difficulty in seeing him as a brother sufferer. In
contrast the Christ at Daphni, is an aloof, idealized vision. The *Ill. 54*
bronze figure, whose forms are clearly derived from wood
carving, is elongated in the Byzantine manner, but the mysti-
cism this might inspire is contradicted by the naturalism of the
chest and ribs.

There was, for the first time, a close bond between sculpture
and architecture in Romanesque times. The centre doorways
of churches were increased in size partly to accommodate
sculpture. The first thing to notice about the entrance porch
relief at *Vézelay*, of Christ at the time of Pentecost, is that it is *Ill. 66*
in form and nature the early basilica apse mosaic brought for- *Ill. 52*
ward and *outside* the nave. Filling in the top half (tympanum)
of the entrance arch, it was intended as a forceful message to the

66 Typanum of the inner west doorway of Ste Madeleine, Vézelay, showing Pentecost and the peoples of the world

worshipper before he entered. The subject was carefully chosen, for the time of Pentecost was when the tongues of flame descended on the Apostles, prior to their spreading the Gospel throughout the world. At Ste Madeleine, Vézelay, pilgrims gathered together before they set out on one of the routes to the shrine of St James at Santiago de Compostela in Spain. It was here also that St Bernard of Clairvaux preached the Second Crusade. These churches on the pilgrimage routes – Ste Foy, Conques; St Trôphime, Arles; St Pierre, Moissac; St Sernin, Toulouse – were not only the shrines of saints but shelters of pilgrims, who not only worshipped in them but slept, ate, gossiped and bought merchandise in them as well. So much space was needed. This also serves as a reminder of the Northern mixture of mysticism and reality.

Ill. 66 Mysticism is certainly present in the asymmetrical and unnatural scales of the figures of the tympanum which is composed with a restless curvilinear rhythm. The same style can be examined more closely in the support column (trumeau) of

66

67 St Sernin, Toulouse,
exterior from the east

68 West porch
of St-Trophime,
Arles

69 *Jeremiah*,
stone trumeau figure
at St Pierre,
Moissac

Ill. 69 the tympanum at *Moissac*. Unlike the Byzantine craftsman, who turned capitals into fragile shells, the Romanesque artist 'animated' columns and capitals, making them alive with beasts and figures. This treatment does not make the stone look fragile, for the lionesses on the front are crossed over in steel girder fashion, and the back is cut into linked vertical arches. Besides, to the medieval pilgrim, there could be no stronger a support than Jeremiah, one of the Old Testament prophets to proclaim the coming of Christ. For the common man, these figures of prophets performed the important task of warding off the forces of evil, which all ranks of society regarded with superstitious dread. More effective, perhaps, than architectural sculpture, was the portable image, which could be taken to *Ill. 70* anywhere in the countryside. *Ste Foy* was a young Christian girl martyred by a Roman governor, but here she is represented

68

by an effigy of gold, covered with precious stones and antique cameos, which are arranged in the same asymmetrical manner noted already. Another principle of medieval art may be added here – beauty was thought of as splendour, a mixture of bright colour and shining lustre, and what could be brighter and more lustrous than precious stones and gold?

A similar surface is suggested by the artists of the *Winchester Bible*, by giving strong highlights to parts of the figures and to the fruit and leaves, then further 'raising' them off the page with a bright blue background. When this capital letter is compared to that of the Book of Kells, one may recognize that while the pattern is still curvilinear, there is a feeling of greater space and that there are both balance and symmetry in the lay-out of the design. Even the complicated knot at the top of the upright, known as 'interlace', begins and ends at the top. Knots, it should be observed, also warded off evil. The interlace, here, provides a 'capital' to the upright, but the most common in Romanesque architecture was the 'cushion', seen at the top of the zig-zag (chevron) patterned column on the left of the Durham nave, which is rich in differently incised columns. This idea probably stems from the desire to 'slow up' the passage of the eye to the altar, in contrast to the rapid progress encouraged at Sta Sabina. But another method had been introduced of alternating column-pier-column, so that each pier marked a division – as can be seen here on the left – consisting of two arches (a bay). The pier is no longer the plain, square block type but is made up of a cluster of pipe-like shafts around a solid core. As these shafts are 'engaged' (see the Maison Carrée) to the wall, they are known as wall shafts, and the inside ones (near left) run without a break from the floor of the nave up to a half 'cushion' capital (see above – the next pier on the left) which takes part of the weight of the ceiling arch. Most early Romanesque churches had flat wooden ceilings; the Roman barrel or tunnel vault was also employed, and from this was developed the groin vault, which proved too heavy and was little used for nave ceilings. At Durham, however, the

Ill. 71

Ill. 57

Ill. 63

Ill. 49

Ill. 63

Ill. 27

Ill. 63

69

first ribbed vaults were used. The ribs can be seen crossing diagonally from one main roof arch to the next. The rhythm created by the side arches of the nave is repeated up on the ceiling. The next step was to be taken by the Gothic architects.

Finally to remind one of the Roman contribution to Romanesque, there is no better example than the west porch of *St Trôphime at Arles*, in the south of France, for its pitched roof, large arch, emphatic horizontal frieze and Corinthian type columns combine most of the features of a Roman temple front and a triumphal arch – with good reason, since there is still at Arles a Roman amphitheatre; at Nîmes, close by, the Maison Carrée and the Temple of Diana; and a little further to the north, at Orange, a Triumphal Arch.

Ill. 68

Ill. 35
Ill. 40

Ills. 27, 36

But the Gothic style in architecture was to be based on Northern inventions and inspired by Northern feeling.

71 MASTER OF THE LEAPING FIGURES *The Calling of Jeremiah,* from the *Winchester Bible*

71

72 Central portal of the west front of Chartres cathedral

Gothic Art: Northern Europe and Italy c. 1150–1530

NORTHERN ARCHITECTURE AND SCULPTURE

The Middle Ages were once called the 'Dark' Ages, so one could call the Gothic period the 'Light Age', for it is noticeable about the beginning of the thirteenth century (1200) that there are many enlightened changes in the attitude towards religion and art. These changes were due, in part, to the revival of Greek philosophy and its influence on Christian scholars, like Thomas Aquinas and others. Briefly, the irrational and emotional art of the Romanesque was rearranged and reformed, so that man could feel and see not only the glory of God, but the human mind and hand that had fashioned this glory. The people of Conques, perhaps, liked to believe that the golden effigy of Ste Foy was the saint herself. Such a symbol was seen by the *Ill. 70* Gothic world as a man-made 'veil' or a screen which stood between man and divine truth. The tympanum sculpture of the west or 'Royal' porch at *Chartres* illustrates this new attitude, *Ill. 72* particularly when it is compared to the Vézelay tympanum. *Ill. 66*

At Chartres, symmetry replaces asymmetry; proportion replaces disproportion; reasoned clarity replaces emotional disorder. The artist of Chartres designs and models his figures so that they fit harmoniously into the space allotted to them, while at Vézelay, the sculptor ignores such limits, with figures (to the right of Christ's feet) that are half in one zone and half in another. Nevertheless, at Chartres there is no mistaking in the linear patterning of Christ's drapery and the wings of the Gospel symbols (see Sta Pudenziana) the continuing *Ill. 52* Northern interest in the rhythmic use of line. Nor does the Gothic image lose the frontal view, even though it is given a more rounded form. This new clarity is shown by the programme of the porch. Christ is seen at his second Coming

73

73, 74, 75 Reims cathedral. Left, interior of the nave looking east. Below, plan. Bottom, cross-section of the nave and aisles showing system of buttressing

76 Bourges cathedral from the south-east ▶

witnessed above by angels and the twenty-four Elders of the Church, and below by the Apostles divided in four groups of three, since they were to preach the Gospel in the four corners of the world. On either side of the door (jamb figures) Old Testament kings and queens symbolize the alliance between kingship and priesthood or State and Church.

Similar changes may be observed in Gothic architecture. On comparing the plans of the Abbey Church at Cluny and the Cathedral of *Notre-Dame at Reims*, the latter reveals a new approach. At Cluny the architect *adds*, to the traditional plan of the basilica, a second transept to the east and lengthens the nave. But at Reims, the builder has reasoned out a completely fresh arrangement – from east to west, the chapels are enlarged and brought *inside* the main wall which now closes in the transepts. The eastern transept disappears and the original western one is placed more towards the middle. The nave is shortened so that a harmonious balance exists between it and the east end (the choir). The effect of these changes can be seen at Reims and Bourges. Looking towards the east, the space of the nave becomes visibly compressed as the eye drops down to pass through the narrow arches at ground level (the semi-circle at the end of the nave). At *Bourges*, the chapels no longer cluster round the east end as at St Sernin, but are wrapped into the main body of the church. In effect, the Gothic architect transforms the external *appearance* of the Romanesque into a *feeling* of internal space.

Ill. 61
Ill. 74

Ill. 73

Ill. 76
Ill. 67

By moving from the extreme east end of the cathedral towards the west and into the nave, there would be a feeling of release, of expanding space, like entering a high-ceilinged room from a low narrow corridor. This effect was also obtained by moving from the nave into one of the side aisles or vice *Ill. 75* versa, as can be noted in the cross-section of Reims. A third variation of space was obtained where the nave meets the transepts (the crossing), for here it expanded sideways. Space, however, can only be experienced so long as there is light. Placed in the middle of a blacked-out room, one cannot *sense* its size. Consequently, the Gothic builder devised means of bringing in light, not ordinary daylight, but light filtered and coloured by stained glass windows, to make it extraordinary.

If the Romanesque builders aimed at creating a heaven on earth, it was the Gothic architects who achieved it, for by combining unnatural space and unnatural light, they created a super-real sensation. They did not find the solution immediately, as can be seen if one compares the nave sections of *Ills. 77, 78* Chartres (1195) and *Amiens* (1220): at Amiens the height of the nave arches is greater, the piers are more slender, the number of verticals in the triforium and clerestory arches is

77, 78 Nave elevations of Chartres and Amiens cathedrals

79 Interior of Chartres cathedral, looking north-west across the nave

80 Interior of Amiens cathedral, looking east

greater, while both show that the greater use of glass has reduced the triforium to an almost decorative band (compare Durham). Another vital difference is the Gothic use of identical piers in the nave, instead of the column-pier-column system at Durham. The result was the same as at Sta Sabina: the eye rushed towards the east, but in the Gothic nave it also was directed upwards. The effect obtained is not dissimilar to walking briskly along a main street lined with very tall buildings, with the eye flicking from shop window to high building so much that the feet seem to lose contact with the pavement. This 'optical direction' of Gothic is different from Greek 'optical correction', although it too depends on balancing horizontal and vertical lines.

Ill. 63

Ill. 49

Ills. 73, 79

Ills. 79, 11

This Northern Gothic expression of feeling is attained also, by *almost* disregarding the fact that stone is a solid and weighty substance and by employing constructional forms which went further than those of the Romans in overcoming its natural

77

laws. Thus the pointed arch was stronger structurally than the round (it also 'pointed upward'). Its upper part is triangular and the triangle was the geometric figure on which a great *Ill. 74* deal of Gothic planning was based – the east chapels of Reims represent triangles with their apexes meeting at one point, and *Ill. 75* the section of Reims can be seen as a vertical triangle. The *Ill. 76* flying buttress, like a diagonal girder, counteracted the outward thrust of the roof arches more efficiently, and at the same time left the nave wall clear for large windows to let in light *Ills. 60, 79* (compare Gernrode). Assembled clusters of shafts and arch curves (archivolts) performed the same task as the solid Romanesque forms, but *multiplied* the number of direction lines and lightened the *appearance* of these supports (compare a railing fence to a brick wall).

Lastly, the pointed arch narrowed the space between each *Ills. 63, 91* pier (compare Durham and York naves), producing a brisker rhythm to hurry the worshipper towards the east end.

A great many of the internal features of the Gothic cathedral *Ill. 81* appear on the façade (west front). The vertical is stressed by the towers, while the huge area is lightened by 'opening up' the surface with arches, arcading, figures in niches and a large 'rose' window. While there is a certain likeness in the porch *Ill. 68* to that at Arles, the use of the pointed arch and numerous sculpted figures on the archivolts both lightens it in appearance and allows the sculpture to be 'read', clearly. For Gothic porch sculpture, instead of acting as an awesome reminder to the entering worshipper, was intended to instruct and inform.

So extensive were these instructions, that they required the extra space provided by the two side porches on the west front and also in the porches at the entrances to the two transepts (north and south). The 'programme' of each porch was worked out by the clergy and carved by the artist, or rather craftsman, for in the thirteenth century, neither painting nor sculpture *Ill. 81* were included amongst the seven liberal arts. At Amiens, the façade programme was as follows: the centre porch – the *Last Judgment* on the tympanum, and below Christ the Teacher on

78

the trumeau, and Apostles and Prophets ranged on either side wall (jamb) of the porch; in the left porch – the community of Saints; and in the right porch – Mary as a symbol of the Church (Ecclesia) and also the events in which she was a major figure: *The Visitation, Annunciation, Adoration of the Magi* and the *Presentation in the Temple.* Other subjects were carved in relief – representing the signs of the Zodiac, the type of work associated with each month, and the Virtues and Vices, which were shown in pairs – Hope and Despair – where virtue always triumphs. While the Greeks had used this type of *Ill. 8* allegory in a similar way on their temples, their symbols were simple compared to those of Gothic times. The Virgin Mary, for instance, was not only the Mother of Christ, but the Body of the Church, the Bride of Christ and the Queen of Heaven,

83 *Death of the Virgin*. Tympanum of the south transept of Strasbourg cathedral

for by the thirteenth century there was increasing reverence for her. At *Notre-Dame*, Paris, the Virgin porch on the *right* of the main porch (for the Virgin Mary is always at the right hand of Christ) shows her Coronation. In the zone below, the Death and Resurrection of the Virgin takes place, for at that time all the Apostles and Christ were together once again. Below, three Old Testament prophets and kings sit at either side of the Ark of the Covenant, which Gregory the Great had described as the Old Testament symbol of Holy Church, as Mary was of the New Testament. It can be imagined that the sculptor had no easy task in following such a programme and showing it clearly within the limits of the allotted space.

Ill. 82

The Paris style maintains the frontal view of the tympanum at Chartres, but the linear patterning has disappeared and the figures and drapery have a greater sense of volume and weight. Most noticeable is the even balance between spiritual expression and the interest in naturalism. A very similar balance was achieved in the Ludovisi Throne. This with the architecture of the period – 1190–1230 – is known as High Gothic. However,

Ill. 72

Ill. 5

◀ 82 *Death and Coronation of the Virgin*. Tympanum of the Virgin Portal at Notre-Dame, Paris

Northern artistic expression, so evident in Romanesque art, is never overwhelmed by Southern influence even in Gothic *Ill. 83* times, so that the relief of the *Death of the Virgin* at Strasbourg seems to continue the Romanesque tradition of asymmetry, unnatural proportion and linear rhythmic pattern. But once the details of gesture, pose and drapery are examined, their classical origins are apparent, and particularly in the young girl, the Roman interest in 'life' as it is (note the way the hands are clasped). Furthermore, the placing of the girl *in front* of the Virgin shows a revival of interest in pictorial space, which is *Ills. 82, 72* certainly not apparent at Notre-Dame, Paris or at Chartres. The very emotional spirituality of the Strasbourg relief is evidence of the raging conflict between heretics like the Cathars and the official Church. In 1212 at Strasbourg, eighty men, women and children were burnt at the stake, and between 1231 and 1233 Conrad of Marburg conducted a reign of terror in the name of the True Church, putting thousands to death. Such a conflict bred a kind of religious hysteria. In the Paris area, where Church and State supported each other, as indicated at Chartres, artistic expression was restrained and also refined by the presence of the scholars of the Church and the aristocratic taste of the court.

Not only did the major ideas of Gothic come from this area, but the workshops of the cathedrals trained many of the crafts-men who went to work in different parts of Europe. One of *Ill. 84* the most important of these was Reims, where, about 1250, a Gothic-Neo-classical style emerged. Here in the centre porch of the west front at Reims in the *Annunciation* (left) there are the severe but impressive drapery folds to be seen in the bust *Ill. 38* of Caracalla; in the *Visitation* (right), broken, sharp-edged folds *Ill. 24* like those in the swathe around Augustus, in addition the figures and heads of the Virgin and Elizabeth of this group have *Ill. 26* the volume and fullness of the Augustan style (Tellus, Ara Pacis). The hieratic, frontal column-like jamb figures of the *Ill. 72* earlier style at Chartres are replaced here by 'live' personages turned towards each other. While story-telling was practised

84 *Annunciation* (left) and *Visitation* (right) from the west front of
Reims cathedral

in the reliefs, this is an early example of major sacred figures
being treated in such a way. The Reims sculptures also stand
further away from the building, suggesting that these jamb
figures are to be viewed as sculpture alone and not as symbolic
semi-architectural forms. The builders of Reims cathedral were
also Gothic Neo-Classicists, for they built and designed their
piers as though they were classical columns with Corinthian
capitals. Compared to those of Chartres, they make a much *Ills. 73, 79*
more emphatic horizontal line and resemble the columns of
Sta Sabina in the way they are so clearly defined. Note that the *Ill. 49*
vertical wall shafts do not run continuously down to the floor,

83

and the blocks (plinths) on which the piers rest are higher off
Ill. 91 the ground than those of York and even those of Chartres.

The German sculptors at Naumburg, were amongst those
trained at Reims, for the same interest in naturalism is apparent
Ill. 85 in these figures of *Eckhardt* and *Uta*. But it is important to dis-
tinguish that the German sculptors are much more concerned
with the real than the French, for Eckhardt had been the Mar-
grave of Meissen in the fifth century and with the other legend-
ary founders of the cathedral he stands with his wife Uta, carved
in a most life-like fashion, *inside* the choir of the church. Not
only is this different from French tradition, but, like spectators,
the Naumburg figures are watching the punishment of Thimo
by Ditmar, a sculpted scene at the head of the choir. This
sculpted drama and its spectators reminds one of a theatre, with
its power of creating the illusion of reality. There was, in fact,
a tradition of performing plays dealing with the Passion of
Christ in the churches. Another type, the Mystery play, was
acted by the various trade guilds, in a series of episodes, which,
performed on carts moving through the streets, provided a
kind of mobile theatre. There is no doubt that these plays both
gave artists ideas on the grouping of figures and also allowed
them to see these Old and New Testament characters as fellow
citizens in the dress of their own time.

If the Naumburg sculptors were interested in life-like
portraiture, in the weight and texture of drapery, in capturing
the expression of people absorbed in a drama, they also made
sure that this couple's hands and bunched drapery maintained
the same horizontal line set by the shafts and arcading behind
Ill. 84 them. A similar horizontal is maintained at Reims. Sculpture
still had to perform an architectural duty. This interest in
Classical naturalism and humanity of the mid-thirteenth
century is found throughout Europe, and its effect in Italy will
be studied later. But in Northern Europe, there was a powerful
force which helped to form another aspect of the Gothic style.
Both the courts and aristocracy obeyed the code of chivalry,
which was based on love. The romantic love between knight

85 *Eckhardt and Uta* from the west
choir of Naumburg cathedral

86 *Vierge Dorée* (Golden Virgin),
trumeau figure on the south
porch of Amiens cathedral

and lady, equalled the love of the noble and good for the pure
and beautiful and thus the earthly equal of Christian love for
the Church. Since the Virgin Mary was the Church and
Jerusalem a symbol of the Church Militant, which fought for
and defended its faith, the knight rescuing his lady or fighting
in a crusade was saving virtue from vice or saving his good
faith from pagan sin. The *Vierge Dorée* (the Golden Virgin) of *Ill. 86*
Amiens cathedral, conveys this chivalric and courtly notion,
for she is young, beautiful and very elegant. Compared to the
Angel of the Annunciation at Reims, this figure describes a more *Ill. 84*
S-shaped pose not unlike the *Hermes with Dionysus* of Praxiteles. *Ill. 16*
The majestic heavy folds of her drapery makes her young body
and head even more youthful. Her crown is not only a regal

and courtly symbol but also the triumphant symbol of her Coronation. Her elegant slim height is also typical of the last phase of architecture, Late Gothic.

Ill. 87 The *Sainte Chapelle* was built by Louis IX, who was also a saint. It is a small building, but immensely high compared to its width. The windows now occupy all the wall space between the buttresses, and the rose window fills almost the whole width of the west front. It is now the windows which instruct and inform, for 1,134 scenes are depicted in stained glass. A much Ill. 89 larger building, *St Ouen* at Rouen, shows similar characteristics Ills. 88, 74 to the Sainte Chapelle. The plan compared to Reims is narrower in width and the chapels at the east end lose the uniform size they had at Reims and the centre one extends outwards. The effect within is like looking through the wrong end of a telescope. Moreover, on the walls, the vertical direction is increased by reducing the High Gothic capitals on the piers to small carved brackets. Finally the triforium and clerestory levels become almost one, since they are separated by a very narrow stone division. Late Gothic, therefore, extends to the utmost limit all the earlier Gothic characteristics. The reasoned order

87 Sainte Chapelle, Paris, from the south-west

88, 89 St Ouen, Rouen.
Below, plan. Right,
interior of the nave looking
east

of Chartres, has an almost Classical harmony and stability *Ill. 79*
compared to the sensational treatment at St Ouen.

Elsewhere the Gothic style was adapted to suit local traditions.
In England, the cathedrals were much longer and less high than
the French, consequently, flying buttresses were not common.
To compensate for the lack of these exciting girder-like forms
on the outside, the English developed the vaulting system into
an intricate pattern of ribs (*York* may be contrasted to the simple *Ill. 91*
vaulting at Reims and even at St Ouen, Rouen). Also typical *Ills. 73, 89*
of English Gothic is the large tower over the crossing which,
shedding a strong light, breaks the passage of the eye towards
the east. The transepts, too, project out from the main wall line
as they did at Cluny. *Ill. 61*

87

In general the English devoted more attention to surface decoration, which at York, a relatively restrained example, can be seen towards the east end to have the effect of creating a network of fine lines, which gives in another way a weightless appearance to the stonework. Most English cathedrals can claim some unique effect of decoration or engineering and the

Ill. 92 'strainer' arches in the nave at *Wells* demonstrate both the skill in treating stone as though it was a plastic material, the Northern spirit in the strong rhythmic pattern, and the expressive use of compressed and expanding space. In contrast the lighter tracery

Ill. 87 of the rose window of the Sainte Chapelle shows the influence of the French court style.

Similar in spirit but different in expression is the Great

Ill. 90 Refectory (Dining Hall) of the *Castle of Marienburg* in Germany, now the Polish town of Marlbork, near Danzig. Geographically, York to Marienburg gives some idea of the extent to which the Gothic style spread over Europe. The castle was the headquarters of the Teutonic Knights, known as 'the sword-bearing brothers of Christ's chivalry', who played a leading role in the expansion of the German States towards the east. Because of the hall shape the vaulting is supported directly from columns. The airy elegance of this hall fits in with the courtly Gothic style of Paris, but at Marienburg and elsewhere, the style was put to non-sacred or secular use, and its decorative elegance was the characteristic which appealed so much to court and aristocracy.

90 Interior of the great refectory in the Castle of Marienburg, Poland

91 Nave of York Minster,
looking east

92 Strainer arches
in the crossing of
Wells cathedral

93 HANS LEINBERGER
Virgin and Child

Ill. 93 Further south at Landshut in Germany, is the wood and painted plaster *Virgin and Child* by Hans Leinberger, who was working there *c.* 1510–30. This indicates how long lasting the
Ill. 86 Gothic style was in Northern Europe, for the Vierge Dorée was sculpted two hundred years before, but it can be recognized as the original source of Leinberger's work. The differences are important, and these can be examined in the swathe of drapery, which is unnatural to a far greater degree than that of
Ill. 18 Mausolus; the straight vertical fold on the right of the Amiens figure becomes a tense arc in the Landshut work, in which the midriff folds also convey a strained, distorted impression.
Ill. 83 Indeed, the spirit here is closer to the relief at Strasbourg, with which it shares a similar nervous anxiety, although the methods used to express this are different.

90

Since Northern Europe not only created the Gothic style but preserved it far longer than Italy, it is necessary to look at the painting of the French and Flemish artists first, even though they were working a hundred years later than their counterparts in Italy. While the art of large-scale painting never died out (there are, for instance, many examples of wall paintings in churches through Romanesque and early Gothic times), it is true that the art of the *framed* painting or painting which is independent of architecture was preserved and developed in manuscript illumination.

By the beginning of the fifteenth century, this art, assisted particularly by court patronage, had begun to treat subjects

94
MBOURG BROTHERS
The Month of May,
from *Les Très
Riches Heures*
of the Duc
de Berri

95　JAN AND HUBERT VAN EYCK *The Ghent Altarpiece*

Ill. 94
other than sacred ones, as may be seen in the page from the
calendar book (*Les Très Riches Heures*) ordered by the Duc de
Berri from the Limbourg brothers. It shows the month of
May, with the Duke and his retinue riding out to celebrate the
first of May, the ladies wearing green riding coats and coronets
of green leaves. Above the picture are the signs of the Zodiac,
the Ram (April) and the Twins (May); in the semi-circle
Apollo rides in his car, bearing the sun through the heavens.
The idea of linking this information together was based on
the system already described in the Gothic cathedral porch,
but here the interest is centred on the cavalcade, the woods and
the town of Riom in the distance. Immediately apparent is that
foreground and background are equally detailed, because the
artist has painted the cavalcade from a different viewpoint
from the one he takes of the woods and city. In reality, from
the angle one looks at the foreground figures, the eye would

92

finish up at the foot of the trees. This could be explained by suggesting that the laws of perspective were not understood, but more correctly the painting represents the Gothic view of the natural world; that the eye sees everything with the same clarity, as it does in the nave of a cathedral. The variety of detail reveals the same encyclopaedic approach of the porch sculpture (a considerable number of encyclopaedias were written in the thirteenth century).

The same conception may be observed in the lower section of the *Ghent Altarpiece*, where in spite of the intervening frames the landscape and figures are seen as in a panorama. Here also a similar perspective system is used, giving a tilted appearance to the composition. Both these, the miniature and the painting, represent the 'open world' branch of Gothic art, the artists of which were interested in every aspect of life, for all reflected the life of man, the wonders of nature and, most importantly,

Ill. 95

96 *A Dying Man Commends his Soul to God*, from the *Rohan Book of Hours*

God's creative genius. On the other hand 'the closed world' is represented by the page from the *Rohan Book of Hours*, ordered by another aristocratic patron, Yolande d'Anjou. One of the main reasons for this attitude was the succession of calamities that struck Europe from about 1350. The Black Death was only the worst of a number of bubonic plague epidemics; storms and famine also added to the feeling in the last part of the fourteenth century that the wrath of God had descended on Europe. Hence the *Ars Morendi* (Art of Dying) was an important religious lesson. Here in the manuscript, the dying man commends his spirit to God, while an angel and a devil wrestle for his soul. The artist has composed his picture in a series of flat planes – from the bottom: the skull and inscription; the man on his black burial cloth; the Almighty and the angel and devil. The scrolls (cartouches) and the Sword of Judgment divide the composition into irregular sections and emphasize the flatness of each plane. Northern expression once

97 JAN VAN EYCK
Rolin Madonna

98 ROGIER VAN DER WEYDEN *Deposition*

again asserts itself against the stable reasoned influence of Classical times. These two aspects of Gothic art may be observed, on the one hand in Jan van Eyck and Giotto and on the other in Rogier van der Weyden and Pietro Lorenzetti.

Ills. 95, 97, 103, 104
Ills. 98, 106

In painting of the Gothic North, there are three main treatments of the style. The first is the treatment of space – in its natural sense it can be observed in the *Rolin Madonna*, where the Chancellor and the Madonna and Child are set at a natural distance from the spectator and the background in a series of horizontals (the terrace, bridge and ship), and the winding river guides the eye naturally into the distance. Contrary to this, is the closed-up space of the *Deposition*, in which the figures describe a complicated pattern within a space which is quite unnatural (compare the Strasbourg relief), but as in the Rohan Hours page, strong diagonals are marked by the Dead Christ and the fainting Virgin.

Ill. 97

Ill. 98

Ill. 83
Ill. 96

Ills. 103, 104
Ills. 101,
105, 106
Ill. 99

These two kinds of space were used by Giotto and by Giovanni Pisano, Simone Martini and Pietro Lorenzetti in the preceding century, the fourteenth. A third type of space is that used by Hugo van der Goes (in, for example, the *Portinari Altarpiece*) which, in a general way, could be described as a combination of the first two. The areas of space are compressed and expanded by the position and the grouping-up of figures, *Ill. 92* not unlike the sensation made by the strainer arches at Wells. In this last painting may be noted the veiled symbolism of Gothic: in the foreground, the discarded shoe indicates holy ground; of the flowers, the scarlet lily is the Passion of Christ, the iris is the sword that pierces the Virgin's heart, the seven colombines the seven sorrows of the Virgin: the wheatsheaf is the house of bread or Bethlehem: the fifteen angels the fifteen joys of the Virgin. Also the major figures are much larger than the minor, regardless of their position in the composition. *Ill. 98* There is little of this in the *Deposition*, where agony and emotion are conveyed by posture, expression and the broken jerky folds *Ill. 97* of the drapery. In the van Eyck, it is weighty but natural, like *Ill. 85* the carved type at Naumburg.

The Flemish and Gothic love of detail is to be observed in *Ill. 97*
all these paintings, in the portrait of Chancellor Rolin and that *Ill. 100*
of *Francesco d'Este* by Rogier van der Weyden, in which the
angular, linear pattern of the fingers should be noticed. These
persons can be identified, but even in Biblical subjects the
figures are given the 'portraits' of local people, for the careful
characterization of each human face was observed from life.
In drapery, floor tiles and other objects, the Gothic attention to
painstaking detail describes its idea that the perfect part repre-
sents not only all such earthly types but also the most perfect
of all, which is in heaven.

In the North, as these examples show, the sacred scene of the
manuscript or the cathedral porch was transferred to the
painted altarpiece; an elaborate example, known as a polyptych
(of many panels), is the *Ghent Altarpiece*. The *Deposition* and *Ills. 95, 98*
the Portinari Altarpiece are the centre panels of triptychs, in *Ill. 99*

97

◀ 99 HUGO VAN DER GOES *The Nativity*,
central panel of the *Portinari Altarpiece*

which two wing panels are hinged on either side, so they could be closed exactly over the centre panel. In the Ghent Altarpiece, when the two sides are closed, another principal composition is revealed – the Annunciation. Thus a painting of this kind attempted the same kind of encyclopaedic instruction of the cathedral porches. With the wings open, there is seen in the lower zone the Worship of the Holy Lamb attended by representatives of all races, social classes and religious orders, indicating as part of its message the universality of Christianity. Above in the centre is God as the Trinity, on either side the Virgin and St John, then music-making angels, then, the ancestors of man, Adam and Eve. Thus the hierarchic order is still preserved, despite changes in the artist's attitude to the world around him. Noticeable are the figures of Adam and Eve, two of the earliest naturalistic studies of the nude to appear in the North. Like other painted Flemish figures they come straight from life; nothing is done to make them finely proportioned or beautiful in appearance. Eve's pear-shaped body is typical of the female shape as it was represented at the time. Nevertheless, all these artists maintain the frontal view for all major sacred figures. Even van Eyck, the least 'Gothic'

Ill. 97 of Flemish artists, makes a clear distinction in the *Rolin Madonna* between the inside and the outside world, for the floor tiles seem to pace out an immeasurable distance to the columns, nor are there any shadows in the room, for the Virgin radiated her own shadowless light. This Northern conception, then, suggests a super-real world parallel to the super-real sensation of the cathedral interior.

ITALIAN GOTHIC ART

Gothic architecture in Italy is unlike that of the North; the

Ill. 102 nave of *Sta Croce* in Florence shows a type of Gothic plan similar to the hall-type church of France and Germany; both were popularized by the teaching and preaching friars – the Dominicans and Franciscans. The plan is based on the Early Christian basilica, made Gothic with pointed arches and the long win-

101 GIOVANNI PISANO
Pulpit in the church
of S. Andrea, Pistoia

102 Interior of Sta Croce,
Florence,
looking east

dows at the east end. But the general feeling is one of spacious-
ness. There is also an evenness of space, because all the
proportions of length, breadth and height are harmoniously
balanced – evidence of the strong Roman influence already
observed in S. Miniato. The same characteristics can be seen *Ill. 62*
in the *pulpit of S. Andrea Pistoia* by Giovanni Pisano, for in *Ill. 101*
appearance it is obviously Gothic and even the crowded scenes
of the carved panels remind one of the North, but the
Corinthian capitals of the columns, the figures standing at each
corner of the octagon and others in the corners between each
arch are equally strong reminders of the Roman past, and what
one might call the Roman tradition. Even the symbols of the
four Evangelists which support the pulpit seem to be closer to
the Romanesque idea than to the Gothic, for the symbols here
give both spiritual and physical support like Jeremiah at *Ill. 69*
Moissac.

99

It is necessary to stress the fact that all the Italian art represented here is almost a hundred years *earlier* than the Flemish art described above. With this in mind, the appearance of the art of Giotto and his followers can be seen as a humanizing style parallel to that noted at Reims and Naumburg. The painting of the *Sienese School* shown here, by Martini and Lorenzetti, then, is approximate to the court Gothic of the Vierge Dorée and the relief at Strasbourg, respectively. Approximate only, for the Italians had the presence of the unbroken tradition of Byzantine large-scale mosaic to allow them to make changes, without having to invent a new system of pictorial art.

Changing the medium from mosaic to fresco enabled the artist to work more quickly and with colour tones closer to those of Nature. 'Quickly' is a key word in fresco, for the artist paints on wet plaster, which when dry seals in the colour.

Ills. 84, 85
Ill. 105
Ill. 106
Ills. 86, 83

103　GIOTTO *Noli me tangere*, fresco in the Arena Chapel, Padua

104 GIOTTO *Feast of Herod*, fresco in the Peruzzi Chapel in Sta Croce, Florence

All he had to guide him was an outline marked on the plaster from a previously prepared drawing (a cartoon) of the same size as the painting. Mistakes had to be scraped off and the whole done again.

Despite these problems, an artist like Giotto could work with great freedom. In one of the frescoes from the Arena Chapel, the *Noli me tangere* (Do not touch me), the Gothic aspects may *Ill. 103* be noted: the shallow space in which the figures are placed and the frontal position of the major figures. But the changes in interpretation are numerous: the extension of space to include a landscape and blue sky, the variety and naturalism of gesture, and the solidity of the figures – the sleeping soldiers really 'weigh down' on the ground. While it is important to remember that this is part of a narrative series, and that the *Noli me tangere* is a separate episode from the discovery of the empty tomb, the placing of Christ on the extreme edge of the composition indicates the freedom in which Giotto re-interprets these scenes, not according to a strict programme laid down by tradition but to one in which 'human interest' directs him. He brings his subject matter 'down to earth'.

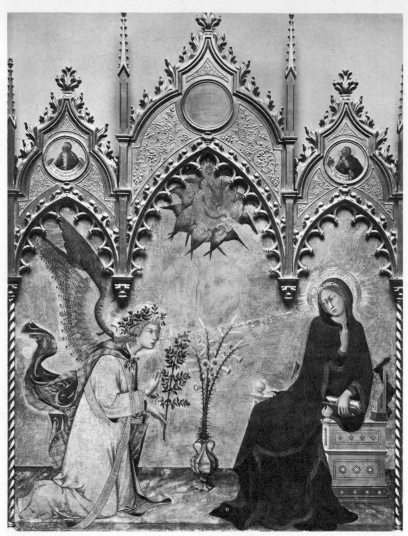

105 SIMONE MARTINI *Annunciation*, central panel of an altarpiece

However, he makes no attempt, other than those noted, to characterize his people, so that while they act like human beings, they do not *look* like them, an attitude he shares with *Ill. 82* the sculptor at Notre-Dame, Paris.

In a later work, the *Feast of Herod*, in the Peruzzi Chapel *Ill. 104*
in Sta Croce, Giotto develops a more extensive space in which
figures stand and sit naturally, and the space between them is
'real'. Drapery hangs according to its weight, and gestures
reveal close observation of life. But the Gothic attitude is still
present in that the inside and the outside of the building are
seen together and its scale is a different one from the figures.
In the fresco in the Arena Chapel, the landscape is stylized and
is out of scale with the figures. This is the Italian Gothic view
of the world, not the super-real one of the North but an ideal
one, in some ways equivalent to that of Early Classical Greece, *Ill. 5*
not unreasonably since Italy had shared that tradition in
Roman times.

Siena is about sixty miles from Florence, but the Italian
city-states were independent and independently minded, so
that it was quite possible for an alternative style to be favoured.
It is clear from Simone Martini's *Annunciation*, that its elegant *Ill. 105*
linear rhythm is associated with the court style of the North,
for the Angel and the Virgin share some of the qualities of the

106 PIETRO LORENZETTI *Deposition*, fresco in the Lower Church of S.
Francesco at Assisi

Ill. 86 Vierge Dorée. But the forms are flatter, and in the shrinking posture of the Virgin there is introduced a feeling of awe, almost of fear, which is certainly not noticeable in the *Ills. 64, 84* Romanesque manuscript or at Reims, and gives some indica- *Ill. 96* tion of the religious mood so much more evident in the Rohan page. The background of this work is of burnished gold leaf, following the Byzantine tradition of gold mosaic. If the figures occupy a shallow space, then this can only be a heavenly space. This painting is a good example of the contemporary practice of making frame and painting together, and the Gothic arches and thin columns on either side turn the work into a richly decorated shrine.

The movement of artists during the Gothic period increased so much that there is a continual interchange of ideas from North to South and vice versa – Giovanni Pisano is thought to have visited France and Simone spent his last years there; in the next century van der Weyden visited Italy. A closer exchange was effected between Siena and Florence, and the *Ill. 106* evidence is in Lorenzetti's *Deposition*. Here is combined both Florentine solidity and Sienese linear rhythm, and Giotto may be seen as the influence on Lorenzetti, while linear quality is to be seen wholly in the outlining of the group, which is arranged within a triangle with its apex at the head of St John the Apostle. This arrangement is Sienese and was originated by the great master of Siena, Duccio, in 1310–11, and it is much more Gothic in its adoption of the triangle than is Florentine art, where, in general, the triangular plan is much less emphatic, and the figures are spread more across the composition as in a *Ill. 31* Roman composition like the *Aldobrandini Wedding*.

The emotion displayed in this work is a painful grief, which with the gaunt thin body of Christ signify the calamities which occurred about the time this work was painted. Pietro Loren-zetti, indeed, is thought to have perished in the Black Death.

Despite these calamities, both Florence and Siena were to recover, and initiate, in their different ways, the period known as the Renaissance.

Italian Renaissance – Northern Renaissance
Italian Mannerism c. 1400–1590

ITALIAN RENAISSANCE

As the Gothic style was created in the Paris region, the Renaissance originated in and around Florence. There were good reasons for this. First there was the humanistic tradition of Giotto and his followers, whose painting has been referred to as proto-Renaissance, as it gave advance notice of the characteristics of the full style which was to follow later. Second, there was Florence itself, a town having great commercial wealth, a banking system which had its branches in many parts of Europe, and a political organization which was independent of the Church. Florence provided an atmosphere in which men of creative talent could feel comparatively free and also enjoy a type of patronage which did not constrain them too rigidly within traditional patterns. Third, was the hard-won professional position of the artist. In 1327, Giotto had had to join the guild of physicians and apothecaries, since there was no painters guild. But by the middle of the fourteenth century, artists guilds had been formed, and by 1400 not only the guild itself but the individual workshop (*bottega*) was able to exert its authority and its fame. It is proper, therefore, to remember that the individual names of artists appearing constantly in this chapter are those of the masters of separate workshops, that is, they were master tradesmen, even if many of them became the friends of dukes and cardinals. Throughout the fifteenth century the artist gradually asserts himself as someone possessing rare talent and genius, and therefore as a quite extraordinary person. This stress on individuality is at once apparent in the various works illustrated, which make the *general* aspects of the Renaissance style rather more difficult to recognize than those already discussed.

107, 108 FILIPPO BRUNELLESCHI Left, interior of S. Lorenzo, Florence, looking east. Right, plan of Sto Spirito, Florence

Brunelleschi may be considered as the first professional architect, for he prepared both measured drawings and models for his buildings, and every bit of carving and decoration was detailed on his plans, so that the masons worked from one man's idea. This kind of uniformity did not occur in Gothic architecture, and it illustrates very well the Renaissance conception of the whole thing being a sum of its components, each of which had to play its part, no more and no less than any other. The Gothic idea of perfecting each part was for its *Ills. 49,* sake alone. The difference may be shown by comparing the *102, 107* churches of Sta Sabina, Sta Croce and Brunelleschi's *S. Lorenzo*. Looking only at the capitals of the columns in each church – in Sta Sabina they are overweighed by the arch bases, and appear unsubstantial as supports between the columns and the wall above; in Sta Croce, the capitals serve only as horizontal markers, for the bases of the arches are the same thickness as the piers below. In contrast, the capitals in S. Lorenzo are separated from the arch bases by carefully detailed blocks (impost block), which allow the columns with their capitals to be seen clearly and yet fulfil their function as supports. As the architect prepared *measured* drawings, so he now thought in

terms of a uniform system of measured proportion which was also based on optical perspective. In S. Lorenzo the proportion of the nave arches to those of the aisle chapels is 5 to 3, and even from the illustrations one may see that the eye concentrating on the aisle chapels of S. Lorenzo can 'take in' the nave arches and the ceiling without any feeling of strain. This is not true of Sta Croce, where the eye is forced to shift. *Ill. 102*

The change over to *arithmetical* planning from the *geometric* planning of Gothic, may be noted in the plans of Brunelleschi's *Sto Spirito* and Notre-Dame, Reims; for in the former, the *Ills. 108, 74* nave is eight divisions, the transept four and the east end two, the width of the transept is equal to the length of the nave. None of these proportions and measured relationships can be worked out in the Reims plan. The light in both S. Lorenzo and Sto Spirito is even throughout the interior, due largely to

109 View of Florence showing Baptistery, Campanile and Cathedral, with dome by BRUNELLESCHI

the use of a dome over the crossing and the small circular windows in S. Lorenzo. There is thus a complete unity between the regularity of the proportions, the uniformity of the light and the fact that the eye may take in at one glance the *whole* idea. Even the problem Brunelleschi faced, in adding a dome to the existing Gothic cathedral, he solved, in the new manner, by making its height equal to the length of the nave. The octagonal east end had already been determined by Arnolfo di Cambio who designed Sta Croce and the cathedral at the beginning of the fourteenth century. This octagonal shape was taken from the famous *baptistery* – visible to the left of Giotto's bell tower (campanile) – which most Florentines believed to have been a Roman temple. The *cathedral* dome, with its exposed ribs, has a Gothic look to it, except that, since its height is only fifty feet less than its diameter, any Gothic 'verticality' is offset by the span of the base. So that the ribs suggest a 'natural' curve which can be measured by the eye.

Ill. 109

Ill. 102

The same effect of naturalness is to be observed in Masaccio's fresco, *The Tribute Money*, from the Brancacci Chapel, and

Ill. 112

111 Diagram to show the perspective construction of MASACCIO's *Tribute Money*

110 LORENZO GHIBERTI *Story of Isaac*, bronze gilt panel from the east doors of the Baptistery, Florence (Paradise Doors)

112 MASACCIO *The Tribute Money*, fresco in the Brancacci chapel of Sta Maria del Carmine, Florence

Ghiberti's relief from the *bronze doors* of the Baptistery. This is partly due to the adoption of linear perspective. Using the Cathedral Square (Piazza del Duomo) in Florence, Brunelleschi had devised a system of sight lines from eye level to various heights on the buildings before him, transferring measurements and angles to paper he was able to establish the laws of perspective. For the painter and sculptor, however, this architectural system, being based on *real* distances and angles, was inappropriate. The painter's method was to mark off the base of his panel or wall area into equal divisions and join each of these to a 'vanishing point' (in the Masaccio, a central point above Christ's head). From another point, level with the 'vanishing point' on the side, other lines were drawn to the same points on the base. The bisections of the two sets of lines thus determined the horizontals marking the 'scale' and position of the human, natural and architectural forms in the composition. Hence, Christ and his Apostles are seen related in scale and

Ill. 110

Ill. 111

space to their natural surroundings, as though one was looking through a window into an approximation of the real world.

This early perspective system was to be replaced by a much more accurate one invented by Alberti the architect. In his interest in the volume of figures, in human expression and *Ill. 103* natural gesture, Masaccio follows the tradition of Giotto, but he sets them in a convincing spatial area quite different from the *Ill. 110* Gothic. In the relief by Ghiberti the vanishing point is near the chopped-off branch on the central tree, and the sculptor has adopted the Roman method of cutting his forms at different depths. Ghiberti's figures, however, are less weighty and more elegant than Masaccio's and he shows more interest in the decorative lines of the drapery folds. Both artists, while they strive after unity, do not yet apply this to the action, for separate episodes of the Biblical story are shown in the same

114 SASSETTA
*Betrothal of
St Francis
to Poverty*

◀ 113 ANTONIO PISANELLO
Vision of St Eustace

composition. These elements point to the continued presence
of the Gothic style (International Gothic), which may be seen
in the works here by Pisanello and Sassetta. In *The Vision of*
St Eustace, despite the attention to the modelling, the scale
varies, and foreground and background are seen from two
different viewpoints as in the work by the Limburgs. The
courtly aspects of this style are strengthened by the heraldic
treatment of the hound and scroll in the foreground; Pisanello
was, in fact, famous as a designer of medals.

Sassetta (for example in his *Betrothal of St Francis*) continues
the Sienese tradition of Simone Martini with his elegant linear

Ill. 113

Ill. 94

Ill. 114
Ill. 105

III

figures; these are now combined with a panoramic landscape view in the naturalistic manner of Florence, but the scale is quite irregular when the figures and the building on the right *Ill. 112* are compared to those in Masaccio's work. Sassetta's scale and *Ill. 64* composition are reminiscent of the Romanesque manuscript illumination, for Italian Romanesque was seen as the native – the Latin – style in contrast to International Gothic, which was foreign. To the artists of the Early Renaissance, therefore, in their careful examination of the antique buildings and reliefs in Rome, the discovery of Roman methods and artistic ideas was a means of building the new style in the Latin tradition. It was Alberti, writer and architect, who objected to the Gothic arch because the eye cannot pass along its line without irritation, whereas the round arch provided a comfortable passage. In his *Ill. 116* *Palazzo Rucellai* and the additions he made to the façade of *Ill. 115* *Sta Maria Novella*, one may see the relationship referred to above. The Rucellai Palace has the same arcaded effect as the *Ill. 30* Colosseum, and uses the Doric, Ionic and Corinthian orders in a similar arrangement, but instead of columns substitutes flat pilasters to preserve a reasonably uniform surface for the wall. Both these pilasters and the narrow cornices (string course), which divide the storeys, give the building a harmonic regularity of appearance. This was essential, since the Renaissance architect, like the Greek, thought of a building as a regular unit, so that seeing one side only was enough to give the clue to the shape and harmony of the whole building. This is particularly true of the Renaissance *palazzo* since it was a four-sided construction enclosing a spacious courtyard. The *palazzo* was derived from the fortress and still carried out this function from time to time, as the small high windows on the ground level prove.

Ill. 115 Sta Maria Novella may be compared to the Romanesque *Ill. 62* Florentine church of S. Miniato, to show the continuation of tradition. Italian Gothic architects had employed a similar arrangement for the central portion of their façades. But a little study will reveal that Alberti's façade is different, for the

115, 116 LEON BATTISTA ALBERTI Left, façade of Sta Maria Novella, Florence. Right, Palazzo Rucellai, Florence

wide horizontal section below the rose window rests on an architrave supported by four large Corinthian columns, like a Greek or Roman façade. This horizontal section corrects any Gothic verticality. But, in fact, the whole of Alberti's façade can be enclosed by a square, as can all the main parts (the upper section including the pediment, the scrolls on either side, which are the diagonals of squares), while the lower section from below the rose window can be divided into two squares by a centre line drawn down the main entrance. There is then a harmony of the whole front because of the regular relationship of all the parts.

Ills. 22, 40

These characteristics demonstrate a close study of Classical buildings, and indeed in 1431–33 Brunelleschi and Donatello had visited Rome together and there made observations and measured drawings of everything that interested them. Donatello's *David*, one of the earliest of fifteenth-century free-standing bronze male nudes, reflects this visit to Rome. The stance recalls that of Augustus, and the harmonic proportions are in accord with those noticed in architecture. Each volume of the figure is clearly expressed by slightly flattening the

Ill. 117

Ill. 24

117 DONATELLO *David*

Ill. 25 curved surfaces (compare the bust of Octavia). This may be
seen in the sword arm, where the back of the hand, the forearm
and the outer side of the upper arm, appear almost as a series
of angled planes, but this arm also shows knowledge of the
mechanism or articulation of the human body. That it is a
major interest is shown by the changes in the placement of the
arms, for these allow variations in the figure as the spectator
moves round it. The deepening and expanding of pictorial
space has a great deal to do with this idea of seeing things in the
round and as *a whole*. The same sculptor's relief of a *Miracle of*
Ill. 118 *St Anthony* is an excellent example of this Renaissance view.
Here is one single event in which every figure in the composi-
Ill. 112 tion participates, but the statuesque calm of Masaccio is
replaced here by excitement, emphasized by the directions of

114

118 DONATELLO *Miracle of St Anthony*, bronze relief from the High Altar of the Santo, Padua

arms and the irregular outlines described by the various figures across the foreground. Donatello, in these two works, suggests the stable calm of the Classical past and the unstable ferment of religious feeling. This latter expression is part of the continued influence of Gothic.

The new and the old style are seen together in the paintings of Veneziano and Piero della Francesca. For Veneziano – as we can see in the *St Lucy Altarpiece* – adopts the balanced centralized composition of the new style for his rather hard linear treatment of figures and drapery. In the *Flagellation* the composition is asymmetrical, but the space is worked out with such scientific exactness that the painting is a three-dimensional scale model of reality. Nor is the *Flagellation* merely part of a 'story', but symbolizes in a Gothic way the spirit overcoming physical pain,

Ill. 119

Ill. 121

119 DOMENICO VENEZIAN
St Lucy Altarpiece

120 PAOLO UCCELLO
A Hunt in a Forest

121 PIERO DELLA FRANCES
The Flagellation

122 ANTONIO AND PIERO
POLLAIUOLO
*The Martyrdom of
St Sebastian*

since, according to recent research, the two older men on the right had sons afflicted by disease. But Piero is also a master of form, which is evident for instance in the painting of the men's legs in the foreground.

Scientific inquiry is common to both Uccello and Pollaiuolo. *Ill. 120* But Uccello shares something of the heraldic interest of Pisanello, in his view of *A Hunt* dashing after its quarry amongst *Ill. 113* the trees. Here the earlier perspective system described above has been much improved, and the difference between the Renaissance and Gothic view of the world can be seen by *Ill. 94* referring back to the manuscript painting of the Limburgs. The same advanced knowledge of perspective is quite obvious *Ill. 122* in *The Martyrdom of St Sebastian* where there is not only an extensive distance but also an effect of atmospheric distance, due to lighter tones employed for forms further away from the eye. This had been learned from the Flemish artists like Jan van Eyck, who were also amongst the first artists to use oil as a medium. The Italian traditional painting medium was tempera, not unlike the glair used in manuscript work: powdered colour being mixed with the beaten yolk of egg or even the whole egg. While this produced brilliant, clear colour it had no 'body', no thickness by which it could be painted on in various depths or textures. Nor was it possible to paint over a mistake with tempera, whereas this was possible with oil. At first, artists tended to use the two media together. One may imagine, therefore, that the use of oil paint was of prime importance to the Renaissance artists with their particular interests in form, for oil colours may be mixed to produce numerous gradations of tone.

Pollaiuolo is a good example of the Renaissance artist concerned with aggressive action, seen here in the men rewinding their crossbows. The artist gives both the front and back view of this action as he does also of the men firing their bolts. In the background, he shows the same interest in men on horseback, posed against an imaginary view of Rome with *Ill. 140* part of the Arch of Constantine on the left, for St Sebastian

118

123 PIETRO PERUGINO *Christ giving the Keys to St Peter*, fresco in the Sistine Chapel in the Vatican

was martyred at Rome. He also protected people against plague, hence his martyrdom was a popular subject in the fifteenth century. This aggressive aspect of the Renaissance style can be contrasted with the gentler interpretation of Perugino, in his fresco in the Sistine Chapel, one of a series *Ill. 123* commissioned by the Pope Sixtus IV. In the second half of the fifteenth century, Rome, through papal patronage, became an important artistic centre rivalling both Florence and Venice.

In both colour and gesture Perugino's *Christ Giving the Keys to St Peter* conveys a more poetic mood. Although the distant figures, standing and moving about give a feeling of actuality as in the Pollaiuolo, those of Christ and the Apostles in the foreground are given both weighty and imposing drapery and *Ill. 122* gestures which are idealized, in that they are not quite everyday gestures. In the background, the two arches to the right and left are based on Roman models; if they are compared to Sta Maria Novella there is the same expression of balanced *Ill. 115*

119

harmony, for they too are squares. The central building is the familiar octagon, with equal projecting porches, making the shape of the Greek cross already noticed at Hagia Sophia, but Ill. 21 in spirit it is closer to the Tower of the Winds, although this had only two porches. It will be noticed also that Perugino's building is raised up from ground level on a stepped plinth. This combination of ideas, suggesting both unity, harmony and the perfect whole, is the basis of the Renaissance conception of the central plan for the church.

Ill. 125 The Greek-cross plan had been adopted by Alberti for S. Sebastiano, Mantua; raised up above ground level, it was to be approached by a flight of steps running right across the west façade, like a Roman temple – and, indeed, 'temple' is the word used by Alberti for 'church'. In his *Ten Books of Architecture* (written between 1443 and 1452) he followed the famous Classical architectural writer, Vitruvius. Significantly, this Roman author described how a well proportioned man with legs and arms outstretched would have feet and hands not only on the circumference of a circle but at the four corners of a

124 GIULIANO DA SANGALLO
Sta Maria delle Carcere, Prato

125 LEON BATTISTA ALBERTI
Plan of S. Sebastiano, Mantua

126 ANDREA DEL VERROCCHIO Equestrian monument to *Bartolommeo Colleone* in the Piazza SS. Giovanni e Paolo, Venice

square set within the circle. Since man was God's highest creation and the circle the most perfect whole, and also the shape of the universe, one can see the logic of the Renaissance architect choosing these measured geometric forms. A good example is Giuliano di Sangallo's church at *Prato*, for this *Ill. 124* fulfils all the ideas discussed above. What is more, it was intended to stand free from all surrounding buildings, like the temple or church in Perugino's fresco. This idea not only *Ill. 123* satisfies the desire for seeing things in the round, but also, because of the plinth, the church is given the meaning of a shrine built in a sacred place like some Classical temples. But the plinth also suggests the pedestal for a sculpture, which also required the all-round view – for instance the Donatello work that we have seen, or Verrochio's equestrian statue of the powerful and successful general, *Colleoni*. In the latter, the style *Ill. 126*

127 ANDREA MANTEGNA *Virtue expelling the Vices*

suits the man, for this rather hard, powerful use of forms is one part of the High Renaissance style. A very different idea from *Ills. 37, 51* that of Marcus Aurelius and the Emperor Anastasius, in which the horse is only an imperial symbol, not an aggressive force.

The growth of interest in Classical philosophy and literature during the fifteenth century led to the introduction of paintings of Greek or Roman mythology and history. Such works were generally commissioned by patrons with intellectual interests for their palaces or villas, and therefore not intended for the public spectator. Often they were not single works, but *Ill. 129* belonged to an elaborate series. Botticelli's *Birth of Venus* was paired with his *Primavera*, and Mantegna's *Virtue expelling the* *Ill. 127* *Vices* belonged to a complex series of works ordered by

122

129 SANDRO BOTTICELLI *The Birth of Venus* ▶

28 LUCA SIGNORELLI *Pan and other Gods*

Isabella d'Este for a room in the ducal palace in Mantua.

Ill. 128 Signorelli's *Pan and other Gods* was painted for the Florentine Lorenzo de' Medici, who was both poet, scholar and political leader of that city. Supported by this patron was the Platonic Academy, which, under the guidance of Marsilio Ficino, contributed much to Renaissance Neo-Platonism which, briefly, was a combination of Classical philosophy and Christian principles.

The Gothic scholar described the symbol as veiling truth, and his Renaissance counterpart used it in a similar way, except that he was in effect using pagan mystery to veil Christian morality. Thus, Botticelli's Venus is Heavenly Love; Signorelli's group of gods demonstrates the dark and light side of human character, as gods or goddesses possessed both aggressive and calming characteristics, and often were described by Classical authors as pairs, for instance Minerva-

Ill. 127 Venus. This pair appears in Mantegna's painting, Minerva as Virtue on the left and Venus as Vice, in the centre. From this very brief description it should be clear that these paintings are not *illustrations* of Classical stories nor are they *imitations* of Classical reliefs or paintings, even though one may recognize that Botticelli's Venus is based on an Antique model like the

Ill. 15 Cnidian Venus.

Ill. 129 While Botticelli shows the High Renaissance version of Gothic linear rhythm, there is also, particularly in the drapery,

Ill. 93 a feeling of strain and tension like that noted in the Leinberger
Ill. 128 sculpture. Signorelli expresses a combination of the interest in
Ill. 121 solid volumes of Piero della Francesca and the aggressive
Ill. 122 interpretation of Pollaiuolo. Both may be contrasted with
Ill. 127 Mantegna, who represents the North Italian area – Padua and Venice – which in direct contact with Northern art reflects this in the hard modelling of the figures. Those of the Vices in the foreground show the direct, often brutal, realism of the North. At the same time, Mantegna also shares the Northern interest in Nature – the extensive landscape, the cumulus clouds and the exploding mountain high up on the left.

124

130 LEONARDO DA VINCI *The Last Supper*, wall-painting in the Refectory
of the Convent of Sta Maria delle Grazie, Milan

The High Renaissance style is not to be seen as the summit to
which earlier artists strived, but as one that idealizes the
naturalism of the Early Renaissance. An approximate parallel
is the difference between the Ludovisi Throne and the Three
Goddesses from the Parthenon.

Ills. 5, 6

But the High Renaissance had many more problems to
solve to achieve a convincing idealism, for there was not only
the idealizing of form, but the creation of a just balance between
its interest in the natural world, in the Classical past and in the
Christian faith. Even these interests could be put into numerous
divisions. In Leonardo's *Last Supper*, Masaccio's statuesque and
solemn Apostles become completely individualized, each per-
sonality marked by gesture and expression. Brunelleschi's space
in S. Lorenzo is more finely adjusted, so that the light from the
rear windows in the *Last Supper* allows Leonardo to 'realize'

Ills. 130, 112

Ill. 107

131, 132 MICHELANGELO
Left, *David*.
Below, projected plan
for St Peter's, Rome

Ill. 131
Ill. 117

Ill. 133

Ill. 34

his figures more completely in the round. In Michelangelo's *David*, Donatello's clearly identified Biblical hero becomes an over life-size, more generalized hero, for Donatello's David has triumphed, Virtue has conquered Vice, but Michelangelo's hero *has not* overcome Goliath – yet. He is a young man preparing to struggle and overcome the problems of Life – Truth defeating Falsehood, Wisdom driving out Stupidity and so on.

Bramante's *Tempietto* is a Christian chapel, a Classical round temple, a shrine and the all-round whole of a sculpture. Nevertheless, the Pantheon was the basic Classical source for the central plan of the Renaissance, and the Doric columns, and the details of the curved architrave demonstrate the *archaeological* interest in the past. It is also fairly certain that

126

133 BRAMANTE Tempietto, S. Pietro in Montorio, Rome ▶

134 MICHELANGELO *Creation of Man*, ceiling fresco in the Sistine Chapel in the Vatican

Ill. 132 Bramante intended a central plan for the new St Peter's in Rome, and the plan made by Michelangelo in 1546 follows the idea of the Greek cross with a large dome surmounting it which Bramante had proposed. However, as can be seen in the *Ill. 182* aerial view of St Peter's the completed building was to look *Ill. 135* rather different (see Chapter Five). In Raphael's *Philosophy* (generally known as *The School of Athens*) one may see the interior of St Peter's, probably as Bramante designed it, with Roman barrel vaulting and a severe use of pilasters and an emphatic cornice placed around the gigantic piers which support the dome. On a minute scale the little chapel at *Ill. 59* Germigny-des-Prés shows how close Bramante was to continuing Early Christian tradition as well.

Ill. 134 A delicate balance between physical and spiritual is struck by Michelangelo in his *Creation of Man*, from his great frescoes on the ceiling of the Sistine Chapel. Not only are the figures over life-size but there is no difference in scale between God and man, for here is symbolized the creation of physical beauty through spiritual power. This is a very personal interpretation, which not only indicates the individuality of the High Renaissance artist, but the almost complete break with the earlier *Ill. 95* hierarchical order that Jan van Eyck follows.

Ills. 135, 136 In these two works by Raphael the physical and philosophic

128

135 RAPHAEL *The School of Athens*, fresco in the Stanza della Segnatura in the Vatican

136 MARCANTONIO RAIMONDI, after RAPHAEL Engraving of *The Massacre of the Innocents*

137 TITIAN *Bacchus and Ariadne*

aspects of man himself are clearly expressed and are ideal interpretations of Early Renaissance ideas. *The Massacre of the Innocents* is an engraving after a lost work of Raphael's, by Marcantonio Raimondi, the High Renaissance engraver who reproduced most of Raphael's great works. Since about thirty prints could be taken off an engraved copper plate, the art of Raphael and other masters could be publicized all over Europe, leading to influences in style and subject matter on artists who had never visited Italy. Like Michelangelo, Raphael *generalizes* a particular event, to make it an allegory of man's inhumanity to man, or barbarism overcoming spiritual love, represented by the women with their children. The executioners, compared to the bowmen of Pollaiuolo or the hunters of Uccello, show that Raphael *tones down* the aggressiveness and selects almost the same split second of the action noticed in Polyclitus and in

Ill. 136

Ill. 127
Ills. 122, 120

Ill. 7

the Centaur and Lapith relief. In the *Philosophy*, the artist *Ills. 8, 135*
arranges a perfect balance between the space and the groups
of figures set about in it. This may be compared with the
Donatello relief and the painting by Mantegna, in which the *Ills. 118, 127*
'action' occurs as it might have done in reality, whereas
Raphael's action is indeed an ideal situation. Here Plato and
Aristotle preside over an assembly of ancient philosophers,
mathematicians and astronomers, represented by artists and
architects of the High Renaissance. On the far right Raphael
talks with Ptolemy and Zoroaster.

The Venetian High Renaissance presents a different aspect,
since Venice preserved an independence unique amongst the
Italian city-states, due to its geographical position and its
commercial wealth, which was gained from extensive trade
both with the East and northern Europe. Its painters were far
more interested in rich colours and textures than those of

138 GIORGIONE *Concert Champêtre*

Florence and Rome. Its distance from Rome, perhaps, allowed the artists to take a more romantic view of Antiquity. In 1499 a novel was published in Venice called *Hypnerotomachia Poliphili*, in which the adventures of two lovers are described taking place in a kind of Classical dream world. It is in this *Ill. 138* light that one must look at Giorgione's *Concert Champêtre*, where two Venetian men make music with two nymphs in a lush summer landscape. This poetic treatment is matched by the soft almost blurred outlining of the nudes, in contrast to *Ill. 129* the clear contours of Botticelli's Venus. The same blurring and *Ill. 137* interest in textures are present in Titian's *Bacchus and Ariadne* which, like the Mantegna, belongs to a series. But unlike it, the figures are massed up in a rhythm which is suggested by volumes in several planes, in contrast to the linear, almost single-plane pattern of Mantegna's figures. Both Giorgione and

139 TITIAN *The Concert*

132

140 ANTONIO DA SANGALLO THE YOUNGER and MICHELANGELO Palazzo
Farnese, Rome

Titian introduce the notion of mood into landscape and the
relationship of the human form to that of Nature. The
Renaissance, despite these interests in the ideal and the poetic,
and because of its interest in natural observation produced
portraits where individual character and expression is fully
explored. This may be noted at the ideal level in Leonardo and *Ill. 130*
at the human level in Titian's *Concert*, where each person has *Ill. 139*
his or her particular identity and together create the atmosphere
of a particular occasion, even though there may be also an
allegorical meaning.

In domestic architecture the High Renaissance also creates
an ideal assembly of earlier ideas, for the *Palazzo Farnese* obeys *Ill. 140*
the same harmonic order as Alberti's Palazzo Rucellai, except *Ill. 116*
that the windows in the Farnese palace with their engaged
columns create the vertical divisions, while their alternating
Classical pediments give a textural relief to the surface of the
wall. In fact there is the same just balance between all the
architectural elements, the same feeling for the monumental
composition that are to be observed in the paintings of
Leonardo and Raphael and the sculpture of Michelangelo.

To use the term 'Renaissance' for the art of the North during the sixteenth century is to imply only that many of the ideas and practices of the Italian scholars and artists were put into effect on Northern art. But in the main, Germany and the Netherlands preserved the Northern stress on self-expression to such an extent that not even in the work of Dürer is it possible to recognize the balanced rational art of the South. Representatives of the Early Renaissance in the North are Jan *Ills. 95, 98* van Eyck and Rogier van der Weyden; while their Gothic conception is quite evident, their interest in the 'science' of picture making and their depiction of human character and gesture relate them to their Italian contemporaries of 1400–50. Hieronymus Bosch combines aspects from both these fore-runners, for he adopts the shallow space and hard linear style of Rogier van der Weyden, but there is also an interest in the fullness of modelled forms noticed in Van Eyck.

Ill. 141 Bosch reworks the earlier Gothic symbolism into a more general system, which sees Christ (as in the *Crowning with Thorns*) as common man and the figures surrounding him as the kinds of torment experienced by man – physical threat, deception, insult, oppression and physical pain. Christ is seen, in fact, as the supreme human martyr, a conception which hardly occurs in the South, where he is more often conceived as a Classical hero and teacher. The religious dissent and conflict already pointed out continued, with the Reformation move-ment led by Martin Luther as the most outstanding, but not the most extreme, of the sects which abounded during this period. The wholesale destruction of religious works in Basel was one of the reasons which persuaded Holbein to work permanently in England; while Dürer, despite his strong humanist interests and sympathies with Italian culture, was in his last years much affected by Luther's teaching. In the en-*Ills. 142, 143* gravings of the *Great Fortune* and the woodcut of the *Noli me tangere*, these two sides of his art may be noted.

Ill. 142 Engraving on copper is the medium in which Dürer created

141 HIERONYMUS BOSCH *Crowning with Thorns*

most of his greatest masterpieces, attaining in it a range of tone and texture in black and white never achieved before. The subject is based on a poem by Poliziano, a member of Lorenzo de' Medici's Platonic Academy, and Fortune is based on the proportions of Vitruvius, but her figure is a Northern one. There is not the least hint of a Classical model as was noted in *Ill. 129* Botticelli's Venus, nor does it have the soft luxurious form of *Ill. 138* Giorgione's nymphs. Below Fortune there is a view of the Alpine landscape, through which Dürer passed on his first visit to Italy in 1494–95 – the small town has been identified as Klausen/Chiusi. While Mantegna and the Venetians were absorbed with aspects of landscape they were not, like painters of the North, so interested in topographic accuracy, on identifying exactly a particular area. This almost scientific interest in topography also leads to a more general feeling for 'place', *Ill. 144* of which Altdorfer's painting of *St George and the Dragon in a Wood* is an example. In fact this is Virtue in the shape of a German knight destroying vice or eastern barbarism in a setting which was typical of nearly the whole of eastern *Ill. 120* Germany and its neighbouring territories. Uccello's wood has been pruned and cultivated; the German has the denseness of a tropical rain forest.

Ill. 143 The human relationship suggested by Dürer's Christ and *Ill. 103* Magdalen is like Giotto's interpretation, but the similarity ends there, for Dürer's Christ shows the wounds in his hands and feet and he is dressed (as described in the Bible) to look like one of the gardeners; he is central in the composition and posed in the near foreground. While Dürer, therefore, creates many changes, he observes the Gothic tradition of a frontal treatment for major figures. His style here may be compared to the *Ill. 93* Leinberger, which is a wooden carving, to show how cutting a wood block imposes certain limitations because of its nature and its grain. This stresses the point, as has been observed in connection with encaustic and fresco, that a technique and medium may often play a part in the forming of a style. Even so, Dürer manages to give his woodcut a similar variety of tone

142, 143 ALBRECHT DÜRER Engravings: left, *The Great Fortune* (Nemesis); right, *Noli me tangere*

and texture to that already noted in his copper engraving. The drapery in the Dürer, because it observes the natural laws of the weight and hang of material, is closer to Van Eyck than to Leinberger. *Ill. 97* *Ill. 93*

Dürer and Van Eyck exhibit the same openness to both the intellectual and technical discoveries of Italy and therefore stand a little apart from other Northern artists. This may be readily observed in comparing the hand gestures in the Dürer with the centre crucifixion of Grünewald's *Isenheim Altarpiece*. *Ill. 145* All the hands in this latter work are intertwined, clasped or

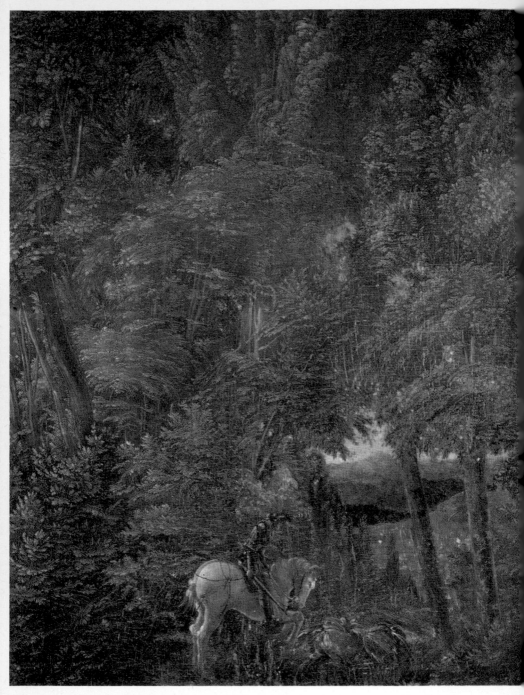

144 ALBRECHT ALTDORFER *St George and the Dragon in a Wood*

145 MATTHIAS GRÜNEWALD *Crucifixion* from the *Isenheim Altarpiece*

stretched into positions almost beyond normal physical capacity. Bodies or limbs are bent at angles which no human being could sustain for very long. If Van der Weyden used the body to express anguish, he does not exceed the normal actions of grief. This Grünewald does, and he follows, not the Biblical accounts, but the visions of St Brigid of Sweden, whose *Revelations* gave harrowing descriptions of Christ's suffering. Dürer's more naturalistic and humanist conception appears in the balanced composition he adopts; the 'weight' of his figures is in harmony with the space given to the landscape. In contrast, Bosch gives a 'close-up' view of his event, so one is forced to take in only facial expression and hand gesture. In contrast again, Grünewald sets up an asymmetrical balance (the cross is not in the dead centre of the panel) of figures and also an uneasy

Ill. 98

Ill. 143

Ill. 141

139

relationship between these solid forms and the space around and behind them. But two very forceful diagonals, described by the Baptist's pointing hand, the left arm of Christ and the bent bodies of the kneeling Magdalen and St John the Apostle supporting the Virgin hold the composition together.

A similar comparison may be made between the Cranach and the Holbein portraits. For *Henry the Pious*, in his curvilinear patterned garments, fills the narrow rectangle of the canvas, while the dog, virtually cut in two by the figure of his master, serves as a diagonal form to describe the very shallow space. The piety of the Duke is stressed by the fact that his physical solidity is almost camouflaged by the repetition of the pattern. Holbein's merchant, *Georg Gisze*, on the other hand, occupies an evenly balanced space, in which the table and shelves measure the various areas into a harmonic arrangement. It is interesting to note that the tradition of hidden symbols in the Van der Goes has in the next century become useful in itemizing the profession of the sitter – his taste and his social class being evidenced by the documents, the Eastern carpet, the Venetian

Ill. 147

Ill. 146

Ill. 99

146 HANS HOLBEIN
Portrait of *Georg Gisze*

147 LUCAS CRANACH
Henry the Pious, Duke of Saxony

148 BERNARD STRIGEL
David returning with the Head of Goliath

glass vase, the puffed and generous sleeves of silk. After a close
inspection, one knows a great deal about Georg Gisze and his
class, which played by far the largest part in the patronage of
art in Northern Europe.

The unidealizing attitude of the North is well shown in
Strigel's *David,* in which David is depicted as a young squire, *Ill. 148*
attended by his men bringing back his trophy to the ladies of
the castle. Even the architecture and landscape are German.
This interpretation emphasizes the continuance of the chivalric
code in Germany, for such Biblical heroes were held up as

149 PIETER BRUEGHEL THE ELDER *Flemish Proverbs*

Ills. 117, 131 examples. This conception could hardly be more different from that held by Donatello or Michelangelo. Strigel was painter to the Holy Roman Emperor, Maximilian I, at Ulm, so in many ways the German aristocracy shared the down-to-earth attitudes of the middle-class patron.

The underlying moral instruction in the Strigel is also present in the work of Pieter Brueghel. Brueghel, like Dürer, travelled to Italy, but while he maintained close contacts with the intellectual society of Brussels on his return, he exhibits the same unidealized conception and Northern tradition noted *Ill. 149* above. In his painting, *Flemish Proverbs*, he adopts the same kind of multiple instruction of the Gothic artists, only he uses common sayings to point a finger at man's stupidity and superstition. A man bangs his head against a wall, for instance, and another strews roses before a pig. Brueghel preserves the story-telling style of the previous century, but he gives his

142

150 PIETER BRUEGHEL THE ELDER *Landscape with Gallows* ▶

composition an overall unity with the use of colour: reds and blues are placed in every plane of the picture space. His horizontal rectangular composition is also organized into a system of vertical and horizontal divisions provided by the architecture. This is a more open, balanced view than the rather cramped vertical composition of Strigel. In his later painting, *Landscape* *Ill. 150* *with Gallows*, the moral is still present, for the peasants dance mindlessly beside the gallows, but it is the vast panoramic landscape which holds the attention, for it develops a sense of atmospheric space and a real natural world exceeding that of Pollaiuolo. Brueghel replaces Dürer's bird's-eye view and *Ills. 122, 142* Giorgione's poetic view of landscape with a man's-eye view. *Ill. 138* The scale that he adopts suggests that the spectator himself stands on the ridge overlooking the great stretch of country.

Many art-historical terms do not help very much in understanding the styles they refer to, and 'Mannerism' is one of these, for it suggests something exaggerated, something abnormal, rather irritating. A person full of mannerisms is often thought of as artificial and very seldom profound or serious. If one looks rapidly at the pictures on the next few pages, none strikes the eye as being artificial or lacking in seriousness, although certain exaggerations, elongations, unnatural use of space or scale may be observed. These non-natural features, as has been shown in Byzantine, Romanesque and Gothic art, are not caused by a lack of creative power or a decline in craftsmanship, but by the *desire* of the artist. Therefore in *Ills. 151, 135* contrasting Pontormo *Visitation* with Raphael's *Philosophy* one should not imply that the Raphael or any other work of the High Renaissance is a yardstick by which all succeeding art should be measured. For Pontormo's intention is to create a quite different mood both within the composition and consequently in the spectator. Thus where Raphael orders his groups, space and architecture as they would appear in an ideal *natural* world, Pontormo compresses his groups, exaggerates the poses and turns his space into deceptive atmospheric areas as they might appear in an ideal *spiritual* world. Where the eye may easily determine the extent of the background space in the Raphael, it cannot do this readily in the Pontormo. The nude boy in the Pontormo has his limbs splayed to an unnatural extent when compared to the similar figure in the *Philosophy*. Raphael's Pythagoras, seated in the left centre foreground, may be compared to Pontormo's woman who is sprawled up the steps, in such a way that her feet are in the immediate foreground and her head in the space of the central group. Nor is it quite possible to decide whether the steps themselves are long or short.

Ill. 152 This illusion also occurs in the steps of Michelangelo's anteroom at the *Laurentian Library*, for they are not only divided by the balustrades, but the central stairs are curved

151 JACOPO PONTORMO *The Visitation*, fresco in the Cloister of SS. Annunziata, Florence

outwards, with the bottom steps very deep, to suggest a leisurely incline, when in fact the straight steps on either side indicate a fairly steep ascent. Elsewhere, Michelangelo has double columns supported by heavy scrolled forms (consoles), which suggest that they hold up an enormous load, when in fact they do not. There are blank windows with heavy pediments, which, when viewed from the foot of the steps, suggest the outside of a building and not the inside. This reversing of appearance (inversion) is found also by looking up the left side

145

stair, for it ends, or seems to, at a scroll, and beyond that the tops of two consoles, the moulded cornice then the double columns combine to suggest that they all are in the same plane, and appear nearer to the eye than they really are. The eye, therefore, has to continually readjust its focal length, as it has *Ill. 153* to in Parmigianino's *Madonna with the Long Neck*, where the elongated forms of the foreground group not only press up close, but tower over the spectator. To take in the background, a completely unnatural adjustment has to be made, both in the angle of sight and focal length. Mannerist colours are also unnatural since they are more like the colour dyes used on dress fabrics. These, with the brilliant highlighting of the column, the Virgin's neck and the dangling arm of the Child suggest that they lie in the same plane. While these characteristics remind one of Gothic ideas of creating a spiritual atmosphere, the Mannerist mood lacks the clarity and balance of Gothic; it is, in fact, almost unbalanced in its use of massed solids and telescopic voids.

152 MICHELANGELO Anteroom of the Laurentian Library, Florence

153 FRANCESCO PARMIGIANINO
Madonna with the Long Neck

154 BENVENUTO CELLINI
Apollo and Hyacinth

Even in Classical subjects, like the marble by Cellini, *Apollo* *Ills. 154*
and Hyacinth, this strange imbalance and anti-natural conception
is present. The figure of Hyacinth is pressed up so closely to
Apollo's leg that they appear to have grown into each other –
a fusion of bodies that is also apparent in the Parmigianino.
Mannerist inversion may be observed by comparing the
Cellini to the Michelangelo *David*. Apollo's arm and hand are *Ill. 131*
reversed and the regularity of the all-round view of the David
is made quite irregular by Cellini, so that as one walks around
the group all kinds of odd juxtapositions of limbs come into
view. The elongation of limbs and neck and the small head
tend to make Apollo 'weightless' compared to the solid,
natural stance of David.

147

Some of the reasons for this disturbing style are to be found in the historical and intellectual background. Rome, for instance, was sacked in 1527 and the power of Florence waned at the same time. There was also a religious crisis created by the conflict between the Church of Rome and the reformers in the North. Coupled with this, the expanding knowledge of man, particularly in natural science, was leading to contradictions of the teachings of the Church. The security of Catholic faith was threatened on two sides.

Mannerist ideas are employed by such an architect as Palladio, whose planning and study of antique buildings was as rational *Ill. 155* and deep as Alberti's. The *Palazzo Chiericati* has for its centre section the Classical façade which the Renaissance architect used for the *inside* court of the *palazzo*; it also is extended forward of the line of the façade, while double columns on both levels effectively concentrate the eye on the centre rather than uniformly over the whole façade as was intended in the *Ills. 116, 140* Palazzo Rucellai and the Palazzo Farnese. But this latter building, begun by San Gallo completed by Michelangelo, who,

155 ANDREA PALLADIO Palazzo Chiericati, Vicenza

156 TINTORETTO
The Finding of the Body of St Mark

157 GIORGIO VASARI The Uffizi, Florence;
two ranges linked by an open loggia

it will be noticed, has used a heavy projecting top cornice to make it, contrary to Renaissance ideas, over-dominant. His additions to the centre doorway and window have the same effect. Palladio also *compresses* the small windows of the upper storey under the overhang of the cornice, and each of the columns of his façade appears to sprout along the roof line into a figure. The centre looks like a reassembled Arch of Constantine. As noted in the Parmigianino, there is a similar effect on the eye between the solid and highly decorated upper section and the voids below and to either side; the eye may even, in a manner, slide off the building altogether through the open arch at the end of each storey.

Ill. 40

Mannerism may be said to employ Renaissance forms and appearances but reverses or extends them. However, with architecture, the Mannerist artist could never, obviously, use the illusionary methods available to the painter. This can be

149

159 PAOLO VERONESE
*Christic disputing
with the Doctors*

◄ 158 GIOVANNI DA BOLOGNA
The Rape of the Sabines

seen in the *Uffizi* courtyard by Vasari and Tintoretto's *Finding* *Ills. 157, 156*
of the Body of St Mark, for the telescope effect of the buildings is
heightened and made almost hypnotic by Tintoretto's figures.
Those rushing into the building on the left connect the feeling
and mysterious mood of the architecture with human nervous
suspense. The group to the right, because of its illusive closeness
to the eye, is able to make the focal adjustment all the more
abrupt and disturbing. Vasari has to employ a *real* optical
illusion, for the eye, rushed to the arches at the end of the court,
finally comes to an uneasy rest on the distant buildings, but
these lie on the other side of the river Arno which flows

160 VIGNOLA and DELLA PORTA
Façade of the Gesù, Rome

161 MICHELANGELO and DELLA PORTA
Dome of St Peter's, Rome

Ill. 89 between. It should be noted that while there is a superficial resemblance between Vasari's court and, for instance, the nave of St Ouen, Rouen, Gothic space is, apart from other differences, contained, internal and artificially lit.

lls. 151, 153, 156 Pontormo, Parmigianino and Tintoretto all use a vertical rectangular shape or format for their compositions, because it assists them in achieving the Mannerist sensation. But even the *Ill. 159* horizontal rectangle employed by Veronese in *Christ disputing with the Doctors* can produce the same compression of figures – the Doctors of the Temple squeezed between the column and the edge of the painting on the left; the same uncertainties of space – the curved colonnade on the right, the open doorway

152

beyond and the column against which Christ sits – upset the natural order of space (compare Leonardo's *Last Supper*). There is the Mannerist use of the 'cut off' limb or head or half of the body to be noted also in the Parmigianino and Tintoretto.

Ill. 130

The way figures, limbs and drapery seem to revolve around the front column in the Veronese is evident in Giovanni da Bologna's *Rape of the Sabines*. The odd juxtapositions already referred to in the Cellini are very clearly seen here in heads, hands and feet. The suggestion of revolving in the Veronese is made more emphatic by these struggling figures, and the whole group seems to swing round and round in a giddy and erratic manner from the outstretched hand of the woman. In contrast to the Renaissance idea of each part contributing equally to the whole, the Mannerist part operates in an independent manner, and when these parts are combined, a whole emerges which is unsettled, disturbing and which does not conform to any rational system of harmony or proportion.

Ill. 158
Ill. 154

The seriousness and emotional intensity in Mannerist religious works are present in the façade of the *Gesù* church. Completed by della Porta, who also completed Michelangelo's dome of *St Peter's*, one may recognize his aim to stress attention on the central doorway. Compared to Alberti's façade, where they are evenly distributed, the features are now concentrated towards and at the centre; and as in the Palazzo Chiericati, this centre advances from the main wall line. There is also a 'weighing down' effect of the upper storey on the lower (this is particularly true of Michelangelo's dome, although not so apparent in the illustration), which is also aided by the heavy cornice and double pediment. All this tends to compress and reduce the entrance but at the same time the eye is 'forced' to find it. One may imagine that if Bramante's central plan for St Peter's had been followed, then Michelangelo's dome would not only have dominated the city but also impressed the spectator as a symbol of the majestic 'weight' of the faith. Such an awesome symbol was necessary, since, for the first time for centuries, the faith was being questioned both within and without the Church.

Ill. 160
Ill. 161

Ill. 115

Ill. 155

Italian Baroque – Spanish Baroque
Northern Baroque – Rococo c. 1600–1770

ITALIAN BAROQUE ART

Like Mannerism, 'Baroque' (meaning a misshapen pearl in Portuguese) does not explain much about the style it names. We saw that in the Early Renaissance the presence of the preceding style Gothic made itself felt and indeed helped to create the new style. As European art evolved, these overlaps of styles became more complex. Particularly by the end of the sixteenth century, the artist had become an individual and someone of social consequence and was thought of more as a creative person than as a tradesman. This promotion of the visual arts was due partly to the respect and attention given to the phrase of the Roman poet, Horace, *Ut pictura poesis* (as poetry is, so is painting). By 1600, it was, therefore, recognized that the artist, like the poet, had his own *maniera* (manner) – imaginative or creative ideas which he applied to his art.

As Giotto and his followers provided a proto-Renaissance group, a similar proto-Baroque movement emerged in the period *c.* 1580–1610. One of its achievements was to give a more positive and clear interpretation of some of the Mannerist ideas. As an example, Maderno's façade of *Sta Susanna* and *Ill. 162* della Porta's *Gesù* may be compared. Maderno emphasizes the *Ill. 160* centre section by advancing it twice from the main wall line, removes the string courses which della Porta runs *behind* verticals and bends cornices *around* each vertical where della Porta runs them straight across. The Mannerist 'weighing down' effect is altered into an upward movement, not only by heightening the upper storey, but by elevating the side scrolls and making a more continuous vertical line run up from each of the ground storey columns. The result stems from a *new* conception. For the interest in the vertical suggests the uplifting

155

163 ANNIBALE CARRACCI *Triumph of Bacchus and Ariadne*, ceiling fresco in the gallery of the Palazzo Farnese, Rome

of the spirit and Maderno's steps lead straight to a larger front entrance, unlike della Porta's which give no direction at all.

The new *positive* approach was partly inspired by the Counter-Reformation movement and particularly by the Council of Trent (1545–63) which issued a great many instructions as to how the Catholic faith was to counter Protestantism. Artists were asked above all to make everything clear in their religious works, so that *all* could understand. In general, a refreshing optimism was introduced not only in religious works but in Classical mythology. This may be noted in the ceiling *Ill. 163* fresco by Annibale Carracci, *Triumph of Bacchus and Ariadne*, which in a way is a subtle combination of Raphael and Titian; but what makes it different is that these legendary figures look as though they are alive. Their actions are not ideal as in the *Ill. 135* Raphael but those of life itself, which further separates the *Ill. 137* work from Titian's poetic dream world. Nevertheless, Annibale composes this lively, pushing crowd of figures into an

164 CARAVAGGIO
Martyrdom of St Matthew

evenly balanced composition like the Raphael, but the rhythm and structure of Annibale's work depend more on masses rather than on line, a characteristic he shares with Titian.

In Rome at the same time as Annibale Carracci was Caravaggio, who had a similar interest in reality or actuality, but turns it to a far different purpose. His *Martyrdom of St Matthew* *Ill. 164* at first sight looks like a Mannerist painting (cf. Pontormo, for *Ill. 151* instance), but the two principal figures are closer to the eye, and the lighting sharpens and dramatizes the event, rather than making a mystery of it. The people are as down to earth as any in Northern art, but they are more than that, for they give in expression and gesture a compelling sense of *actuality*. This is a deliberate blending of fact and fiction, in order to excite the emotion of the spectator. The Spiritual Exercises, devised by the Jesuits, aimed at the same result; through intense meditation on the sufferings of Christ, one should come to *feel* the same agonies and therefore gain spiritual strength to

157

overcome them. Caravaggio's light, after careful study, does not come from a single source, like a theatrical spotlight, but from the artist's imagination. While he uses a reasonable range of colour, he employs slightly metallic tones, so that all the smooth surfaces of his forms look as though they have been dully or highly polished, and reflect light on to each other. This suggestion of a super-real world recalls the Gothic idea of light issuing from the Virgin, as in Van Eyck's painting, and Caravaggio's composition is not unlike that of Van der Goes. But in neither of the Flemish works is one so overwhelmed both physically and emotionally, for Caravaggio opens up a space in the foreground of his composition so that the spectator can *actively* take part.

Ill. 97
Ill. 99

The results of the proto-Baroque period may be observed in the following four works. Reni's great fresco, the *Aurora*, has the same joy of life as that by Annibale, but the figures occupy a much shallower space and are not evenly balanced on either side of the centre line. Instead there is the sensation of rushing movement towards the right, and the composition is 'balanced' visually by the artist arranging diagonals which 'lean' the other way – in the immediate foreground figure, for instance. The arrangement is very like a relief frieze; the Titus relief indicates the kind of source that Reni would have drawn from. But the main purpose of such a shallow space was to engage the spectator 'within' the action of the composition to almost convince him that Aurora and Apollo in his chariot were driving across the wall.

Ill. 165

Ill. 29

In another context, Domenichino opens up the front of the composition of the *Last Communion of St Jerome*, and in contrast to Caravaggio places his figures in a more compact group in which he establishes verticals and horizontals parallel to those of the architecture and landscape. He thus tones down the dramatic spirituality of Caravaggio and the exuberance of Reni. Combined here is the stability, natural space and balance of Raphael *and* the idea of engaging the spectator, which is one of the most important features of the Baroque style.

Ill. 166

165 GUIDO RENI *Aurora*,
ceiling fresco in the Casino,
Palazzo Rospigliosi-
Pallavicini, Rome

166 DOMENICHINO
Last Communion of St Jerome

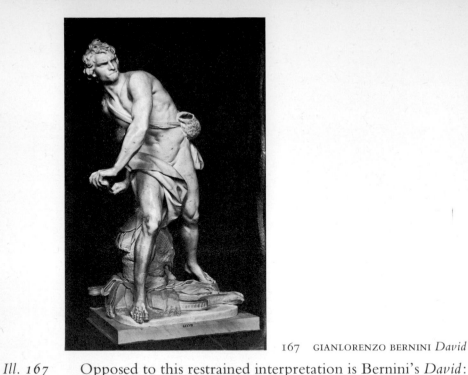

Ill. 167 Opposed to this restrained interpretation is Bernini's *David*: here is symbolized the militant Church of the Counter-Reformation; action, expression and muscles show a pent-up energy about to be released. The artist also engages the spectator directly, for it was never intended that the work should be seen from the sides or from the back. Bernini had in fact been *Ill. 20* studying Hellenistic sculpture like the Laocoön, which had been excavated a century earlier, in 1516. Like it, the *David* advances forward in a series of planes made by the head, shoulder, elbow and knee. Between the elbow and knee, the most 'hard' of these convex forms, comes the 'soft' concave *Ill. 65* form made by the thigh and lower torso. Where Reni corrects any imbalance by 'visual' means, the sculptor must use physical solid counterweights, as Bernini has with the haversack and drapery to balance the weight thrown to the left.

Most art of the Baroque is not only individualized in terms of each artist emphasizing his own imagination, but it is addressed to and engages the individual spectator. Michel-

160

angelo's *David* is so over life-size, that his appeal is to humanity *Ill. 131*
at large, whereas Bernini's hero, on his low plinth, is on ground
level with the spectator, who is *personally* being stimulated to
exert the same militant faith. The blending of fact and fiction
was applied to contemporary heroes of the Church, as Daniele
Crespi does in his painting of the *Meal of S. Carlo Borromeo*, *Ill. 168*
who died in Milan in 1584 and was canonized in 1610. As
Cardinal and Bishop, he lived a simple life and personally cared
for the poor and the sick. In the painting he sits weeping over
the Passion of Christ. While an attendant looks in from one
door the spectator is 'brought in' through another. The
actuality of this situation is assisted by the realism of the artist's
painting, for Crespi not only paints things as they *look* but also
as they *feel* – the crustiness of bread, the hard smoothness of
glass, for instance, are indicated by the texture of the paint. In
addition the principal masses of a form, like the cape, are liter-
ally modelled in paint. The deep inward fold just below the
shoulder is 'constructed' by the artist brushing in the lighter
areas across the dark brown underpainting, but leaving it
exposed where the deepest shadow is required. Thus, the
painting consists not only of various textures but of different
layers, like a *very low* relief sculpture.

168 DANIELE CRESPI *Meal of S. Carlo Borromeo*

This new technique helped to 'advance' the forms of the composition towards the spectator, and is quite different from *Ill. 130* a High Renaissance work like Leonardo's, where both forms and space *recede* and the paint surface is flat. The Baroque concern with actuality shows clearly in the portraits of the *Ill. 169* period, e.g. Bernini's lively study of *Cardinal Scipione Borghese*, one of his principal patrons. Here the interest in the 'feel' of textures is present even in marble – the shiny surfaces of the satin cape and the soft fleshiness of the face. It is recorded that Bernini allowed the subject of a portrait to walk about and talk, so that he could select a characteristic gesture or expression, which would result in a portrait of an individual and not a type. This kind of bust portrait and certain aspects of its technique Bernini drew from Roman portraits: a general similarity may *Ill. 38* be noticed in Caracalla.

It is significant that the Baroque artists looked to Classical Antiquity much more for technical and artistic ideas, rather than as a source of laws on which to base a style, as the Renaissance had done. When he was in France, Bernini suggested to the French Academy that they obtain Greeks from whom to make life studies, *in addition* to making drawings from Antique marbles, inferring in this way that a closer *actuality* of Classical forms would be obtained. Scipione Borghese, nephew of Pope Paul V, reflects not only his own exuberant personality but the worldly confidence of the papal Court, whose patronage was principally responsible for Rome being the great artistic centre of the seventeenth century. The self-denying character of S. Carlo Borromeo and the instructions of the Council of Trent no longer carried much weight with Roman papal families like the Borghese and the Barberini. This is quite clearly stated in the title of Pietro da Cortona's ceiling in the Palazzo Barberini: *Ill. 172* *Glorification of Urban VIII's Reign*. The technique employed to give the illusion of far greater height and space than the *real* ceiling allows, is known as *quadratura* and depends on a detailed knowledge of perspective. There are two points to note. Firstly, *Ill. 134* that the system employed by Michelangelo in the Sistine Chapel

169 GIANLORENZO BERNINI
Bust of *Cardinal Scipione Borghese*

170 ANDREA SACCHI *Vision of St Romuald*

171 NICHOLAS POUSSIN *Et in Arcadia Ego*

and by Annibale Carracci in the Palazzo Farnese is the normal *Ill. 163* perspective used for paintings or wall frescoes; and secondly that da Cortona's ceiling is a *natural* extension of space and not the telescopic space of Mannerism.

The blending of fact and fiction is seen at its high point in these Baroque ceilings, for the illusion stems in part from the mixture of real and painted architecture and the use of figures of painted plaster relief which stretch across from real into imaginary space. In one composition, therefore, there is a unity of architecture, painting and sculpture within a single artistic conception. This unifying of the three arts is the key to understanding the total sensation of engaging the spectator, at which the Baroque artist aimed. For whereas in the salon of the Palazzo Farnese the ceiling painting must be looked at from one point of view, that in the Palazzo Barberini must be looked at from *all* points of view.

Parallel to this 'dramatic' style, there was the restrained Neo-classical interpretation noticed already in the Domenichino. But it should be stressed that as various currents of interpretation are noticeable in the Renaissance, so they occurred in the seventeenth century, for the so-called Neo-classical artists give clear evidence of *their* interest in actuality, as may be seen in the Sacchi painting, *Vision of St Romuald*, and that by Poussin, *Ill. 170* *Et in Arcadia Ego*. For the gestures are taken from life, and *Ill. 171* whatever similarities of style there are to Raphael, it is these – Sacchi's monk who puts his head to one side so that he may see past his colleague, and the relaxed casual posture of Poussin's shepherd with his arm on the tomb – that point unmistakably to the new concern with actuality of the Baroque approach.

This casualness has already been commented on in *The Aldobrandini Wedding*, a work which Poussin copied shortly *Ill. 31* after his arrival in Rome. It was this more intimate aspect of Roman art that attracted Poussin as well as Roman poetry of the kind that Virgil and Horace wrote, praising the peace and solitude of the countryside. But as Poussin points out in his painting, death is also present in Arcady – a fabulous classical

◀ 172 PIETRO DA CORTONA *Glorification of Urban VIII's Reign*, ceiling fresco in the Palazzo Barberini, Rome

173 SALVATOR ROSA
Grotto with Waterfall

174 GUERCINO
Vision of St Bruno

country where all was peace and man knew neither anger, bitterness nor strife. The idea, therefore, that Giorgione and Titian had of using landscape to suggest a mood, was extended by the 1640s. If Poussin creates a feeling of poetic melancholy, then Rosa recognizes a contemporary mood of awe in the presence of savage nature. His figures, like pygmies, are domin-

Ill. 173 ated by the spectacle of the natural *Grotto with Waterfall* dashing down the rocks. Nevertheless, this mood of wonderment runs parallel to the awe created by Pietro da Cortona's ceiling. Also the emphasis in both Poussin and Rosa lies on the personal engagement of the spectator in the moods they create. Significantly both St Romuald and St Bruno did actually withdraw from the worldly life to the remote countryside, to found orders of hermit monks, so that they could commune more

personally with God. Where Sacchi employs a Neo-classical composition, Guercino uses dramatic lighting and advancing planes to increase the emotional feeling of the *Vision of St Bruno*.

Ill. 170

Ill. 174

The unity of the three arts has already been noted in the Palazzo Barberini ceiling; unity implies not just a bringing together of the arts, but that artist, sculptor and architect create in their own art the qualities of the others. This is evident in Baroque architecture, for the buildings and their interiors have a 'modelled' appearance, and the use of textures, light and shade are painterly. The idea of 'modelling' architecture has been noted in the Roman building at Baalbek, which was, in fact, known to the Baroque architects. The similarity between the form of Borromini's dome of *S. Ivo* and the Round Temple is quite clear, but at the same time there is also a relationship with Rosa's painting, suggesting an organic or natural-growth conception of architectural space, which reminds one of the Byzantine view.

Ill. 39

Ill. 175

175
FRANCESCO BORROMINI
Interior of the dome
of S. Ivo della
Sapienza, Rome

176 GIANLORENZO BERNINI Plan of S. Andrea al Quirinale

177 FRANCESCO BORROMINI Plan of S. Carlo alle Quattro Fontane, Rome

Ill. 177 These points may be observed in the plan of S. Carlo, which resembles an oval pressed in at its two ends. As one enters this small church (approximately eighty-five feet long) the sensation is one of being drawn in, owing to the convex-concave wave of the walls; these and the deep chapels create alternating areas of light and dark. The dome of S. Carlo is a perfect oval,

Ill. 175 but at S. Ivo Borromini repeats the shape of floor and walls in the dome, and here one may see the counteraction of sharp

Ill. 167 convex, shallow convex and concave noted in Bernini's *David*. It is known from Borromini's drawings that the equilateral triangle was the basis of his planning, which is quite apparent in the S. Ivo dome. This is a reminder of Gothic architectural

Ill. 74 practice as noted in the plan of Notre-Dame, Reims, but the Baroque sculptural or modelled space is not the same as Gothic.

Ill. 176 Bernini's plan of *S. Andrea,* while a regular oval, makes the entrance across the width so that on entering one is drawn directly towards the high altar over the shortest distance. One may note here not only that this plan is an oval version of the

Ill. 34 circular Pantheon, but that Baroque space is *not* Renaissance space, for neither the forms that enclose it nor the light are regular.

A great deal of Baroque light comes from sources hidden to

Ill. 178 the eye as it does over the group of *The Ecstasy of St Teresa*. The

168

surround and the group are made up of coloured and white marbles and bronze shafts, reminiscent of the Roman use of mixed coloured stone. Thus, there is great variety of *painterly* texture and colour, as a comparison with Guercino's painting will show, for *visually* the two works, although in different media, have qualities which are interchangeable. But Bernini's group is not imaginary, it is drawn *exactly* from St Teresa's own account (*Life*. 1565) of how the arrow of heavenly love was plunged into her heart by a smiling angel. Bernini extends the whole idea of sculpture in his *Fountain of the Four Rivers*, opposite the Church of *Sta Agnese*. Here he combines stone carved to look like natural rock, white marble figures, coloured stone for plants and the palm tree, and water, which because the rock is tunnelled through from four sides can flow in and out of the rock. Water-spouts also issue from many parts of the work. The pool of the fountain not only reflects the sculptured forms above, but the sprays of water, as can be seen, create all kinds of formal and textural distortions. Bernini in a small area com- bines in a make-believe way many of the romantic features to be seen in Rosa's painting.

Ill. 174

Ill. 179
Ill. 183

Ill. 173

The same combination of natural and man-made forms appears in Poussin's *Orpheus and Eurydice*, in which the artist's Neo-classical temperament requires a balance between all these elements. Thus, where Bernini and Guercino use a near vertical oval to encompass their figures, Poussin makes it horizontal, as one can see in the foreground group, so that in a landscape he can maintain a balance between verticals and horizontals. But Horace's phrase, quoted at the start of this chapter, is made quite clear by Poussin's *Orpheus and Eurydice* and Claude's *Aeneas arriving at Delos*, for not only are their paintings *exact* illustrations of Classical texts (Poussin: Ovid's *Metamorphoses* Book X; Claude: Virgil's *Aeneid* Book III), but through their direct observation and drawing from Nature, they con- struct a landscape setting for their story, in which the spectator also feels himself present. Not so engaged as in the Rosa, but looking on. This is achieved by painting the figures

Ill. 180

Ill. 181

179 GIANLORENZO BERNINI *Fountain of the Four Rivers* in the Piazza Navona, Rome

to a scale which is correct for the distance between them and the spectator's eye and the rest of the landscape. It also depends on the atmospheric space, for one may notice, in both works, that the sky *hangs* over the whole landscape. Claude used a number of glazes (colour mixed with a lot of oil) to create an extraordinary sensation of looking through an immense

171

180 NICHOLAS POUSSIN *Orpheus and Eurydice*

distance of coloured light. These landscapes of Poussin and Claude are often called ideal, but more properly they are
Ill. 32 poetic, like the Roman landscape. As the poet transcribes what he observes into verse, so these paintings are poems of the countryside around Rome, which these artists drew and loved. To recognize the difference in the viewing of Nature, the
Ill. 122 Claude should be compared to the Pollaiuolo: *real* distance is painted by Claude; the Roman architecture, an archaeological symbol in the Pollaiuolo, becomes a poetic reference in the Claude.
Ill. 182 To enter the *colonnaded piazza of St Peter's* is to feel, in reality, the sensation of engagement in Baroque art, for here Bernini designed two great arms for the church and, as in his plan for
Ill. 176 S. Andrea, one is drawn through to the entrance of the cathedral. The façade and the extended nave had been completed by Maderno in 1614, effectively cancelling Michelangelo's plan to

172

have the dome dominate the body of the church. In some way, however, *Sta Agnese* would meet with Michelangelo's approval, for here the dome remains in view until one is quite close to the entrance. In this façade can be seen the perfecting, in full Baroque terms, of the centralizing and vertical directions noted in Sta Susanna. But in Sta Agnese convex-concave forms replace the right-angled planes of Maderno, and this rhythm is carried on right up to the 'lantern' on top of the dome. There is also a continuous vertical rise achieved from the columns of the entrance on and up through the ribs of the dome, as well as up the towers on either side. From Brunelleschi's Early Renaissance-Gothic dome to Michelangelo's St Peter's and that of Sta Agnese, one may see the variety of expression possible in one architectural form. Brunelleschi's soars off the top of the church, Michelangelo's 'weighs down' on the building, and that of Sta Agnese rises up out of the body of the church.

Ill. 183

Ill. 162

Ill. 109
Ills. 133, 161

181 CLAUDE LORRAINE *Aeneas arriving at Delos*

182 Aerial view of St Peter's showing the colonnaded piazza by BERNINI

183 CARLO RAINALDI and FRANCESCO BORROMINI Sta Agnese in Piazza Navona, Rome

184 FRANCESCO BORROMINI
Façade of S. Carlo
alle Quattro Fontane,
Rome

The most telling of comparisons may be made between Sta *Ill. 162*
Susanna and S. Carlo, for the latter's façade, finished twenty *Ill. 184*
years after the rest of the church, is the prime example of
Baroque architecture. While its two-storey arrangement is
traditional (S. Miniato, Sta Maria Novella, the Gesù, Sta *Ills. 62, 115,*
Susanna), the earlier flat and later advanced plane treatment is *160, 162*
replaced by a rhythmic wave of convex and concave forms.
The most complex rhythm being created at the top, where a
scooped out oval, containing a high relief figure of S. Carlo,
is placed so that its lower half is tilted in on a concave and its
top half tilted out on a convex. Supporting angels 'float' below
and other sculptured figures fill the niches on the ground
storey. Thus architecture plays not only its functional role but
also the part of a large sculptural relief and a painting of textured
light and shade – a much more dramatic conception than is to
be seen in the Arch of Constantine. *Ill. 40*

175

SPANISH BAROQUE PAINTING

Spain in the seventeenth century offers the clearest example
of a national or regional style. Amongst the reasons for this
are its geographical isolation from Europe, the strong sense of
nationality amongst all social classes and the country-wide
power of Church and State. Both St Ignatius Loyola, founder
of the Jesuits, and St Teresa were Spaniards. Their mysticism
was influenced by Arab thought and feeling, owing to the large

Moorish population in Spain, which originated from the Arab conquest of Spain in the seventh century. Both this mysticism and intense national piety is expressed in the *Burial of Count* *Ill. 185* *Orgaz*. El Greco, a Cretan, studied in Venice and Rome before settling at Toledo in 1577, the year St Teresa wrote her book, *Los Moradas*, in the same city. El Greco's painting, while it contains elongations and Mannerist colour, anticipates the Baroque, for the Count is being lowered into his real tomb, immediately below the painting. The dark tones of the mourners 'push forward' the foreground group, while the young boy on the left, by his gesture, invites the spectator to join the ceremony. The priest on the right, by the natural way he looks up, turns the vision into a reality (compare the vision of St Bruno).

This almost casual acceptance is typical of Spain; St Teresa wrote of her visions in the common or vernacular language of the ordinary people. It is very evident in Zurbarán's *Adoration* *Ill. 186* *of the Shepherds* where peasants crowd around the Virgin and Child, a guitarist plays in the background and an angel plays a harp in the sky. In contrast to the aristocratic religious interpretation of El Greco, Zurbarán presents the popular

◀ 185 EL GRECO
Burial of Count Orgaz

186 FRANCISCO DE ZURBARÁN
Adoration of the Shepherds

187 JUSEPE RIBERA
Boy with a Club Foot

188 EL GRECO *Cardinal Don Fernando*
Niño de Guevara (The Grand Inquisitor)

version, where religion is completely bound up with ordinary day-to-day living and folklore. On another level, a mixture of stern authority and spirituality is present in the portrait of *Cardinal Guevara*, head of the Inquisition in Seville. El Greco creates a shallow space and advances the figure by very slightly contrasting the textured patterns of the wall, the chair back and the Cardinal's cape. The Cardinal's physical presence is indicated by his head and hands alone, for the flat planes of the drapery, with metallic tones like tinfoil, seem to deny the existence of the body beneath. Bernini, indeed, uses similar flat folds for his St Teresa (note also Leinberger's use of drapery). That this is a particularly Spanish blend of authority and

Ill. 188

Ills. 178, 93

178

spirituality, may be seen by comparing it with the painting of Crespi and the marble bust of Scipione Borghese, and by recognizing that El Greco's very individual style matches exactly the Spanish character of the Catholic faith. *Ills. 168, 16*

It may appear a strange parallel, but Ribera's painting, *Boy with a Club Foot*, gives much the same compositional importance to his subject as El Greco does to the Cardinal – the principal reason being that beggars and cripples in Spain were considered as the special children of Christ. The paper in the boy's hand reads: 'Give me alms for the love of God'. Ribera worked in Naples, a possession of Spain, and it was due to him that the influence of Caravaggio spread to Spain, mostly through the port of Seville, where all the Spanish painters mentioned here, except El Greco, were trained. Although Ribera's subject becomes, in the hands of lesser painters, a sentimental daily *Ill. 187*

189 FRANCISCO DE ZURBARÁN *St Bonaventura and St Thomas Aquinas*

life (genre) type, one may see the serious interpretation con-
Ill. 190
tinued by Velazquez (in particular the dwarf on the right) and
Ill. 193
Murillo, whose painting was one of a series for the Hospital
of Charity in Seville, the artist belonging to the Brotherhood
that maintained it. Zurbarán, Velazquez and Murillo each
painted for a different level of patron – Zurbarán for the
monastic orders, Velazquez for the court in Madrid and Murillo
for the well-to-do merchant class in Seville. Each artist reflects
his patronage in his subject matter and style. Zurbarán uses a
clear penetrating light which defines each form as to its volume
and character with extraordinary precision. The composition
relies on a very subtle combination of rounded forms, the
monks' heads and cassocks, and the verticals and horizontals of
the room and its meagre furniture. Zurbarán's Italian counter-
Ill. 170
part is Sacchi, particularly in the Neo-classical emphasis on
intellect rather than on feeling. Even so, Zurbarán employs
conversational gesture rather than the more studied action of
Sacchi.

It is Velazquez, who made two visits to Italy, who combines
Baroque space, engagement of the spectator and the blend of
Ill. 190
fact and fiction or illusion and reality. *Las Meniñas* (Maids
of Honour) is one of the most successful works in which the
real space, where the spectator stands, is carried on into the
background of the painting, for the picture frame rests on the
Ill. 167
floor, and the top touches the ceiling. As with Bernini's David,
the spectator is on the same level as the people represented.
Using a rapid brush technique, Velazquez shows each form as
it reacts to the light, which enters in various densities through
the row of windows on the right. Note the artist himself to the
left and the two figures to the rear on the right who are furthest
or hidden from the light source. Each of the young attendants
receives a share of the light from the nearest window, but the
full light falls only on the princess in the centre. The only other
figure so prominently lit is the king, looking into the room,
in the far background. Only in Spain, probably, could royal
personages be portrayed in such an intimate and natural setting.

190 VELAZQUEZ
Las Meniñas
(Maids of Honour)

In *The Fable of Arachne* a rather more complex mixture of *Ill. 191*
Baroque reality, illusion and space is presented by the artist. For
here are realist figures of weavers in the foreground, con-
vincingly at work; in the room beyond, the fable is acted in
front of a painting, *The Rape of Europa* by Titian. Arachne
(Ovid, *Metamorphoses* VI) challenged Minerva at tapestry work,
was defeated, hanged herself and was changed into a spider.
Thus from spectator to the painting in the background, there
are four kinds of real and illusionary existence, but they all are
placed in the same space. To compare this painting with Raphael's
Philosophy is to see the difference between Baroque and *Ill. 135*

191 VELAZQUEZ *The Fable of Arachne*

192 MURILLO *The Marriage Feast of Cana*

193 MURILLO *Christ at the Pool of Bethesda* ▶

Renaissance space. The importance Velazquez gives to his working women, even though they may represent Minerva (the old woman) and Arachne (the girl), indicates that even the king's painter accorded the same dignity to the worker as he did to the princess.

Murillo's interpretation is straightforward compared to the much more profound and sophisticated nature of Velazquez. The two scenes from the life of Christ here are depicted in a clear manner so that *all* can understand. Light and form are given an even balance, but at the same time Murillo is a master of Baroque composition, for the earthenware pots in the *Marriage Feast of Cana* form the key to the composition, which *Ill. 192* consists of an oval, with highlighted concave and convex forms. The rich colour of this painting points to the influence of the Venetians and it is Veronese particularly to whom Murillo *Ill. 159* owes the setting of *Christ at the Pool of Bethesda*, but one can *Ill. 193* see at once the clarity and naturalism of Baroque space, composition and gesture in comparing the two.

Rubens is the painterly counterpart to Bernini. For one thing he had spent eight years in Italy (1600–08), sufficiently long to form an Italianate style, which on his return to the Netherlands *Ill. 194* he 'filled out' both in form and colour. In *The Deposition* one can sense the artist's 'muscular Christianity', an unquestioning belief in the heroic nature of the Catholic faith. In this way he is *Ill. 167* different from Bernini, who emphasizes, even in the *David*, the spirituality of his faith. In contrast to both is Rembrandt, who gives an unheroic, pathetic interpretation of Christ, a con- *Ills. 141, 145* ception much closer to Bosch and Grünewald, even though he uses a dramatic Baroque arrangement of dark and light. But both Rubens, for example, in his *Deposition*, and Rembrandt follow Northern tradition in the way they suggest that the *Ill. 195* light comes from Christ himself, for neither the candle nor the lamp in the Rembrandt explain the burst of light around Christ's head and shoulder. Here Rembrandt is closer, for

194 RUBENS
The Deposition
(central section
of a triptych)

195 REMBRANDT VAN RIJN *Entombment*

Ill. 164 instance, to Caravaggio than he is to Rubens. It is certainly in the seventeenth century that Christ becomes a universal symbol, that he is made to represent so many aspects of human nature.

Much of Rubens's optimism and confidence is to be seen *Ill. 196* in the portrait of himself and his first wife. The couple, clasping hands, sit casually out of doors and give a feeling of intimacy between themselves and the spectator. Compositionally, both this portrait and the *Deposition* make use of the vertical oval form and, within it, a rich interplay of convex and concave forms. There is no hint in the Rubens portrait of any break in *Ill. 197* the unity of its formal pattern, but in Rembrandt's work of himself and *his* young wife, the unity of the figures is broken by the upraised glass, which is the apex of an acute triangle with its base running across the artist's arm, while any such triangulation in the Rubens is equilateral (the foot extreme left, the wife's hand, right, the artist's disengaged hand) and lies *within* the oval. This acute accent is also to be seen in Rem- *Ill. 195* brandt's *Entombment* in the figure who strains back on the burial sheet. Rembrandt's pose in his portrait is echoed by the fore-

196 RUBENS *The Artist and his first wife, Isabella Brandt* (in the Honeysuckle Bower)

197 REMBRANDT VAN RIJN *The Artist and his first wife, Saskia*

198 FRANS HALS *Meeting of the Officers of the Cluveniers-doelen*

ground figure in the group by Hals, which is made up of *Ill. 198*
interlinked horizontal ovals, in a rather similar way to Murillo's
Marriage Feast of Cana. But Hals faced a special problem, since *Ill. 192*
each member of this volunteer band demanded equal treatment.
This he manages to do without too many strained postures,
although he has to use composition-strengtheners like the
halberds and banners to control the acute diagonals of the
figures. With only one patron to satisfy, El Greco is able to *Ill. 188*
construct a more artistically satisfying composition.

In his study of '*Malle Bobbe*', Hals almost makes the spectator *Ill. 199*
recoil from this cackling woman, for her expression is intensified
by the artist's slashing brush work around the ruff and down
the sleeve. She was not only known as the Witch of Haarlem,
but represents a traditional Netherlands folklore woman, who

Ill. 168

makes trouble for everyone she meets. The textural 'feel' of materials is expressed here as it was in the Crespi, but where the Italian uses 'dry' and larger paint planes, Hals's paint is 'fat'; he uses a lot of oil, and since he applies the paint thickly (impasto) in separate brushstrokes, the surface 'vibrates', which aids the spontaneous effect of his subject.

Ill. 200

The master painter was, however, Rubens, and his painting of the *Rape of the Daughters of Leucippus* is a fine example of his painting of the nude. Rubens had the same technical mastery in paint as Bernini had in marble: he perfectly expresses the interaction of masses, of convex and concave forms which is found in Baroque architecture. His flesh tones have real life to them, so that he almost overwhelms the spectator with the energy which the men, women and horses display within the oval which is diagonally inclined to the right. Nor is there any doubt of Rubens's close observation of life; note the way in which the upper girl's leg dangles down as the rider hauls

Ill. 194

her up on his horse, or, in the *Deposition*, how the man leaning over the cross holds the burial sheet with his teeth.

199 FRANS HALS
'Malle Bobbe'
(The Witch
of Haarlem)

200 RUBENS *Rape of the Daughters of Leucippus*

The international nature of the Baroque style and the indi-
vidual renown of the artists is expressed by Rubens's visits, as
artist and diplomat, to Spain, France and England; but he was
not alone, for many artists changed countries permanently or
made visits to carry out commissions. The best proof of the

201 REMBRANDT VAN RIJN
Self-portrait

renown and individualism of the artist is Bernini's letter to Louis XIV of France, postponing his visit there because at that time he was too busy to go!

Parallel to the religious idea of withdrawal noted in both *Ills. 174, 170* St Bruno and St Romuald, a similar notion began to spread, that the simple country life and the time to reflect alone with nature was as necessary for any man, but one must remember that the ownership of land proclaimed social position. In this *Ill. 202* large landscape with the *Château de Steen*, Rubens's country retreat, there is no sign of the bustling energy of Rubens's figure paintings. The eye is guided in a leisurely way by convex and concave curves down to the house on the left or through *Ills. 180, 181* into the landscape. Unlike the Poussin and the Claude which are 'closed' compositions, the Rubens is 'open' to the right, so that the spectator can in his mind's eye continue his view of the panorama. Thus, where Poussin and Claude arrange a central fixed point, the summit of a small hill in both paintings, Rubens marks his 'centre', in space, with two magpies, which catch the corner of the eye, however far to the right or to the

190

left one looks. Rubens communicates a more intimate feeling about the land for he substitutes a *particular* or *personal* topography for Brueghel's *general* one.

Ill. 150

Rembrandt is much less confident and more profound than Rubens, for he continually questions man's nature and his beliefs and above all, himself. There is no other artist who has left such a record of his passage through life as Rembrandt has in his *self-portraits*. He is virtually alone, amongst the seventeenth-century artists, in using *himself* as a symbol and image of humanity. The richness in materials, textures, colour and expression in the first are changed in the second. Here, with a sparing use of colour, there is a simple formal pattern in which the almost relief surface of overlapped brushstrokes provides a unity from drapery to hair. The paint is applied in the direction and angle of each plane (note the neck and top of the shirt and the palette and brushes). All these, combined with the expression, give an image of both the inward and outward nature of the creative spirit of man.

Ill. 201

Ill. 197

202 RUBENS *Château de Steen*

203 GIOVANNI BATTISTA TIEPOLO *Two Magicians and a Boy,* engraving from the *Scherzi di Fantasia*

ROCOCO

The name, from the French *rocaille* (rock-work), refers generally to the natural forms from which artists borrowed to construct the linear patterns of this style, which was fairly extensive throughout Europe during the eighteenth century. Few styles can compare with Rococo in the way it penetrated both major and minor arts. Starting from the asymmetrical tree-branch pattern of the troupe of Watteau's courtiers in the *Embarkation from Cythera,* one can follow this in the plaster scrolls and wavy cornice in the *Hôtel Soubise* and in the vaulting and plan of the church of *Vierzehnheiligen*; in the raised embroidery of the Viscount's coat on the right in Hogarth's painting *The Contract*; in Piranesi's *Decorative Caprice*, a treasure trove of antique remains; in the arm of the rustic seat in Gainsborough's portrait of *Mr and Mrs Andrews*; in Tiepolo's *Wedding of Frederick Barbarossa* and in the magicians and dog of the *Fantastic Caprice*; in the spray of flowers pinned to the dress of

Ill. 208
Ill. 204
Ill. 211
Ill. 210
Ill. 214
Ill. 206
Ill. 216
Ill. 203

192

204 GERMAIN BOFFRAND
Salon de la Princesse
in the Hôtel de
Soubise, Paris

205 FRANÇOIS BOUCHER
Madame de Pompadour

206 THOMAS GAINSBOROUGH *Mr and Mrs Robert Andrews*

Ill. 205 *Madame de Pompadour*; and in Gainsborough's decorative
Ill. 207 procession of *Peasants Going to Market*.

 Rococo has the character of a transitional style, for one can
detect Baroque in the oval arrangements of figures like that
Ill. 210 on the right in the Hogarth; in the realism of the postures in
Ill. 209 Watteau's *Shop Sign for the Art Dealer Gersaint*; in the illusion
Ill. 215 of fact and fiction in Tiepolo's *Banquet of Cleopatra* in the
Palazzo Labia; and the succeeding styles, Neo-classicism and
Ill. 213 Romanticism, in Gabriel's *Petit Trianon* and both paintings by
Gainsborough. But despite this character, Rococo preserves a
unity of expression during its short period from about 1715 to
about 1770, although by this time it is overlapped by the new
styles. Rococo had an international spread, largely because it
was the style of the 'Establishment', today's term for that well-
to-do, well educated, interested-in-the-arts class, made up of
administrators, bankers, landowners and the like. For with the
death of Louis XIV of France, patronage by Church and State
began to fall away, and private patronage took over to a far

194

207 THOMAS
GAINSBOROUGH
*Peasants going to
Market*

208 JEAN-ANTOINE WATTEAU *Embarkation from Cythera*

larger extent than it had in the sixteenth and seventeenth centuries. But this new class of patron had ambitions to equal its predecessors, only on a smaller and more intimate scale.

Because of this change in patronage, the artist became even more of an individual. The workshop system had been weakened as early as the late sixteenth century, when Annibale Carracci had founded a teaching Academy in Bologna. In seventeenth-century Spain, the young artist paid a fee to a workshop rather than serving an apprenticeship, although this latter method was to continue throughout Europe until around 1800. The shortage of large-scale contracts and the many years taken to complete them made the maintenance of large workshops unnecessary as well as uneconomic. This trend led to artists specializing; for instance, in England there were 'face' painters and 'drapery' painters, and a 'figure' painter would insert figures in a 'landscape' painter's work. In portraits, prices would be scaled according to whether a master painted only the face or the whole work. So great a demand was there for decorative work that artists, like Watteau, in his earlier years, often did decorative panels, nor was he above producing a very fine shop sign for an art dealer. The contrast between the realism

Ill. 209 and natural observation evident in Gersaint's shop sign and
Ill. 208 the apparently artificial figures of *The Embarkation from Cythera* is not so great, since the eighteenth century was an age of manners, when there was a conscious effort to live and behave elegantly and to possess 'good manners'. So what appears to be an artificial posture, of the man in the centre of the courtiers, is no more so than Gersaint's gesture to the woman on the left of the shop sign. The art dealer's stance can be contrasted with that of the servant, who stands, slightly knock-kneed, on the far left.

Ill. 210 Hogarth is just as observant and, in fact, slightly caricatures the foppish future bridegroom on the left, who imitates the French 'manner'. Hogarth hated all foreign imports, particularly French ones. All his sympathy goes to the gout-ridden Viscount on the right, whose posture is stoutly English.

196

This 'Englishness' is very much part of Gainsborough's country *Ill. 206* squire, who poses casually and a little impatiently beside his wife. This new feeling of nationalism is a particularly English characteristic of the period when, almost for the first time, England begins to produce artists of international standard. It was after his visit to London in 1720 that Watteau painted his *Ill. 209* sign. The artist was to die young, of consumption, and the restlessness which this disease produces is also present in his paintings, in which elegant people depart and arrive, halt on the way, in a make-believe landscape. This landscape, although *Ill. 208* it fades away in a golden hazy distance, is only a park in reality. The mood is one of melancholy, not the ideal poetic melancholy created by Poussin but a real contemporary melancholy, for Watteau acutely points to the fact that these courtiers are only playing at life. This reference to acting is supported by the way that both Watteau and Hogarth treat internal space as a stage; the figures describe a serpentine frieze from front to rear and each figure is seen unobstructed by another. Hogarth, particularly, in the six paintings that make up the series of *Marriage à la Mode*, said that these were to be looked at as scenes of a play and his figures as players.

Hogarth is much more direct in his criticism of society than Watteau, and his slightly caricatured heads indicate types rather than individuals. Both Watteau and Hogarth use fine brushes and tend to *touch* on the paint in small strokes and spots, a technique equally used by painters of porcelain. Throughout the eighteenth century, Chinese wares were imported – lacquered trays, carved screens and cabinets and, of course, china. Baroque colour which was rich and natural in tone is replaced in Rococo by lighter more decorative colour. Boucher's portrait of *Madame de Pompadour*, apart from the rather 'brittle' look of *Ill. 205* the bows on the dress, is painted in ceramic-like colours, and the drapery, unlike that of Bernini's *St Teresa*, is a decorative *Ill. 178* make-believe resemblance of natural forms out of which the head rises like a rosebud in porcelain. Lacquer and wax, in fact, were widely used in women's make-up.

209
JEAN–ANTOINE WATTEAU
*L'enseigne
de Gersaint*
(Signboard for
the Art–Dealer
Gersaint)

210
WILLIAM HOGARTH
*Marriage à la Mode:
The Contract*

The idea of *applied* decoration is the basis of Rococo archi-
tectural decoration, for the plan of Neumann's church of *Ill. 212*
Vierzehnheiligen (Fourteen Saints) shows the difference from
the Baroque conception of a unity of form in the floor plan and
the vaults and dome and the balanced rhythm of convex- *Ill. 175*
concave. Neumann *applies* his vaulting system to the basic *Ill. 211*
Baroque convex-concave construction (the heavy black forms),
disguising its regularity with asymmetrical forms (note centre
section of nave). The true ceiling floats above, contrary to the
Baroque system of blending fact and fiction together as in the
Barberini ceiling. Rococo also replaces the dramatic light and *Ill. 172*
dark space of Baroque, with clear airy light, which in church
and house interiors is intensified by the use of white, blue and
gold – and mirrors, as one can see in the Salon de la Princesse. *Ill. 204*

These not only reflect light but enlarge the small-scale room through illusion. Both in the mirror surround and the reflection of an outside window and in the choir end of Vierzehnheiligen, it will be noticed that Rococo adopts a Roman or Romanesque arch. In general, therefore, Rococo combines several styles to produce one of its own.

The Rococo designer tended to consider a rectangular room as a skeleton to which he gave 'body' by bending and curving the walls and ceiling with plaster (stucco) additions. The feeling gained in the Salon of the Hôtel Soubise is of being in a brightly decorated garden tent or pavilion. For even in a Parisian town house this very sophisticated rural atmosphere was desired as much as it existed in the country, as one can see in the setting

Ill. 213 of Gabriel's Petit Trianon. This small house in the park at

211, 212
BALTHASAR NEUMANN
Interior of nave and
plan of the Pilgrimage
church, Vierzehnheiligen

213 JACQUES-ANGE GABRIEL Le Petit Trianon, Versailles

Versailles is typical of the country houses built in the eighteenth century in England and France, and as is quite plain, the source is Palladio. An English version can be seen in the course of construction through the open window in the Hogarth. These houses differ from Palladio, in that there are few signs of Mannerism and the windows absorb a great deal of the wall space. The main point, however, is that they are essentially town houses placed in the country; they give no sign of any rustic character, as does the thatched cottage in the Gainsborough. This artist, indeed, presents two major aspects of the English eighteenth-century view of rural life. In the first, Gainsborough unites the feeling expressed by Rubens in his portrait and his landscape, to suggest a new combination of taste, intellect, and a return to nature, to develop a more balanced and rational personality. The contrast, therefore, between the interpretation of Watteau and Gainsborough is the latter's emphasis on the productive effects of the relationship of man and the land, not only materially – the stooks of wheat and the flock of sheep in the distance – but philosophically as well. In this way the country subject became so popular that the formerly rather despised peasant was seen now as leading an ideal, simple, good life; the second Gainsborough shows the application of Watteau's picturesque setting and romantic haze to extol the charm and dignity of country people.

Ill. 210
Ill. 155

Ill. 207

Ills. 196, 20

Ill. 208

201

In 1711, a peasant digging a well discovered some pieces of coloured marble and started off a succession of excavations which exposed, once more, the Roman towns of Herculaneum and Pompeii which had been buried during the eruption of Vesuvius in AD 79. Apart from the great amount of sculpture and painting of the Romans these excavations produced, the romantic imagination of people was fired by this extraordinary treasure trove dug from the ground. It is this new romanticism *Ill. 214* towards the classical past which Piranesi expresses in his engraving. For this Antique bric-à-brac is heaped up in a grotto or cave mouth and a half-buried arch lies in the background. But there are certain ominous signs: the rank weeds, the bones of a human skeleton and, on the right, an Egyptian sphinx by a palm tree that appears to be on guard. These details indicate the superstitious dread associated with the opening of graves.

This interest in necromancy or sorcery is more clearly shown *Ill. 203* in the Tiepolo etching, where two sorcerers with their apprentice work out a spell. While this kind of subject matter had

214 GIOVANNI BATTISTA PIRANESI Caprice, etching from *Opere Varie*

215 GIOVANNI BATTISTA TIEPOLO *Banquet of Cleopatra*, fresco in the ball-room of the Palazzo Labia, Venice

a popular appeal, there was also a serious side to it, for it was linked to the artistic or poetic imagination; as the magician conjured up apparitions, the artist conjured up images. Since Egypt with its pyramids, sphinxes and mysterious hieroglyphic writing was considered the home of astrology and magic, it was joined to Greece and Rome to form a new Antiquity, Greece and Rome being the sophisticated part and Egypt the earlier primitive part. It is this new conception of Antiquity that Piranesi suggests. Such an interest plays a minor role in Tiepolo's art, for he is the last great Italian painter in the grand

manner. Both the works here form part of large decorative
schemes, the Palazzo Labia in Venice, the other in the Bishop's
palace in Würzburg, Germany. The artist was to die in Madrid
after completing another scheme in the Royal Palace there.

Ill. 215
Ill. 216

But while Tiepolo continues the tradition of the large-scale
work, he follows the Rococo conception, for in the Palazzo
Labia the ceiling of figures in a billowing cloudy sky is drawn
down *behind* the real wall to join the composition seen through
the arch. The effect is of being in a room almost completely
open to the sky. Where Boffrand in the Hôtel Soubise extends
his small room with mirrors, Tiepolo does this by painting
steps from the real room up to the great terrace where Cleopatra,
queen of Egypt, sits entertaining Mark Antony. The figure
crouched on the steps makes the deception all the more con-
vincing. This is contrary to the Baroque, which certainly
aimed at engaging the spectator but never went so far as to
entice him into a non-existent space.

Ill. 204
Ill. 215

Since both Murillo and Tiepolo were influenced by Veronese,
it is interesting to compare three separate and different inter-
pretations based on the same kind of architectural space. Unlike
the other two, Tiepolo conceives the space as a stage and his
figures as actors in a historic drama. Even the curtains at each
side suggest the proscenium of a theatre and the figures are
disposed across the area according to stagecraft, those nearest
kneeling, bending or crouching down to allow a clear view of
the principal characters. The real-life actuality of the Baroque
is turned by the Rococo into the make-believe reality of
theatrical drama.

Ills. 193, 159

Ill. 216

The subject matter also marks a change. In the past the
'history' picture, which Alberti, in the fifteenth century, had
declared the noblest form of painting, had included classical
mythology and history, then its scope was enlarged to include
the history of the Church and, in the sixteenth century, of
near historical events. In the seventeenth century subjects are
taken from both ancient and contemporary poetry and also
a wider range of ancient history. But in the eighteenth century,

216 GIOVANNI BATTISTA TIEPOLO *Wedding of Frederick Barbarossa*, fresco in the Residenz, Würzburg

there commences a preference for local and national history, as is seen here in the marriage of the great German Emperor, Frederick Barbarossa. To make the national tie between Church and State stronger in theatrical terms, it is the eighteenth-century Prince Bishop of Würzburg who blesses the royal couple of the twelfth century.

The Rococo style and conception offer, then, an amalgamation of old and new ideas in a way that appears theatrical, but both artists and patrons *knew* this. For the men of the eighteenth century, with their access to new laws of science, to free and wide thinking, knew the reason for most aspects of life. They could distinguish *exactly* between what was real and what was imaginary. It was Shakespeare, whose plays were reinterpreted and performed so much in the eighteenth century, who wrote 'All the world's a stage and all the men and women merely players', and Rococo artists and patrons knew this too.

217 BARON GROS *Napoleon at the Bridge of Arcole*

Neo-Classicism and Romanticism c. 1770–1850

The overlapping of styles has been remarked on before, but seldom had this created such cross-currents as it did in the period c. 1770–1840. In Rome between 1590 and 1620 there had been a somewhat similar pattern of artistic directions, but in the late eighteenth century there were other conditions at work to make this similarity only a very general one. For as Rococo makes clear, the traditional position of both artist and patron was changing rapidly. What is evident in this new period, which includes both the French Revolution, the Napoleonic wars and several other political upheavals to gain popular government, is the changeover from an aristocratic idea of art to a democratic one. To use these terms is not to suggest a simply political change (although this did occur, for instance with the artist David, who was a political member of the French National Convention), but an artistic one also. For not only was more popular subject matter introduced but the artist himself *chose* the mode of expression, which would show *his* feelings and ideas about the subject.

Thus, in the stylistic treatment of three contemporary heroes, West reconstructs the actual event of the *Death of General Wolfe*, but his central group, based on a Rubens painting of the dead Christ, is compressed and elongated by the flag, like a Mannerist composition, but also unlike it, since a telescopic space occurs on both sides. The supporting figures, instead of forming a horizontal Baroque oval, are arranged overlapping in a single line, like the front rank in the Titus relief.

Gros uses a Baroque pose for *Napoleon at the Bridge of Arcole*, but idealizes the features, giving the face a smooth marble-like surface as in a Roman figure.

Ill. 218

Ill. 29
Ill. 217

Blake freely adapts Michelangelo's *David* and employs the
Ill. 20 serpent-entwined sons from the Laocoön for his composition,
Ill. 220 *The Spiritual Form of Nelson*, which resembles Michelangelo's
Last Judgment in the Sistine Chapel. But he himself said that it
was similar to monuments of Persian, Hindu and Egyptian
Antiquity revealed to him in a vision, and that these were the
originals from which the Greeks and Romans had copied their
great works. Blake and others also believed that Britain was the
original home of a heroic 'lost' race, more ancient than the
Greeks. Adam, Blake said, was a Druid.

All three artists exhibit a mixture of Neo-classicism and
Romanticism not only in artistic borrowings but in the way
they conceive their subject matter. In the *Monument to Agnes*
Ill. 219 *Cromwell* Flaxman, equally, brings together several styles and
Ill. 14 ideas, including the Classical stele or memorial stone and the
Ill. 26 relief cutting of the Ara Pacis; the narrow, vertical composition
Ill. 158 suggests the Mannerism of Giovanni di Bologna, but is bal-
anced by the two angels on either side – a combination of the

218 BENJAMIN WEST *Death of General Wolfe*

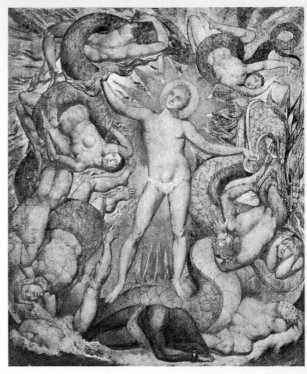

219 JOHN FLAXMAN
Monument to Agnes Cromwell

220 WILLIAM BLAKE
The Spiritual Form of Nelson

Classical 'wet' look drapery and the Gothic rhythmic folds of *Ill. 93*
the girl's dress.

As a gardener grafts and cross-pollinates to produce new
types of shrubs or flowers, the artists of this period did likewise
to produce new styles. Terms like Neo-classicism and Romanti-
cism may serve in a general way to describe the two major
aspects of style, but when a cross-section of the works of the
period are examined, they lead to confusion. For instance, if
one compares Wright's painting of an *Experiment on a Bird in* *Ill. 222*
the Air-pump with the relief by Thomas Banks, the *Death of* *Ill. 221*
Germanicus, their respective subjects are widely separate in
time and type, but the pity expressed by the children in each
work is the same although the cause is different. While both
artists use a Baroque oval, Wright engages the spectator;

221 THOMAS BANKS *Death of Germanicus*, monument in Holkham Hall, Norfolk

222 JOSEPH WRIGHT OF DERBY *Experiment on a Bird in the Air Pump*

223
EUGÈNE DELACROIX
Liberty at the Barricades

224
JACQUES-LOUIS
DAVID
*The Oath of
the Horatii*

Banks uses a Classical single plane like the Stele of Hegeso, but the women grieving resemble those of Rogier van der Weyden in posture and expression more than any Classical example.

In effect, Banks grafts Christian sentiment on to an idealized Roman event, in which Germanicus dies without complaint as a stoic Classical hero should, and as West shows, a contemporary hero did. Present in the works of Wright, West and Banks is an underlying moral: Wright invites the spectator to reflect on the effects of science, by the different reactions of his family group; West and Banks, almost like Gothic artists, give moral instruction in the art of dying – not as a sinner, however, but as a Christian hero. Contemplation on this manner of dying, they imply, will strengthen one's own moral courage. But there was something more, for West reflects a public interest in and feeling for the national hero. Nationalism, in addition to individual artistic selection, played an important part in the choice of subject and the type of hero and heroine. Hogarth had already laid the foundations of 'type casting' national character, but in this later period the subject is taken much further.

It is interesting to compare David's *Oath of the Horatii* and Delacroix's *Liberty at the Barricades*, for while both pictures seek to inspire national feeling, each artist chooses different means to do this. David selects a Roman legend, not directly from a Roman source but inspired by a play by the Frenchman Corneille. The action here does not appear in the play, but, possibly, comes from one of the staged mimes (play without words) of the period. The setting and figures are influenced by Poussin (note the drapery in *Et in Arcadia Ego*) but the gestures are not. The composition, while it is more tightly arranged, is closer to Hogarth than it is to any earlier model, because the subject is seen in theatrical terms. The heroic, upright Horatii make their oath and contrasted to them, on the right, the collapsed forms of grieving women and children. The brave defend the weak. Delacroix uses the same formal contrast of the strong vertical

forms of Liberty and her companions against the horizontal, collapsed forms in the foreground.

Where the Renaissance allegory was made clear by identifying the figures and other items, both David and Delacroix use formal, artistic means. Delacroix's Liberty, also, is clearly identified as French, for she wears a revolutionary cap and waves the *tricolore*. For the first time, then, a general virtue is given a national identity. Across the Channel, there was Britannia. Countries are identified as women and are based on Classical figures. While Delacroix uses a Baroque advancing plane composition, it does not engage the spectator, since it is to be looked at as a *tableau vivant* (living picture) a mimed action like the David. Both artists refer to the patriotic motto – Liberty, Equality, Fraternity – for not only were the Horatii brothers, but one clasps another around the waist. The differences between these two, the Neo-classical David and the Romantic Delacroix, lie only in the way they construct and paint their pictures. A similar difference in expression was noted between Sacchi and Guercino, but between David and Delacroix it is more difficult to decide which expresses his idea more dramatically.

The Goya may be turned to as an interesting amalgamation of the two French paintings. The artist makes the same formal artistic contrast between the firing squad and the victims of the *Shootings of May 3, 1808*, but chooses an actual event, which *Ill. 225* the artist himself saw. The dead man, lying in the foreground, should be compared to General Wolfe and the dead patriot on *Ill. 218* the right of the Delacroix, the former based on a dead Christ the latter on a dead Gaul, a Greek work of the third century BC. Goya's man is only himself. In the centre of the group of victims is a Morisco, a Spaniard of Moorish descent, the new hero of these times. He is a common man but Goya, by putting him in a posture of a crucified Christ, makes him a symbol of oppressed humanity in general, and, in particular, of Spain oppressed by the Napoleonic troops. Goya's use of a Morisco points to the appearance of another common hero, which is

213

225 GOYA *The Shootings of May 3, 1808*

Ill. 226 indicated most emphatically by Géricault in his lithograph of
the *Boxers*. Here the American Negro Tom Molineaux fights
the Englishman Tom Cribb. Although a popular type of
subject, the Negro is given a heroic role and a Classical stance.
Ill. 220 In contrast, but also with a sympathetic treatment, is Blake's
symbol of Africa, the manacled Negro slave below Nelson.
Ill. 218 West's American Indian contemplates, as an equal, the death of
Wolfe. The same heroic interpretation was given to the
Polynesian by the artists who accompanied Cook on his
voyages to the Pacific.

 Of all these artists, David is the only one who played an
active political role, but he chooses the most traditional style.

214

This kind of contradiction is characteristic of the period, for the artists were not only introducing new subjects, but inventing a new mythology, made of new heroes, heroines and new stories to replace the gods and goddesses of Greece and Rome. One of these new heroes was the artist himself, the man who grapples with the imaginative and creative forces within him to produce some sublime image. The term 'sublime' was much used during the eighteenth century to describe the high peak of artistic expression. There were several definitions offered of this quality, but it was only applied to certain types of subject matter – Christian, historical, mythological, and towards the latter end of the century, to landscape. It was partly due to the inclusion of landscape, that the term 'Romantic' came to be used to describe the feeling experienced by the spectator before Nature, or before a work of art that contained the qualities to arouse this feeling. 'Sublime', thus, was objective, describing

226 THÉODORE GÉRICAULT *Boxers* (lithograph)

227 EUGÈNE DELACROIX
Portrait of George Sand

228 JACQUES-LOUIS DAVID
Self-Portrait at the age of 46 in Prison

what was to be admired, and 'Romantic', subjective, since it
described the admiration. In practice, however, there was no
clear division between the two, largely because the artist was
quite capable of alternating between an objective and sub-
jective treatment. For instance, when David painted his *Self-
Portrait* in prison, he adopted a Baroque composition like the
Rembrandt, and painted himself in actuality. His expression is
intense as he stares past the spectator. The more one looks, the
more the artist appears to be in a trance.

Passing on to the portraits of Géricault, Ingres and Delacroix,
one finds a similar absorbed expression, for different reasons
perhaps, but each sitter is wrapped in his own thoughts or
feelings. Even Napoleon's expression is at variance with his
gesture, for it is serious and detached. While the Baroque
artists projected their own or others' personalities they did this
directly, whereas these later artists convey the psychological
state of their sitter *indirectly*, by forcing the spectator to look

Ill. 228

Ill. 201

past the face and see the mind and feeling behind it. In these portraits by both Neo-classical and Romantic artists, there is a common aim to give this kind of interpretation to all sections of society – the artist, the great leader, the powerful bourgeois editor (*Monsieur Bertin*), a woman novelist (*George Sand*) and one who is mentally unstable (*A Madman*). In the last two one can see that Romantic brushwork is similar to the Baroque in its emphasis in working up the textures, so that they look as they feel, as well as how they look. David, Ingres and Gros tend to use a uniform paint surface as the Renaissance artists had done. But Gros, generally considered a Neo-classic, shows in his drawing of *Francis I and Charles V arriving at St Denis* the spontaneous dashing style of a romantic (note the heavy black accents and strong contrasts of light and shade). This shift in expression is common to a great many artists of the period, for the drawing or the oil sketch was seen as the image closest

Ills. 230, 227
Ill. 229

Ill. 231

229 THÉODORE GÉRICAULT
Le Fou Assassin (A Madman)

230 INGRES
Portrait of Monsieur Bertin

to the imagination of the artist. The 'finished' painting repre-
sented, as Delacroix said '. . . the *full* scope of his talents'. The
Romantic artist may be seen as trying to carry the immediacy
of the drawing into his painting, so that each brushstroke would
convey the spirit of his imagination. These ideas go back to the
beginning of the seventeenth century. Caravaggio is thought
to have painted directly on the canvas without making any
preliminary drawings.

Ill. 216 The drawing by Gros draws attention to the trend already
shown by Tiepolo at Würzburg of using local and national
historical subjects, for here a sixteenth-century king of France
and Charles V, one of the most famous of Holy Roman
Emperors, foregather before the abbey church of St Denis,
which had a long association with the kings of France. The
subject reveals the strong feeling for the restoration of the

231 BARON GROS
*Francis I and
Charles V arriving
at St Denis*
(pen and wash drawing)

232 EUGÈNE DELACROIX *The Abduction of Rebecca*

French monarchy, which was to occur in 1814. The subject is as much inspired by a Romantic interest in the past as is *Ill. 232* Delacroix's *Abduction of Rebecca* which is taken from Sir Walter Scott's novel, *Ivanhoe* (1819), set in the time of Richard I of England. Scott included in his novel detailed archaeological descriptions of medieval architecture, dress and armour. So that along with the Romantic devotion to the Classical past, as *Ill. 214* noted in the Piranesi, appears another to the Middle Ages. Delacroix uses a mixture of both Mannerist and Baroque *Ill. 200* compositions, but replaces Rubens's remote Classical myth with an up-to-date story and interpretation. For the beautiful heroine, who is subjected to all manner of extraordinary experiences, was a popular theme of the time and owed its origin to Samuel Richardson's novels *Pamela* (1740–41) and *Clarissa Harlowe* (1747–48). Delacroix raises Romantic feeling, by using a Baroque system of masses, which he overlays with a strongly lit linear pattern made of drapery folds and other elements. The pattern of lines breaks up the solidity of the masses and gives an impression of frenzied and spontaneous action. This type of heroine must be placed alongside other women of the period, who symbolize motherhood, pity and Christian piety, nation and liberty.

Ill. 227 Another heroine is typified by George Sand, the pen-name of Aurore Dupin. A friend of Delacroix, George Sand had love affairs with Alfred de Musset, the poet, and Chopin, the composer. She wore oriental clothes, including trousers, and smoked cigars or a pipe. She was indeed a modern, emancipated woman. This portrait has been cut from a much larger painting which included Chopin at the piano. The novelist is listening and Delacroix brushes in the forms in large plastic masses to suggest a mood of strong emotion. The profile view of the face, almost obscured by a swathe of hair, adds also a feeling of mystery. There was, in fact, a great deal of attention given in all the arts to the *femme fatale* (fatal woman), like Lady Macbeth, for instance, passionate, with the power to lure men to their downfall. The Egyptian Sphinx, or its Greek counter-

220

233 INGRES *Oedipus and the Sphinx*

part the Harpy, was the most fatal, and Ingres shows in his
painting, *Oedipus* avoiding the fate of most men, by guessing *Ill. 233*
the riddle asked him by the Sphinx. Ingres, the most Neo-
classical of artists, here combines a High Renaissance pro-
portioned and smoothly modelled figure and a profile posture

221

234 GOYA
Colossus
(etching
and aquatint)

taken from a Greek vase painting, with a near Mannerist
Ill. 153 composition. It suggests Parmigianino, but has none of that
style's elongations, for the figure in the background is at a
proper distance and is based on Raphael. While the Neo-
classical artist adheres to Classical and traditional means to
express contemporary ideas as did his Renaissance predecessor,
he romanticizes the past, as Ingres does here with the narrow
defile, contrasts of light and shade, and the single foot of a
previous victim in the left foreground.

Ill. 220 Blake also draws on the Classical past, but he is generally
considered a Romantic. Goya presents another problem, for he
freely invents as much as Blake, but is also concerned with the
Ill. 214 actuality of his own time. If Piranesi and Tiepolo suggest to the
Ill. 203 spectator that some dreadful presence lurks in the grotto or is
about to be released by a magician's spell, Goya gives form to
Ill. 234 this presence in his *Colossus*, symbol of man's barbarous nature,

222

which creates war, cruelty and fear. But the idea of such a figure comes from a famous Classical sculpture, the Colossus of Rhodes, which was believed to have stood astride the harbour entrance. The posture of *Colossus* is also a combination of a bronze Boxer and the so-called Belvedere Torso, both Classical works.

These close relationships between Neo-classical and Romantic artists of this period are as evident in the architecture of the time. For the three examples here show a romantic application of the great styles of the past to contemporary ideas and needs. Horace Walpole went to great trouble to give this room in his house at *Strawberry Hill* authentic Gothic details, but when it is compared to Boffrand's Hôtel Soubise, one can see that Walpole has 'domesticated' Gothic, just as the Rococo architect had 'domesticated' the Baroque. For he described his house as a 'little Gothic castle'. His aim was to create a 'Gothic' atmosphere rather than to revive an old style, although, in fact, 'Gothic Revival' is the name given to this development. While it had

Ill. 235
Ill. 204

235 The Holbein Chamber of Strawberry Hill, Twickenham, England

most effect on church-building (Neo-Gothic churches are still being built in the twentieth century), there were also Neo-Gothic cottages and, with the introduction of iron, even Neo-Gothic iron vaulting.

The Gothic Revival was part of the interest in the Middle Ages but, in addition, Gothic was looked upon in England as being thoroughly English. Late English Gothic, for instance, was closely associated with the Tudor kings and queens. It was partly for this reason that the Houses of Parliament were rebuilt in a style combining both Gothic and Renaissance features. The great Classical styles were also domesticated. Ledoux does this *Ill. 236* by giving the *Salt Works of Chaux* a Doric temple entrance. Once past the columns, however, one passes into a simulated cave of carved boulders, representing the organic source of salt. But the temple façade represents the atmosphere of dignity *Ill. 9* and greatness associated with, for instance, the Parthenon. Here this same dignity and greatness is applied to labour or industry. Later the same temple front is applied to the public Museum, for obvious reasons, and equally so to town halls and Government buildings. This Romantic attitude to the past is altogether similar to David and Ingres.

As a Classical style was applied to the dignity and greatness of either industry or governmental authority, so was the *Ill. 237* Renaissance style. *The Reform Club*, one of many in London formed for both social and political reasons, has the façade of a *Ill. 140* small-scale Palazzo Farnese. Many of the members of such clubs were drawn from the new middle class of industrialists, bankers and public servants, the class represented here by *Ill. 230* Monsieur Bertin. Joseph Wright's patrons were, almost exclusively, the industrialists and millowners of Derby. Many of this class, the new rich, because of their wealth and patronage of the arts, were compared to Lorenzo de' Medici; hence the Renaissance style was not only used for clubs of businessmen but also for banks and large business houses. There was no end to this 'architecture by association'; for example, there was an Egyptian Hall in London and the Prince Regent's Indian

236 CLAUDE-NICHOLAS LEDOUX
Entrance to the Salt Works of Chaux,
Arc-et-Senans, France

237 CHARLES BARRY
The Reform Club,
London

Pavilion at Brighton, Sussex, to name only English examples.
Many of the buildings of this period were not just copies of the
past, but designed with some imagination to meet the new
demands. But no really original architectural style was to
emerge. One of the reasons for this is possibly the fact that men
of this period were more drawn to the majesty of natural
architecture than to anything constructed by man.

Where architecture, in fact, was domesticated, landscape
was enlarged and made universal during this period. From the
general topography of Brueghel, and the particular or domestic *Ill. 150*
topography of Rubens, to the poetic conceptions of Poussin and *Ills. 202, 18(*
Claude, Rosa's Baroque romantic idea or Gainsborough's *Ills. 181, 17.*
notion of landscapes' capacity to add to man's character, the *206*
subject is for the first time given both a sublime and monu-
mental interpretation. The withdrawal to a remote country
place for religious or other reflection, noticed in the seventeenth
century, is turned into a direct communication with Nature.
One was moved by a marvel of Nature, either for itself alone,
or because of the presence of a great Classical monument in
Nature, as Robert indicates with the *Pont du Gard*. This latter *Ill. 239*

238 JAMES WARD
Gordale Scar,
Yorkshire

239 HUBERT ROBERT
Le Pont du Gard

Ill. 181 work can be compared with the Claude, to see both the en-
largement of the Classical monument and also the choice of a
Ill. 241 real one. In both Wilson's and Robert's paintings this new
monumental treatment of landscape is linked with real topo-
graphy, whereas both Poussin and Claude constructed an ideal
landscape. Particularly in the case of Wilson's subject matter,
this notion of the sublime was associated not only with moun-
tains, ravines and waterfalls, but these aspects in *particular*

226

localities – Wales, Scotland, the English Lake District, Switzerland and even further afield, in America and in the Pacific. Landscape was not only sublime in the way it uplifted the romantic spirit, but since God was the Great Architect of Nature, the Christian was able through Nature, to communicate directly with God. This notion, known as Pantheism, was in part influenced by the *Lyrical Ballads*, published by Wordsworth and Coleridge in 1798 and 1800, the former not only extolling the virtues of the countryman but also expressing the purity of a Christian faith obtained through Nature.

Two aspects of this pantheistic view are represented in the landscapes by Ward and Constable. Ward's painting is only the finished sketch for the large work in the Tate Gallery, which is nearly eleven feet high and fourteen feet wide, a size reserved in the past for a Biblical or mythological subject. While it represents an actual place, the *Gordale Scar*, the artist has exaggerated the scale to put it at the same monumental level as Goya's *Colossus*. Ward implies a natural cathedral and God's

<div style="text-align: right">*Ill. 238*</div>

<div style="text-align: right">*Ill. 234*</div>

240 JOHN CONSTABLE *The Haywain*

241 RICHARD WILSON *Cader Idris*

Ill. 240 awesome majesty, while he also satisfies the Romantic emotion of 'pleasurable horror' at being confronted and overwhelmed by this natural drama. Constable, in *the Haywain*, comes nearest to Wordsworth in expressing God in Nature, but like other artists of the period, he identifies this landscape as English, not only through natural forms and the cottage and wagon, but through an almost scientific rendering of English climatic atmosphere. Indeed, Constable made meteorological studies of cloud formations, rainstorms and the effects of sunlight on natural forms. To do this he made many oil sketches *out of doors*, so that he could catch the exact tones. While artists since the seventeenth century had made drawings directly from Nature, it is doubtful until this period whether they actually painted outside. This practice at once raised the colour key; lighter and brighter tones had to be used. It also required a variety of different sized brushstrokes, to represent the effect of light falling on so many different surfaces.

The effects of light were also Turner's concern, as in his *Ill. 242* *Steamer in a Snowstorm*, but he is as much concerned with the

sublime character of natural forces. For he turns away from
Wilson's selection of solid natural forms, as in the *Cader Idris*, *Ill. 241*
to the violent motions of snow, sea, smoke and sky, which he
turns into planes of light and dark. Turner thus dramatizes the
character of these natural forces in much the same way as
Delacroix dramatizes the forces of the human character. Dark *Ill. 227*
and light, black and white contrasts are used for symbolic as
well as artistic purposes, to suggest, as in the Goya, that human *Ill. 234*
nature or Nature itself has two sides, good and bad; and that
courage and nobility are not reserved for one race, as Géricault *Ill. 226*
indicates. It was Goethe (1749–1832), the German poet, who
suggested new colour symbols to replace the Christian ones.
A yellow red, he said, combining the colour of the sun and the
colour of blood was the most vital and expressive colour. This
attention given to the possibilities of using abstract forms and
colours to replace traditional representations led the way to late
nineteenth-century and early twentieth-century art.

242 J. M. W. TURNER *Steamer in a Snowstorm*

243 JEAN-FRANCOIS MILLET *The Woodcutter*

European Art c. 1850–1930

This last chapter covers the end of one tradition and the beginning of another, but this does not mean that there is such a shift in artistic interpretation and in the attitude of the spectator that a whole new set of artistic definitions has to be learned. For the artist, while he introduces new materials and new conceptions, still faces the problems of giving these form and expression in one *traditional* art form or another. What has to be taken into account is that this period marks the most rapid and extensive accumulation of knowledge and experience known to man. The inventiveness of the artist matches this. While some national characteristics remain, art becomes more international, and the individual artist, like the scientist, is the originator of a new idea or is the first to employ a new technique. But unlike the scientist, the artist does not *experiment* with art, he *makes* it. It was not just the artist of the late nineteenth century who was affected by new inventions, for, to cite a single example, Turner had romanticized the steamship before 1851. By that year, a permanent split had already occurred between artists themselves, those who were creative and progressive and those who preferred social esteem and the income that went with it. There had always been the imaginative leaders and the competent followers, but the social and economic position of the artist was completely altered by 1850. Patronage was almost entirely in the hands of the middle-class patron, who knew what he liked and knew what he wanted. Art was on the market like any other commodity, and the artists were rather like the manufacturers, either turning out popular works on demand or satisfying the more discerning judgment of a small number of connoisseurs. What was more, the progressive artist, in popular opinion, was considered

244 FORD MADOX BROWN *Work*

245 HONORÉ DAUMIER *Third Class Carriage* ▶

almost as dangerous to society as was the radical or revolutionary politician.

Both Courbet and Daumier were to be imprisoned for their political acts or opinions, while Millet and Ford Madox Brown were not, but they all share a similar subject matter. Their interpretation, however, is different. Courbet in his *Girls on the Bank of the Seine*, for example, aims at idealizing the peasants, raising them to the same pictorial level of importance given to Classical myths and other subjects. By contrasting the sharp detail and bright colours of the girls' dresses with the more broadly painted, darker tones of the grass, trees and leaves, the artist suggests an unreal situation, which indeed it was – since these girls are wearing their Sunday best; but they look as 'at home' in the country as Gainsborough's *Mr and Mrs Andrews*. Millet, on the other hand, carried on the Romantic idea of the peasant as a heroic working man, *the Woodcutter*, in harmony with his work and his materials. Ford Madox Brown, however,

Ill. 246

Ill. 206

Ill. 243

246 GUSTAVE COURBET *Girls on the Bank of the Seine* ▶

Ill. 244 in his painting *Work*, puts together an illustration to Christian Socialism. Brown was an associate of the Pre-Raphaelite Brotherhood, a group of artists formed in Britain in 1848 to restore a pre-Raphael style of painting. The bright clear light, *lls. 121, 120, 122* colour, careful detail, and studied actions may be seen as a combination of Piero della Francesca, Uccello, Pollaiuolo and *Ill. 128* Signorelli. However, the bearded figure on the right is Thomas Carlyle, who, in his book *Past and Present* (1843), spoke for a return to the Christian honesty of labour of the Middle Ages. Around the painting there are four Biblical quotations on work.

Brown and the Christian Socialists shared the view of Millet, but not that of Courbet who wanted social equality for the peasant. Daumier shares Courbet's views, but he is more like Goya or Rembrandt – viewing humanity in general rather than in particular. For the first time in human experience, men, women and children from various walks of life are packed *Ill. 245* together in a *Third Class Carriage* and the artist observes them from a seat in the same carriage. He paints them as they are seated, in horizontal planes. An interesting comparison can be *Ill. 185* made here with El Greco, who advanced his figures by *arranging* them in horizontal planes across the canvas. One could agree here, therefore, with the saying 'Life imitates Art', for Daumier can satisfy his desire for actuality and for artistic expression, without any rearrangement. It should be noticed that both the politically inclined artists, Courbet and Daumier, adopt a Romantic or Baroque brushwork in contrast to their predecessor David's Neo-classicism, for both artists use the way they apply the paint to express their intention. Daumier, for instance, *moulds* his forms with paint to express, for example, the full *maternal* forms of the mother nursing her child.

The democratic character of art, originating in the late eighteenth century, reaches its high point in the work of these artists. It is even present in architecture, for Philip Webb's *Ill. 247* *Red House* is not intended as a 'little castle' like Walpole's Strawberry Hill, but a comfortable house, designed not for atmosphere but for living. Its owner was William Morris, who

was a partner with Webb, Madox Brown and others in a firm dedicated to *hand-made* books, wall-papers, fabrics, furniture and other things. There is a deliberate medieval (but not a Neo-Gothic) look given to this house with its irregularly-sized and placed windows, steep roofs and deep overhanging eaves, resembling thatch – for even Morris, who believed much more in socialism than Thomas Carlyle, looked back to the Middle Ages as a time of honest craftsmanship and human behaviour. Both industry and the growth of the towns contributed to this yearning amongst artists and intellectuals for a time when man was primitive enough to enjoy life, a time before civilization and industrial production corrupted him and turned him into a cog in a machine.

The last half of the nineteenth century was devoted to three basic aims. The first, to use artistic expression *alone* to give meaning to pictorial imagery: to exclude from the interpretation of the work of art any reference to Christian, Classical or other literary or written source. The second, to restore to the visual arts the meaning and power that these had in the distant past or in non-European societies. The third, which was

247 PHILIP WEBB The Red House, Bexley Heath, England

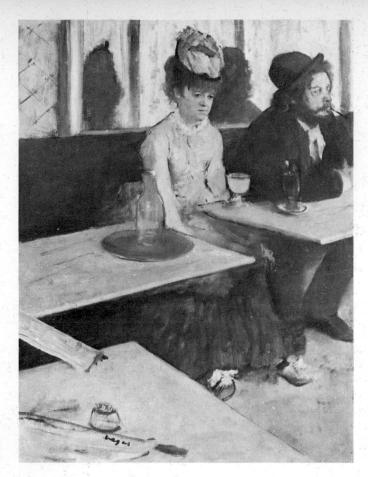

248
EDGAR DEGAS
Absinthe

dependent on the first two, to create a 'modern' art which reflected contemporary life in all its parts. These were the guide-lines along which all the various movements, Impressionism, Post-Impressionism, Neo-Impressionism and others moved. But at the same time, it has to be remembered that all these artists were men of the nineteenth century with *its* traditions, beliefs and knowledge. For instance, Manet, while he removes direct social or literary meaning from his subject, *Le* *déjeuner sur l'herbe* was inspired by Giorgione's *Concert Champêtre*, borrowed the arrangement of his figures from an engraving by Raimondi of a lost painting by Raphael, and was

Ill. 249
Ill. 138

influenced in his brushwork and strong colour contrasts by Velazquez, Hals and Goya.

The difference between Courbet and Manet is that the former is still concerned with the subject matter of his painting, whereas the latter brings together forms, colours, textures for purely *artistic* reasons, to compose them (as a composer of music does) into a pictorial arrangement which pleases the spectator by its qualities alone, but at the same time provides in his subject a contemporary allegory of life and art, as did Giorgione in his time. Degas does likewise, but as Manet *Ill. 248* gives his subject modernity by using contemporary dress, he, like Daumier, selects a contemporary situation and viewpoint. The difference between Manet and Degas is again that Manet is not interested in actuality; Degas is, but gives no social or even humanist interpretation like Daumier. Two new

249 ÉDOUARD MANET *Le déjeuner sur l'herbe*

influences are in evidence here: the Japanese coloured woodcut and the camera. The Japanese, by using simple flat planes at angles and single-tone colours, depicted space *without* using the European laws of perspective. The camera could be used from any angle and provided a 'snap-shot' which recorded exactly

Ill. 259 what was before it. If it was tilted, focal distortions occurred, which seemed to 'flatten' out the space into a shallow series of planes. Both these influences are to be observed in Degas, Gauguin, Van Gogh and Cézanne in varying proportions. The main point of this dual influence was that by adopting an acute angle of view, one *naturally* reduces the amount of space from a horizontal viewpoint (compare the Degas and the Daumier).

Ill. 248 Focal distortion is evident in *Absinthe*, in the disproportionate distances between the spectator's eye and the woman's face *and* her feet, and the composition is 'cut off' on the right, as in a photographic snap-shot. While an Impressionist, like Monet, aimed his eye like a camera lens, taking in everything before it within a short space of time, his main interest being in the

250 CLAUDE MONET
Poplars on the Epte

effects of light and colour as on the *Poplars on the Epte*. Ill. 250

Making use of the fact that white light is divided up into the seven colours of the spectrum, Monet used only these colours on his palette and also painted shadows, in optically correct colour mixtures, instead of the dark tones employed in the past. This painting is one of a series; each was done in different seasons at a different time of the day. Neither subject nor composition is so important as the effect of light, observed and put down on the spot. Monet, however, painted both shadow and reflection in the same thickness of paint as solid objects, so that the painting has a uniform surface or plane. This is aided by a regular short brushstroke, which helps to 'vibrate' colour over the whole surface. Space in this work is achieved, therefore, through natural colour contrasts and not through the old laws of linear or aerial perspective.

Seurat, who invented Pointillism, made Impressionism more optically correct, as in *Afternoon on La Grande Jatte*, by using Ill. 251 only the three primary colours – red, blue and yellow – and

251 GEORGES SEURAT *Afternoon on La Grande Jatte*

252 AUGUSTE RODIN
The Walking Man

mixtures of these, adding white to obtain lighter tones. These colours he put on the canvas in small dots, or more accurately commas, a long and painstaking process. But he also refined forms to give them precise volumes in a clear overall light. His art is best compared with Piero della Francesca and Signorelli and then with Madox Brown, to see that Seurat relied entirely on painterly qualities; there is no easily recognized 'meaning' to his work. There were artists, however, who wanted to put 'meaning' into their work, i.e. to be contemporary, to be concerned with problems of their own time. Rodin can be seen as an artist with a foot in both camps. With *The Walking Man* he creates a modern antiquity, headless and armless, like the Three Goddesses of the Parthenon, and therefore impossible to identify as any one man. The bumps and hollows of the torso react to the light, giving the body a vibrant look of life. But the meaning of this single figure is similar to that of the group

Ills. 121, 128
Ill. 244

Ill. 252

Ill. 6

240

of citizens, *the Burghers of Calais*, taken as hostages by the *Ill. 253* English, under Edward III. Rodin uses them as a symbol not only of the Romantic common heroes, but as *reluctant* heroes groping their way uncertainly, almost without sense of direction. Each figure seems separate and alone like Gothic wall- or jamb-figures, but there is also a Baroque-like engagement of the spectator, to remind him that he is part of this aimless crowd. The way the drapery cloaks the figures in vertical waves, gives them the character of sleep-walkers.

Rodin, Gauguin, Van Gogh and Munch share, in various ways, a kind of missionary zeal to tell their contemporaries something about their problems and about possible solutions. But, unlike the Baroque artist, with no particular faith in mind. Munch shares the anxiety of Rodin; his worried, almost faceless people transmit their feelings into the landscape and the sky. Munch, as a Norwegian, shares in his *Anxiety* the stark *Ill. 254*

253 AUGUSTE RODIN *The Burghers of Calais*

Ill. 145　realism of the German, Grünewald, and his means are as expressive as the early Romanesque artists, for he uses a restless, writhing line. However, this manner was also derived from his use of the woodcut and the expressive nature of wood grain, which is shown here in the sky.

Where Munch concentrates on man's intimate personal emotions, Gauguin and Van Gogh aim at a more universal goal. Man's salvation was to return to the honest, simple existence of ancient or primitive society. It is interesting to note that Gauguin and Van Gogh chose to live in country places, where they considered such a society still existed – Gauguin in Brittany and eventually in Tahiti and the Marquesas in the Pacific, Van Gogh at Arles in the south of France. Gauguin, of course, was the most determined in his search for a primitive society,

242

255　PAUL GAUGUIN *Vision after the Sermon* ▶

and the group of artists he joined in Brittany were as determined at reestablishing the meaning and power of art. This was Gauguin's intention in the *Vision after the Sermon*, for it shows these Breton girls watching Jacob wrestling with the angel, as an act of simple faith. His artistic sources are numerous: the Romanesque tradition of carved wood or stone figures, Gothic stained glass (both the colour and the way the pieces are joined together irregularly with lead) and Japanese colour prints (the tree cutting across the rich red ground creates pictorial space). Gauguin used large planes of evenly toned colours, which were chosen partly for symbolic reasons and partly for their own richness, and his colours are therefore not altogether natural. While his aims are close to Romanesque he achieves them through contemporary subject matter and means.

Ill. 255

Van Gogh follows a similar pattern, of selecting colours which are more symbolic than natural. Yellow was to him the colour of happiness, red meant warmth and comfort. He, too, was much influenced by the Japanese colour print, but through brushstroke and form, in the Northern tradition, he expresses *Ill. 256* *his* feelings about his subject. His *Chair*, with his pipe and tobacco on it, is a symbolic self-portrait and a symbol of honest simplicity. This conception resembles the Gothic use of common objects as religious symbols, but Van Gogh's faith is more in honest human nature than in any particular religion. A room and its furniture reflect its owner's personality. In Van Gogh the artist, as an individual, reached at this time a far more personal level than before.

Cézanne, on the other hand, maintains such a balance between his own personality, nature, symbolism, pictorial space and expression that his art 'works' in a way that combines the discoveries of both Degas and Van Gogh. But while he was aware of the camera and the Japanese print, Cézanne chooses *Ill. 257* to *actually* tilt the table itself, in his *Still Life with Cupid*, so that he maintains a *natural* viewpoint. He uses natural colour and tones which he puts down in separate planes of colour. He also mixes reality and illusion together in a way reminiscent of Velazquez, for the drapery and a sprouting onion in the 'real' still-life in the foreground are *continued* in the painting on the left, and the 'real' plaster cast is repeated by another painted one in the rear. There is also a symbolic suggestion in the contrast between the full curves of the plaster Cupid and fruit, and the rectangular flat planes of the paintings propped against the wall. It is a painting about art itself, how the artist transfers the organic forms of Nature and 'life' into pictorial images.

Cézanne called himself 'a primitive' of a new art. He meant *Ill. 258* that he was a pioneer, but it was Henri Rousseau who was the first real modern Primitive, largely because he had little formal training, but also because he painted a personal world of his own, with almost no reference at all to the universal experience. He invents a dream or super-real existence for his carefully

256 VINCENT VAN GOGH
The Yellow Chair

257 PAUL CÉZANNE
Still Life with Cupid

258 HENRI ROUSSEAU, 'LE DOUANIER'
The Sleeping Gipsy

detailed forms (note the hairs of the lion's mane). Space and proportion are at the whim of the artist, but also have affinities with the extraordinary situations experienced in dreams. Where Poussin and Claude create a painted poetry, so does Rousseau, but his poetry has no meaning, no allusion to the past or to any philosophic idea. *The Sleeping Gipsy* who has the dream is the only one who knows, perhaps, the meaning of it. Technically, Rousseau is not a primitive artist at all. His details are exact as any Gothic artist and his tonally modelled forms are as sensitive as those of Sassetta.

Ill. 114

Ill. 259

The architect, like the painter and sculptor, also desired to create a contemporary style, but since patrons like the Church and the State no longer played a major role, he had to rely on patrons wherever he could find them, and the illustrations here give some idea of the variety of buildings constructed in this period. The *Eiffel Tower* is, properly, engineering rather than architecture, but with the introduction of iron and steel as building materials architecture and engineering become difficult to separate. This tower (1,000 feet high) was unique in its time; exposed steel girders and trusses were familiar in such functional forms as bridges, but the Eiffel Tower served no

259 GUSTAVE EIFFEL View inside the Eiffel Tower

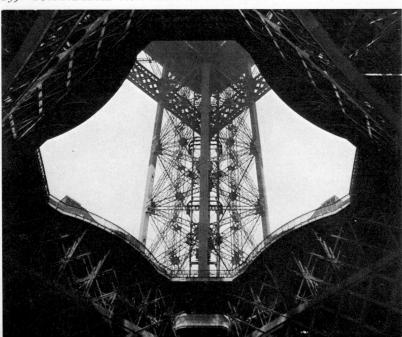

useful purpose. The most novel experience it gave the visitor was complete security without the protection of solid walls. And as the view here shows, it was possible to see both the inside and the outside of the tower at the same time. One also is aware that the design of the tower is derived from the method of construction. There is here a connection with Gothic architecture, first in its interest in tracery and the multiple repeating of forms, and second, in the fact that the flying buttresses on the outside of a cathedral similarly indicate the kind of construction and design of the whole structure. The convex-concave opening relates to the physical tensions of the construction and on this account it resembles Baroque architecture. But the fact that design is based on construction and function, separates late nineteenth-century architecture from that of the more recent past.

Ills. 75, 76

Ill. 175

The design of Sullivan's *Carson Pirie Scott* city store in Chicago depends on the steel grid system of construction, and the 'clean' efficient look of the building with its ample window area is clearly functional. But one also can 'see' what the inside is like from the outside of the building. Gropius and Meyer stressed this idea even more with the glass-walled staircases serving the two floors of their model factory. While there was nothing new in monumental spiral staircases (Bramante built one for the Vatican *c.* 1503), those here also reflect the influence of machined parts, like a vertical gear shaft, for instance. The French architect Le Corbusier later described the house as 'a machine for living'. The idea, therefore, of *gearing* house design to human activity and need, was the most important departure from the past.

Ill. 260

Ill. 263

Frank Lloyd Wright's *Winslow House*, while it retains 'old' features like stressing the entrance by advancing it (as Maderno had done at Sta Susanna), and the harmonic balance of horizontal and vertical features of a Renaissance façade, has the new functional look. The deep overhanging eaves give protection from the heat and glare of the noonday sun. The generous ground-floor windows are lowered so that someone inside can

Ill. 261

Ill. 162

264 ANTONIO GAUDÍ Casa Batlló, ▶
Barcelona

265 ERICH MENDELSOHN Einstein Tower, ▶
Neubabelsberg, near Potsdam

260
262

261
263

260 LOUIS H. SULLIVAN Carson
Pirie Scott Store, Chicago

261 FRANK LLOYD WRIGHT Winslow
House, River Forest, Illinois

262 ADOLF LOOS Steiner House,
Vienna (Garden Front)

263 WALTER GROPIUS
and ADOLF MEYER South side of
the model factory built for the
Werkbund Exhibition, Cologne

264 265

enjoy the outside at the same time. Webb's house possibly gives
the same appearance of domestic comfort, but one 'knows'
from looking at Wright's house what the interior is like. With
the Red House one has no idea at all as to the interior planning.

Adolf Loos's *Steiner House* is much nearer to Le Corbusier's
description. Its 'clean' functional façade is close to Sullivan's
store and the Gropius and Meyer factory. Where Wright
decorates his outside walls, Loos eliminates decoration alto-
gether. However, both Wright and Loos gear their design to
their respective regional climates. Northern Europe has quite
different sun and light conditions from Illinois in the United
States. It is important to note that regional styles still may
continue in architecture but they are related more to climate
rather than to character.

Opposed to the 'clean' machine look, is Gaudí's architecture.
That such an eccentric style came into being at all was partly
due to the fact that Gaudí had a patron who believed com-
pletely in him. The conception is based on a combination of
Art Nouveau decorative motifs with organic or natural

Ill. 247

Ill. 262

Ill. 263

Ill. 264

249

growing forms. Gaudí, like Gauguin and Van Gogh, seems to propose a solution to mechanized living through a return to the 'natural' shelter of the cave-dweller. This kind of haphazard architectural design is common in North Africa from Tunisia to Libya. The forms of the windows and cornices of the

Ill. 184 *Casa Batlló* could be described as a very plastic Baroque, and certainly its modelled sculptural appearance is very similar, but it is in fact inspired by Art Nouveau, the short-lived decorative style of the late nineteenth century, which was based on Gothic and Rococo as well as natural forms.

Ill. 265 Mendelsohn's *Einstein Tower* might look like a more precise version of Gaudí's apartments, but in fact its shape and individual forms are largely taken from marine engineering. One may think of a submarine conning tower, and the windows are shaped in the way that steel plate is cut in shipbuilding. Two other characteristics are worth noting. First the idea of architecture as sculpture in the round – not the uniform appearance

Ill. 133 of Bramante's *Tempietto*, but the contrasted forms of Giovanni
Ill. 158 da Bologna. Second (indirectly, since it is not exactly the material used here), the forms of reinforced concrete, introduced in the late nineteenth century, for the first time since the Romans. Not only could it be moulded into any shape or size required, but it was also immensely strong. Steel, glass and concrete are the materials of twentieth-century architecture.

New materials, new techniques and new ideas all became available in the first ten years of the twentieth century – the high-speed petrol engine, the movie camera, the aeroplane . . . psychology. While the artist may be influenced by a number of ideas, philosophic or literary, he is obviously much more open to visual influence, especially that which can be turned into painterly or sculptural terms. Illustrated magazines and newspapers, for instance, presented a range and variety of such visual influences, never known before. While the artist was stimulated by this profusion of new influences, he also had to solve the problem of translating them into a single pictorial or sculptural image. But technology and philosophy by 1900,

even, had produced *new* definitions for *old* facts. Actuality or reality could no longer be defined from one viewpoint nor by a single image. For instance, all the phases of a horse galloping had been photographed by Muybridge (1872) with twenty cameras set in line. A galloping horse, a running dog, a man striding along, a bird rising in flight could not be shown as representing a single or static image, since this was neither *true* nor *real* any longer, for the reason that any form in motion takes a certain *length of time* to pass through all the phases of its action. So Balla, one of the Italian Futurists, paints in all the *Ill. 266* leg actions of his little dog; Boccioni, another member of the group, models all the muscle and head movements of his *Ill. 271* figure in action and thereby creates aerodynamic design almost before it was applied to high-speed machines. Brancusi creates a 'pure' form to describe his *Bird* of highly polished metal, he *Ill. 267* does not take, in fact, such a scientific view of actuality as the two Italians.

267 CONSTANTIN BRANCUSI
Bird in Space

266 GIACOMO BALLA *Leash in Motion*

For the problem of reality did not lie merely in human or animal actions. Scientific research had shown that all matter was in a continual process of change, and Freud's psychological investigations showed that man himself and his imagination were influenced by forces buried in the subconscious mind. The Cubists, led by Picasso and Braque, proposed one kind of solution, which combined both the artistic aims described already and these new scientific and philosophic ideas. While

Ill. 268 *Les Demoiselles d'Avignon* is not strictly a Cubist painting, it opened the door to Cubism. The following *artistic* sources have been detected in this painting: Roman-Spanish sculpture (Iberian), El Greco, Cézanne and African tribal sculpture. This last and newest influence was threefold: first, the method of carving forms in forceful flat angled or projecting planes; second, the fact that the African *assembled* his figures to provide, as the Archaic Greek sculptors had, an approximate image of man; third, the African assembled his image from all the forms that composed it and not just those that were visible from a particular viewpoint. This last aspect agreed with the new European view of reality, that the true appearance of anything was not revealed from one view but from many. One might

Ill. 158 think that Giovanni da Bologna accomplished this very well, but the spectator has to move round the work and the action of the figures remains static. Picasso's intention was to show all aspects *simultaneously* in a state of change from *one point of view* – the spectator's. The woman squatting on the right is assembled to give three views of her in one. Forms like legs, arms and bodies are flattened in sharply angled planes, and drapery is treated similarly.

It will be noticed that the artist indicates no depth of space, much less than even Cézanne, for the Cubists treated the canvas as the background by painting it in a neutral colour, usually brown or grey, from which the flat planes advanced, so that

Ill. 53 the final image 'floated', as the Byzantine mosaic did with its gold background. The word 'image' is significant, for the Cubists were determined to restore the idea of the icon, to

268　PABLO PICASSO *Les Demoiselles d'Avignon* (Museum of Modern Art, New York)

make the painting a venerated object for its own sake. Most Cubist paintings, therefore, have a single central image. Cubism went through two principal stages – Analytic, and Synthetic. In the Analytic a figure or landscape was literally taken apart and reassembled; for instance, one can see in the *Landscape near Céret* by Juan Gris, the flat overlapping planes representing sections of the original view observed by the artist, but now seen from different points of view (today, *Ill. 269*

269 JUAN GRIS
Landscape near Céret

270 FERNAND LÉGER
The Pink Tug

tourist posters present the same kind of 'composite' view of some holiday place). The second stage – Synthetic – was much nearer to the idea of the African sculptor. The image, as in the Léger, was assembled independently by the artist from a stock of forms already broken up into separate planes. The title *The Pink Tug*, does not necessarily indicate the completed *Ill. 270* image but the thing which first stimulated the artist. Léger was much more influenced by machined forms than by African sculpture. The connection with the machine is made directly by Boccioni with his 'machine-man' and indirectly by Bran- *Ill. 271* cusi, with his highly polished metal *Bird* while Cubism evolved *Ill. 267* from Cézanne's balanced conception of nature and art.

The emphasis laid by Gauguin and Van Gogh on the revival of the spiritual values held by early European societies or existing non-European peoples was extended by some twentieth-century artists. For several reasons, many people had lost faith in Christianity, and in this period there were attempts at proposing some universal religion or belief. This was not a new idea since the Platonic Academy in Florence at the end of the fifteenth century was interested in the same idea of combining together all the known religions of the world. However, this twentieth-century idea was much vaguer, since it involved principles both religious, scientific and psychological.

271 UMBERTO BOCCIONI
Unique Forms of
Continuity in Space

Marc, Kandinsky and Mondrian presented individual ideas. Marc, using symbolic colour and expressive form, suggested a rhythmic life-force which ran through living and inanimate natural forms. By selecting animals, here the *Blue Horses*, he places this force in a world which existed *before* the creation of man. That is a more primitive state than either Gauguin or Van Gogh proposed. Marc's code of colour symbols was based on the one introduced by Goethe (end of Chapter Six) in the Romantic period, but it was more complex since different tones of blue, as here, symbolized states and emotions ranging from 'eternal' to 'sadness'. Kandinsky, who was a member of the same German Expressionist group (Der Blaue Reiter – The Blue Rider), used similar ideas but eliminated all reference to natural forms, suggesting instead a world before the Creation, one in which matter was still in a state of change or of flux, as in his *Deluge*, before matter assumed natural forms. Kandinsky attempted to combine painting with music, so that sounds equal colours and harmony, chords and melody equal masses and line. This type of art is now known as Non-Figurative, but used to be called Abstract. Mondrian evolved his idea from Cubism, but unlike Kandinsky, he proposes a universal order

Ill. 272

Ill. 273

Ill. 274

272 FRANZ MARC *Blue Horses*

273 WASSILY KANDINSKY
Deluge

274 PIET MONDRIAN
*Composition in
Blue Grey
and Pink*

or eternal pattern of forces which governs all aspects of human existence. He places greater stress on line symbols (verticals = male forces; horizontals = female), and where these cross or do not, plus or minus forces are indicated. Like the Cubists his rectangular and square flat planes merge into a centralized image, but without a clearly defined 'shape', for while this may be an eternal pattern it is constantly changing its form because of the ceaseless interplay of the force lines that compose it. Despite this move towards the non-figurative image, one may see, in very general terms, Mondrian representing a Neo-classical, stable, restrained conception and Kandinsky a romantic, emotional view.

The prospect of war and the war itself of 1914–18 *almost* destroyed man's remaining confidence in the long established principles of life and art. The artist began to see himself as a revolutionary, that it was essential to *destroy* the old order of art, including techniques and conceptions, so that a new one could take its place. To do this the artist turned politician, and from 1911 to the 1930s the public was bombarded with printed manifestos, with public appearances of artists on the stages of theatres or in cafés and with new art forms. One of the most revolutionary ideas proposed and carried out was that the work of art could have no lasting value, it was a temporary or fleeting 'statement'; like a pencilled reminder, it could be rubbed out or destroyed. There could be no permanent way of representing a world in a continuous state of change. Thus, Marcel Duchamp walked into a store and bought a metal bottle-drying rack and *Ill. 276* exhibited it as a 'Ready made'. As the young child imagines a hobby horse to be a 'real' horse, the artist turns the common object into art by removing it from its normal surroundings. This object has both sculptural and architectural qualities like a miniature Eiffel Tower.

Ill. 277 Schwitters collected bus tickets and other scraps of newsprint, which he stuck down (collage) to form Cubist-like compositions. These two artists represent the Dada (French: hobby horse) Movement, which replaced the idea of the artist as

276 MARCEL DUCHAMP
'Ready-made'
of a *Bottle Rack*

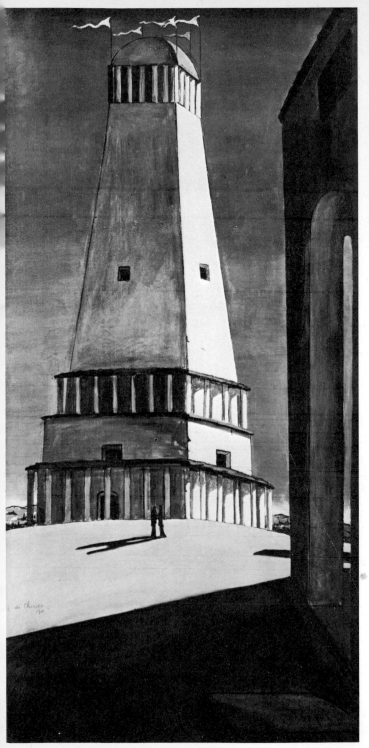

275 GIORGIO DE' CHIRICO
Nostalgia of the Infinite
(Museum of Modern Art,
New York)

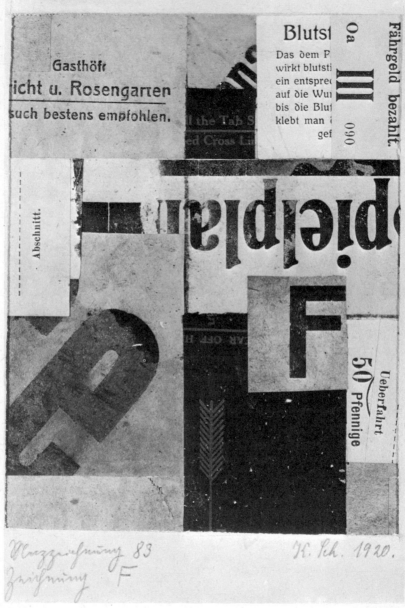

277 KURT SCHWITTERS *Merz 83, Drawing F,* collage of cut paper wrappers, announcements and tickets (Museum of Modern Art, New York)

creator with that of 'finder'. Traditional and special art materials are replaced with anything that comes to hand. The serious idea that lies behind these apparently insulting attitudes to traditional art is metamorphosis – the way things change from one kind of thing into another, like a caterpillar into a butterfly or, in a fairy tale, the ugly toad turns into a handsome prince. What interested the Dada group and the Surrealists, was the half-way stage of change, like Duchamp's *Bottle Rack*, *Ill. 276* which is half useful object, half work of art.

De' Chirico (who, as a member of the Italian Metaphysical group, was a pioneer of Surrealism) and the Surrealists, Ernst and Dali, studied metamorphosis either in the world of dreams and nightmares – as in de' Chirico's Mannerist-like *Ill. 275* lonely place of bright light and long shadows – or in the half dream, half real state which man experiences between sleeping and waking, when the mind works 'automatically', without

278 SALVADOR DALI *The Persistence of Memory* (Museum of Modern Art, New York)

being hindered or directed by fully awakened reason. This kind of half-world represents the human mind in its most *primitive* state for the adult, but it is the almost continuous state

Ill. 278 of mind of the young child. Dali emphasizes the super-real aspects of memory, which stores and recalls sights and experiences, without being affected by time (the bent and rubbery

Ill. 279 watches). The collage by Ernst represents the 'automatic' assembling of Surrealist art, and incidentally, the 'haphazard' way a young child makes a drawing. No consideration is given, *apparently*, to scale, proportion, natural associations or to traditional presentation. For the cut outs of photographs are stuck down on a piece of paper which appears to be partly detached from the canvas on which Loplop, a half silhouette, half outline no-man of memory, is imprinted. Nevertheless, Ernst owes a great deal to Cubism.

It is worth reflecting that these new aspects of the twentieth century, motion, matter in flux or change, the 'flash back' of memory, the dream, reality, the subconscious mind, have been combined together in a new visual form of this century – the film. The motion picture, indeed, represents successfully the twentieth-century idea of metamorphosis – of life and art. But, as one may recognize, the art of the past also, in varying degrees, represents the same idea.

279 MAX ERNST *Loplop introduces Members of the Surrealist Group*, collage of pasted photographs (Museum of Modern Art, New York) ▶

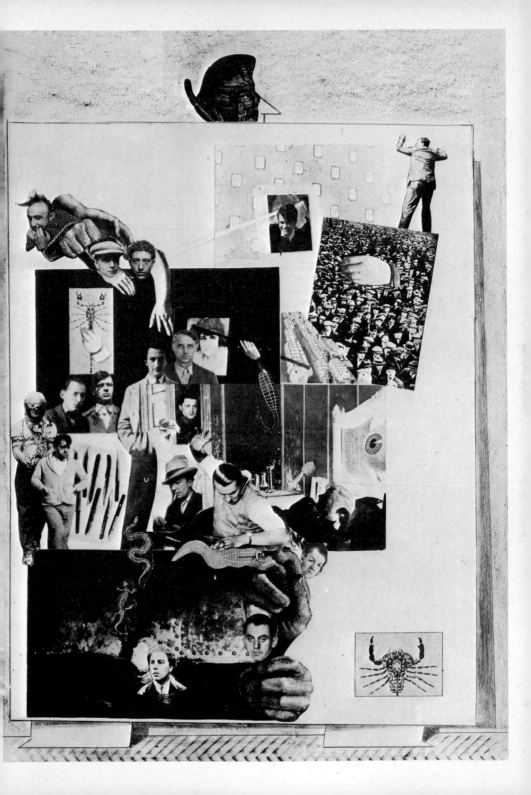

Select Bibliography

General

E. H. Gombrich *The Story of Art*, London (Phaidon) 1959.

H. W. Janson *A History of Art*, London (Thames and Hudson) and New York (Abrams) 1962.

Nikolaus Pevsner *Outline of European Architecture*, London and Baltimore (Penguin) new ed. 1968.

P. and L. Murray *Dictionary of Art and Artists*, London (Thames and Hudson) and New York (Praeger) 1965.

Chapter I: Classical Antiquity

Further Reading

P. P. Kahane *Ancient and Classical Art*, London (Thames and Hudson) and New York (Dell) 1969.

John Boardman *Greek Art*, London (Thames and Hudson) and New York (Praeger) 1964.

Robert L. Scranton *Greek Architecture*, New York (Braziller) 1961 and London (Studio Vista) 1968.

Mortimer Wheeler *Roman Art and Architecture*, London (Thames and Hudson) and New York (Praeger) 1964.

Frank E. Brown *Roman Architecture*, New York (Braziller) 1961 and London (Studio Vista) 1968.

Advanced Reading

R. Lullies *Greek Sculpture*, London (Thames and Hudson) and New York (Abrams) 1960.

D. S. Robertson *Handbook of Greek and Roman Architecture*, Cambridge (University Press) 2nd ed. 1943.

G. M. A. Hanfmann *Roman Art*, London (Cory, Adams and Mackay) 1964.

A. Maiuri *Roman Painting*, Geneva (Skira) 1953.

Chapter II: Early Christian – Byzantine – Romanesque

Further Reading

P. Francastel *The Middle Ages*, London (Thames and Hudson) and New York (Dell) 1969.

D. Talbot Rice *Byzantine Art*, London and Baltimore (Penguin) revised ed. 1968.

William Macdonald *Early Christian and Byzantine Architecture*, New York (Braziller) 1961 and London (Studio Vista) 1968.

John Beckwith *Early Medieval Art*, London (Thames and Hudson) and New York (Praeger) 1964.

Howard Saalman *Medieval Architecture*, New York (Braziller) 1961 and London (Studio Vista) 1968.

Advanced Reading

André Grabar *Byzantium*, London (Thames and Hudson) and New York (Braziller) 1967.

H. Focillon *Art of the West, Vol. I, Romanesque*, London (Phaidon) 1963.

Gustav Kunstler *Romanesque Art in Europe*, London (Thames and Hudson) and New York Graphic) 1969.

Chapter III: Gothic Art: Northern Europe and Italy

Further Reading

P. Francastel *The Middle Ages*, London (Thames and Hudson) and New York (Dell) 1969.

Andrew Martindale *Gothic Art*, London (Thames and Hudson) and New York (Praeger) 1967.

Robert Branner *Gothic Architecture*, New York (Braziller) 1961 and London (Studio Vista) 1968.

Advanced Reading

George Henderson *Gothic*, London and Baltimore (Penguin) 1968.

H. Focillon *Art of the West, Vol. 2, Gothic*, London (Phaidon) 1963.

Paul Frankl *Gothic Architecture*, London and Baltimore (Pelican History of Art) 1962.

Max J. Friedlander *Early Netherlandish Painting, from Van Eyck to Bruegel*, London (Phaidon) 1956.

John White *Art and Architecture in Italy 1250–1400*, London and Baltimore (Pelican History of Art) 1966.

Chapter IV: Renaissance and Mannerism

Further Reading

G. C. Argan *The Renaissance*, London (Thames and Hudson) and New York (Praeger) 1963.

Peter and Linda Murray *Art of the Renaissance*, London (Thames and Hudson) and New York (Praeger) 1963.

Linda Murray *The High Renaissance*, London (Thames and Hudson) and New York (Praeger) 1967.

LINDA MURRAY *The Late Renaissance and Mannerism*, London (Thames and Hudson) and New York (Praeger) 1967.

BATES LOWRY *Renaissance Architecture*, New York (Braziller) 1961 and London (Studio Vista) 1968.

Advanced Reading

MICHAEL LEVEY *Early Renaissance*, London and Baltimore (Penguin) 1968.

JOHN SHEARMAN *Mannerism*, London and Baltimore (Penguin) 1967.

OTTO BENESCH *The Northern Renaissance*, London (Phaidon) 1967.

PETER MURRAY *Architecture of the Italian Renaissance*, London (Thames and Hudson) 1969 and New York (Schocken) 1967.

GERT VON DER OSTEN and HORST VEY *Painting and Sculpture in Germany and the Netherlands 1500–1600*, London and Baltimore (Pelican History of Art) 1969.

Chapter V: Baroque and Rococo

Further Reading

MICHAEL LEVEY *The Seventeenth and Eighteenth Centuries*, London (Thames and Hudson) and New York (Dell) 1969.

GERMAIN BAZIN *Baroque and Rococo*, London (Thames and Hudson) and New York (Praeger) 1964.

MICHAEL LEVEY *Rococo to Revolution*, London (Thames and Hudson) and New York (Praeger) 1966.

HENRY A. MILLON *Baroque and Rococo Architecture*, New York (Braziller) 1961 and London (Studio Vista) 1968.

Advanced Reading

RUDOLF WITTKOWER *Art and Architecture in Italy 1600–1750*, London and Baltimore (Pelican History of Art) 1958.

MARTIN S. SORIA and GEORGE KUBLER *Art and Architecture in Spain and Portugal and their American Dominions 1500–1800*, London and Baltimore (Pelican History of Art) 1959.

ANTHONY BLUNT *Art and Architecture in France 1500–1700*, London and Baltimore (Pelican History of Art) 1953.

H. GERSON and E. H. TER KUILE *Art and Architecture in Belgium 1600–1800*, London and Baltimore (Pelican History of Art) 1960.

J. ROSENBERG, S. SLIVE and E. H. TER KUILE *Dutch Art and Architecture 1600–1800*, London and Baltimore (Pelican History of Art) 1966.

Chapter VI: Neo-Classicism and Romanticism

Further Reading

MICHAEL LEVEY *Rococo to Revolution*, London (Thames and Hudson) and New York (Praeger) 1966.

MARCEL BRION *Art of the Romantic Era*, London (Thames and Hudson) and New York (Praeger) 1966.

HUGH HONOUR *Neo-Classicism*, London and Baltimore (Penguin) 1969.

Advanced Reading

FRITZ NOVOTNY *Painting and Sculpture in Europe 1780–1880*, London and Baltimore (Pelican History of Art) 1960.

GERALDINE PELLES *Art, Artists and Society 1750–1850*, New York (Prentice-Hall) 1963.

WALTER J. FRIEDLANDER *David to Delacroix*, New York (Schocken) 1968.

DAVID PIPER *Painting in England 1500–1870*, London (Penguin) 1960.

KENNETH CLARK *The Gothic Revival*, London and Baltimore (Penguin) new ed. 1967.

Chapter VII: European Art c. 1850–1930

Further Reading

H. L. C. JAFFE *The Nineteenth and Twentieth Centuries*, London (Thames and Hudson) and New York (Dell) 1969.

HERBERT READ *A Concise History of Modern Painting*, London (Thames and Hudson) and New York (Praeger) 1968.

HERBERT READ *A Concise History of Modern Sculpture*, London (Thames and Hudson) and New York (Praeger) 1965.

VINCENT SCULLY JR. *Modern Architecture*, New York (Braziller) 1961 and London (Studio Vista) 1968.

Advanced Reading

GEORGE HEARD HAMILTON *Painting and Sculpture in Europe 1880–1940*, London and Baltimore (Pelican History of Art) 1967.

HENRY-RUSSELL HITCHCOCK *Architecture: Nineteenth and Twentieth Centuries*, London and Baltimore (Pelican History of Art) 1958.

NIKOLAUS PEVSNER *Pioneers of Modern Design*, London and Baltimore (Penguin) new ed. 1968.

List of Illustrations

Measurements are given first in inches, with centimetres in brackets

1 Archaic Greek *kore* from Auxerre (*The Auxerre Goddess*)
 c. 650 B C
 Grey limestone h. 24½ (65)
 Paris, Louvre
 Hirmer Fotoarchiv, Munich

2 Archaic Greek *kouros* (*The Argive Twin*)
 c. 550–500 B C
 Ionian-island marble h. 93 (235)
 Delphi Museum
 Hirmer Fotoarchiv, Munich

3 *Charioteer* from the Apollo Sanctuary, Delphi, Greece
 c. 480–470 B C
 Bronze h. 71 (180)
 Delphi Museum
 Hirmer Fotoarchiv, Munich

4 *Apollo as judge over the battle between Lapiths and Centaurs*, from the west pediment of the Temple of Zeus, Olympia, Greece
 c. 460 B C
 Parian marble h. 129⅞ (330)
 Olympia Museum
 Hirmer Fotoarchiv, Munich

5 *Venus and two handmaidens*, from the front of the *Ludovisi throne*
 c. 460 B C
 Parian marble . Original h. *c.* 42 (107) × 56 (143)
 Rome, Museo delle Terme
 Hirmer Fotoarchiv, Munich

6 *Three goddesses*, from the east pediment of the Parthenon, Athens
 c. 435 B C h. 68⅛ (173)
 Pentelic marble
 London, courtesy of the Trustees of the British Museum

7 Roman copy after POLYCLITUS
 Doryphorus (Spear Bearer)
 Original *c.* 450–440 B C
 Marble h. 83½ (212)
 Naples, Museo Nazionale
 Mansell-Alinari

8 *Centaur and Lapith*, metope relief from the south side of the Parthenon, Athens
 c. 445 B C
 Pentelic marble h. 52¾ (134)
 London, courtesy of the Trustees of the British Museum

9 Athens, Acropolis: Parthenon from the north-west
 447–432 B C
 Hirmer Fotoarchiv, Munich

10 Athens, Acropolis: plan of the Parthenon
 447–432 B C

11 Athens, Acropolis: north-east corner of the Parthenon, showing Doric column capital, architrave, triglyph, metope and cornice
 447–432 B C
 Photograph by the author

12 Athens, Acropolis: east and west elevations of the Erechtheion
 421–409 B C
 After Stevens and Paton: *The Erechtheum* 1927

13 Athens, Acropolis: south side of the Erechtheion showing Caryatid porch on the right
 421–409 B C
 Hirmer Fotoarchiv, Munich

14 Greek tomb monument, the *Stele of Hegeso*
 c. 400 B C
 Pentelic marble 59 × 38 (149 × 95)
 Athens, National Archaeological Museum
 Hirmer Fotoarchiv, Munich

15 Roman copy after PRAXITELES
 Cnidian Venus
 Original *c.* 340–330 B C
 Marble h. 82⅝ (210)
 Rome, Vatican Museums

16 PRAXITELES active 375–*c.* 330 B C
 Hermes with the Infant Dionysus
 c. 320 B C
 Parian marble h. 84 (215)
 Olympia Museum
 Hirmer Fotoarchiv, Munich

268

17 Scopas active mid fourth century BC
Battle between Greeks and Amazons from the
Tomb of Mausolus
c. 359–333 BC
Marble h. 35 (89)
London, courtesy of the Trustees of the
British Museum

18 Statues of Mausolus and his consort Arte-
mesia from the Tomb of Mausolus
c. 350 BC
Marble h. 118⅛ (300)
London, courtesy of the Trustees of the
British Museum

19 Hellenistic relief, *The Apotheosis of Homer*
c. 210 BC
Marble h. 45 (115)
London, courtesy of the Trustees of the
British Museum

20 *Death of Laocoön and his Sons*
c. 50 BC
Marble h. 96 (242)
Rome, Vatican Museums
Hirmer Fotoarchiv, Munich

21 Athens: Tower of the Winds
c. 50 BC
Pamela Jacobson

22 Pergamon, Sanctuary of Athena: the *Pro-
pylon*
c. 200 BC
Berlin, Staatliche Museen

23 Roman funerary portraits, so-called *Cato
and Portia*
c. 50 BC
Marble
Rome, Vatican Museums
Anderson

24 Statue of *Augustus* (27 BC–AD 14)
c. 25 BC
Marble
Rome, Vatican Museums

25 Head of *Octavia*, sister of Augustus
c. 25–10 BC
Green basalt
Paris, Louvre
Mansell-Alinari

26 Tellus relief from the *Ara Pacis* (Altar of
Peace)
13–9 BC
Marble
Rome, Campus Martius
Mansell-Alinari

27 Nîmes, France: Maison Carrée of Agrippa
16 BC
Giraudon

28 Rome: Arch of Titus
c. AD 80
Georgina Masson

29 Relief detail from inside the Arch of Titus,
Rome, showing the *Spoils of Jerusalem*
c. AD 80
Marble and travertine
Mansell Collection

30 Rome: the Colosseum
75–82
Fotocelere, Turin

31 *Aldobrandini Wedding*, fresco from a man-
sion in Rome
First century AD
Rome, Vatican Museums
Mansell-Alinari

32 Romantic landscape with pastoral scene,
wall-painting from Pompeii, Italy
Before AD 79
Naples, Museo Nazionale
André Held

33 *Soldiers*, from Trajan's Column, Rome
AD 114
Marble
German Archaeological Institute, Rome

34 Rome: plan of the Pantheon
AD 125

35 Rome: portico of the Pantheon
AD 125
Fototeca Unione

36 Nîmes, France: Temple of Diana
c. AD 140
Giraudon

37 Equestrian statue of *Marcus Aurelius*
c. 176–193
Bronze
Rome, Piazza del Campidoglio
Mansell-Brogi

38 Bust of *Caracalla*
c. 211–217
Marble
Naples, Museo Nazionale
Mansell-Anderson

39 Baalbek, Lebanon: Temple of Venus
c. AD 245
Bildarchiv Foto Marburg

40 Rome: Arch of Constantine
AD 315
Georgina Masson

41 Head, possibly of *Constantine the Great* (AD 306–337)
c. 324–327
Bronze h. 69 (177)
Rome, Palazzo dei Conservatori
Mansell–Alinari

42 Sarcophagus from Sidamara
c. 260–300
Istanbul, Archaeological Museum
German Archaeological Institute, Istanbul

43 Istanbul: church of Hagia Sophia from the south-west
532–537
Hirmer Fotoarchiv, Munich

44 Sketch of typical Early Christian basilica, showing clerestory, aisles and eastern apse

45 Ravenna, Italy: plan of S. Apollinare Nuovo
493–525
From G. Dehio and G. von Bezold: *Die Kirchliche Baukunst des Abendlandes*, 1892 and 1901

46 Rome: plan of S. Paolo fuori le Mura
c. 380
From G. Dehio and G. von Bezold: *Die Kirchliche Baukunst des Abendlandes*, 1892 and 1901

47 Istanbul: interior of Hagia Sophia, view from the middle of the north-west gallery
532–537
Hirmer Fotoarchiv, Munich

48 Ravenna, Italy: plan of S. Vitale
526–547

49 Rome: Sta Sabina, interior looking east
c. 425
Scala

50 Istanbul: interior of Hagia Sophia, capitals and columns from the south corner of the south-west gallery
532–537
Hirmer Fotoarchiv, Munich

51 Byzantine ivory panel showing the Emperor Anastasius (*The Barberini Ivory*)
c. 500
Ivory $13\frac{1}{2} \times 10\frac{3}{8}$ (39 × 27)
Paris, Louvre
Hirmer Fotoarchiv, Munich

52 *Christ among the Apostles*, mosaic in the apse of Sta Pudenziana, Rome
c. 412–417
Mansell–Alinari

53 *Emperor Justinian and his Retinue*, detail of mosaic in the chancel of S. Vitale, Ravenna, Italy
526–547
Hirmer Fotoarchiv, Munich

54 *Crucifixion*, mosaic in the monastery church of Daphni, Greece
c. 1100
Josephine Powell

55 *Christ Pantocrator, the Virgin, angels and saints*, mosaic in the apse of Monreale cathedral, Sicily
1174–82
Mansell–Anderson

56 Portative Byzantine mosaic of *Christ* as the 'Light of the World'
c. 1150
Mosaic $21\frac{1}{4} \times 16\frac{1}{8}$ (53 × 41)
Florence, Museo Nazionale
Byzantine Exhibition, Edinburgh

57 Initial XPI (Monogram page) from the *Book of Kells* (folio 34 recto)
c. 800
Dublin, Trinity College. By permission of the Board of Trinity College

58 St Denis (near Paris), France: plan of the Carolingian church
Consecrated 775

59 Germigny-des-Prés, France: interior of Theodulf's Oratory
Consecrated 806
Archives Photographiques

60 Gernrode, Germany: exterior of St Cyriakus
Founded 961
Bildarchiv Foto Marburg

61 Cluny, France: plan of the third abbey church
1088–1130

62 Florence, Italy: façade of S. Miniato al Monte
c. 1013
Mansell-Alinari

63 Durham, England: interior of the cathedral, looking west
c. 1120
Martin Hürlimann

64 MASTER OF THE REGISTRUM GREGORII
Annunciation, miniature from the *Egbert Codex* (folio 9 recto)
c. 983
Trier, Stadtbibliothek
Bildarchiv Foto Marburg

65 *Christ on the Cross* (the *Werden Crucifix*)
c. 1070
Bronze
Werden, abbey church
Bildarchiv Foto Marburg

66 *Pentecost and the peoples of the world*, tympanum of the inner west doorway of Ste Madeleine, Vézelay, France (from a cast)
c. 1120–40
Giraudon

67 Toulouse, France: exterior of St Sernin from the east
1096
Giraudon

68 Arles, France: west porch of St-Trophîme
c. 1152
Giraudon

69 *Jeremiah*, stone trumeau figure from the abbey church of St Pierre, Moissac, France
c. 1115
Archives Photographiques

70 Reliquary of Ste Foy, Conques, France
Basically late ninth century, additions tenth, fourteenth and sixteenth centuries
Gold plate over wooden core, covered with precious stones
Trésor de l'église de Conques
Giraudon

71 MASTER OF THE LEAPING FIGURES
The Calling of Jeremiah, illuminated initial from the *Winchester Bible*
1140–60
Winchester Cathedral Bible, Jeremiah I, 4–10
Courtesy Dean and Chapter Winchester Cathedral

72 Chartres, France: central portal of the west front of the cathedral
c. 1145–55
Giraudon

73 Reims, France: interior of the nave looking east
Begun 1210
Bundesdenkmalamt, Vienna

74 Reims, France: plan of the cathedral
Begun 1210

75 Reims, France: cross-section of the nave and aisles
Begun 1210
From G. Dehio and G. von Bezold: *Die kirchliche Baukunst des Abendlandes*, 1892 and 1901

76 Bourges, France: view of the cathedral from the south-east
Begun c. 1195
Martin Hürlimann

77 Chartres, France: nave elevation of the cathedral
1194–1220

78 Amiens, France: nave elevation of the cathedral
1220–36
Courtesy Messrs B. T. Batsford Ltd

79 Chartres, France: interior of the cathedral looking north-west across the nave
1194–1220
Jean Roubier

80 Amiens, France: interior of the cathedral looking east
1220–36
Martin Hürlimann

81 Amiens, France: west front of the cathedral
Begun c. 1220
Giraudon

82 *Death and Coronation of the Virgin*, tympanum of the Virgin Portal on the west front at Notre-Dame, Paris
1210–20
Martin Hürlimann

83 *Death of the Virgin*, tympanum of the south transept of Strasbourg cathedral, France
1220–30
Bildarchiv Foto Marburg

271

84 *Annunciation* (left) and *Visitation* (right) from the centre portal on the west front of Reims cathedral, France
c. 1240
Martin Hürlimann

85 *Eckhardt and Uta*, figures in the west choir of Naumburg cathedral, Germany
c. 1249
Helga Schmidt-Glassner

86 *Vierge Dorée* (Golden Virgin), trumeau figure on the south porch of Amiens cathedral
c. 1288
Bulloz

87 Paris: Sainte-Chapelle from the south-west
1243–48
A. F. Kersting

88 Rouen, France: plan of St Ouen
Begun 1318
After André Masson

89 Rouen, France: interior of St Ouen looking east
Begun 1318
Giraudon

90 Marienburg, Poland: the great refectory in the Castle
1351–82

91 York, England: interior of the Minster looking east
Founded 1291
A. F. Kersting

92 Wells, England: strainer arches in the crossing of the cathedral
1338
Martin Hürlimann

93 HANS LEINBERGER 1470?–after 1530
Virgin and Child
c. 1520
Wood
Landshut, St Martin
Bildarchiv Foto Marburg

94 LIMBOURG BROTHERS
The Month of May, calendar illumination from *Les Très Riches Heures* of the Duc de Berri
1411–16
Chantilly, Musée Condé
Giraudon

95 JAN and HUBERT VAN EYCK (Jan) active 1422–d. 1441 (Hubert) d. 1426
The Ghent Altarpiece. Upper row: Adam, Singing Angels, The Virgin, God the Father (or Christ as Judge), St John the Baptist, Musician Angels, Eve. Lower row: The Just Judges, The Knights of Christ, The Adoration of the Lamb, The Holy Hermits, The Holy Pilgrims
1432
Oil on panel $137\frac{3}{4} \times 181\frac{1}{2}$ (350 × 461)
Ghent, cathedral of St Bavon
A C L

96 *A Dying Man Commends his Soul to God*, miniature in the *Rohan Book of Hours* (folio 159 recto)
1418–25
Paris, Bibliothèque Nationale (MS lat 9471)

97 JAN VAN EYCK active 1422–d. 1441
Rolin Madonna
1433–34
Oil on panel $26 \times 24\frac{1}{2}$ (66 × 62)
Paris, Louvre

98 ROGIER VAN DER WEYDEN *c.* 1400–64
Deposition
1436–37
Oil on panel $65\frac{5}{8} \times 103\frac{1}{8}$ (167 × 262)
Madrid, Prado
Mas

99 HUGO VAN DER GOES *c.* 1440–82
The Nativity, central panel of the *Portinari Altarpiece*
1476
Oil on panel $99\frac{3}{8} \times 119\frac{5}{8}$ (253 × 304)
Florence, Uffizi
Mansell-Alinari

100 ROGIER VAN DER WEYDEN *c.* 1400–64
Portrait of *Francesco d'Este*
c. 1455
Tempera and oil on panel $11\frac{3}{4} \times 8$ (30 × 20)
New York, Metropolitan Museum, Michael Friedsam Collection 1931

101 GIOVANNI PISANO *c.* 1245/50–after 1314
Pulpit
1298–1310
Pistoia, S. Andrea
Mansell-Brogi

102 Florence, Italy: interior of Sta Croce looking east
1294–1330
Mansell-Alinari

103 GIOTTO 1266/7–1337
Noli me tangere
1304–06
Fresco
Padua, Arena Chapel
Mansell-Alinari

104 GIOTTO 1266/7–1337
Feast of Herod
1317–20
Fresco
Florence, Sta Croce, Peruzzi Chapel
Mansell-Alinari

105 SIMONE MARTINI *c.* 1284–1344
Annunciation
1333
Tempera on panel $104\frac{3}{8} \times 120\frac{1}{8}$ (265×305)
Florence, Uffizi
Mansell-Alinari

106 PIETRO LORENZETTI *c.* 1280–1348?
Deposition
c. 1342
Fresco
Assisi, Lower Church of S. Francesco
Mansell-Alinari

107 FILIPPO BRUNELLESCHI 1377–1446
Florence, Italy: interior of S. Lorenzo looking east
1415–25
Alinari

108 FILIPPO BRUNELLESCHI 1377–1446
Florence, Italy: plan of Sto Spirito
1436–44

109 Florence, Italy: view of the Baptistery, Campanile and Cathedral, with dome by BRUNELLESCHI
1419–62
Mansell Collection

110 LORENZO GHIBERTI *c.* 1378–1455
Story of Isaac
1425–52
Bronze gilt panel
Florence Baptistery, east doors
Mansell-Alinari

111 Diagram to show the perspective construction of the *Tribute Money* by MASACCIO

112 MASACCIO 1401–28
The Tribute Money
1425–28
Fresco
Florence, Sta Maria del Carmine, Brancacci chapel
Alinari

113 ANTONIO PISANELLO probably 1395–1455/6
Vision of St Eustace
c. 1440
Oil on panel $21\frac{1}{2} \times 25\frac{3}{4}$ (545×655)
London, courtesy of the Trustees of the National Gallery

114 STEFANO DI GIOVANNI SASSETTA *c.* 1400, perhaps 1392–1450
Betrothal of St Francis to Poverty
1437–44
Panel 38×23 (97×89)
Chantilly, Musée Condé
Bulloz

115 LEON BATTISTA ALBERTI 1404–72
Florence, Italy: façade of Sta Maria Novella
1446–51
Mansell-Anderson

116 LEON BATTISTA ALBERTI 1404–72
Florence, Italy: Palazzo Rucellai
1446–51
Mansell-Anderson

117 DONATELLO *c.* 1386–1466
David
Bronze h. $62\frac{1}{4}$ (158)
Florence, Museo Nazionale
Brogi

118 DONATELLO *c.* 1386–1466
Miracle of St Anthony
1445–48
Bronze relief
Padua, High Altar of the Santo
Mansell-Anderson

119 DOMENICO DI BARTOLOMMEO VENEZIANO active 1438–d. 1461
St Lucy Altarpiece. The Virgin and Child with SS. Francis, John the Baptist, Zenobius and Lucy, altarpiece from the church of Sta Lucia dei Magnoli, Florence
1438
Panel $78 \times 83\frac{7}{8}$ (200×213)
Florence, Uffizi
Mansell-Alinari

120 PAOLO UCCELLO 1396/7–1475
A Hunt in a Forest
1467–68
Panel $28\frac{3}{4} \times 69\frac{5}{8}$ (73×177)
Oxford, Ashmolean Museum

121 PIERO DELLA FRANCESCA 1410/20–92
The Flagellation
c. 1456–60
Panel $23\frac{1}{4} \times 32$ (59×81)
Urbino, Galleria Nazionale delle Marche
Mansell-Anderson

122 ANTONIO and PIERO POLLAIUOLO
(Antonio) *c.* 1432–98 (Piero) *c.* 1441–96
Martyrdom of St Sebastian
1475
Oil on panel 114¾ × 79¾ (291 × 202)
London, courtesy of the Trustees of the
National Gallery

123 PIETRO PERUGINO *c.* 1445/50–1523
Christ giving the Keys to St Peter
c. 1482
Fresco
Vatican, Sistine Chapel
Mansell-Alinari

124 GIULIANO DA SANGALLO 1445–1516
Prato, Italy: view of Sta Maria delle
Carcere
c. 1485

125 LEON BATTISTA ALBERTI 1404–72
Mantua, Italy: plan of S. Sebastiano
1460

126 ANDREA DEL VERROCCHIO *c.* 1435–88
Equestrian monument to *Bartolommeo Col-
leone*
c. 1488
Venice, Piazza SS. Giovanni e Paolo
Mansell-Anderson

127 ANDREA MANTEGNA *c.* 1431–1506
Virtue expelling the Vices
1496–1506
Oil on canvas 63 × 75⅝ (160 × 192)
Paris, Louvre

128 LUCA SIGNORELLI *c.* 1441–1523
Pan and other Gods
1478
Oil on panel 76⅜ × 101⅛ (194 × 257)
Formerly Berlin, Kaiser Friedrich Museum
Destroyed World War II
Walter Steinkopf

129 SANDRO BOTTICELLI *c.* 1445–1510
Birth of Venus
1485–87
Oil on canvas 68⅞ × 109½ (175 × 278)
Florence, Uffizi

130 LEONARDO DA VINCI 1452–1519
The Last Supper
c. 1497
Tempera 105⅜ × 358¼ (267 × 910)
Milan, Refectory of the Convent of Sta
Maria delle Grazie
Mansell-Anderson

131 MICHELANGELO BUONAROTTI 1475–1564
David
1503–04
Marble h. 198⅞ (505)
Florence, Accademia
Alinari

132 MICHELANGELO BUONAROTTI 1475–1564
Rome: projected plan for St Peter's
1546

133 DONATO BRAMANTE 1444–1514
Rome: Tempietto, S. Pietro in Montorio
1502
Linda Murray

134 MICHELANGELO BUONAROTTI 1475–1564
Creation of Man
1508–12
Fresco
Vatican, Sistine Chapel ceiling
Archivio Fotografico

135 RAPHAEL 1483–1520
The School of Athens
1510–11
Fresco
Vatican, Stanza della Segnatura
Mansell-Alinari

136 MARCANTONIO RAIMONDI *c.* 1480–1527/34
Massacre of the Innocents, after RAPHAEL
1510–11
Engraving 16½ × 11 (41 × 28)
London, courtesy of the Trustees of the
British Museum

137 TITIAN (Tiziano Vecelli) *c.* 1487/90–1576
Bacchus and Ariadne
1518–25
Oil on canvas 69 × 75 (175 × 190)
London, courtesy of the Trustees of the
National Gallery

138 GIORGIONE *c.* 1476/8–1510
Concert Champêtre
c. 1508
Oil on canvas 43½ × 54¼ (110 × 138)
Paris, Louvre

139 TITIAN (Tiziano Vecelli) *c.* 1487/90–1576
The Concert
c. 1515
Oil on canvas 42⅞ × 48⅜ (108 × 122)
Florence, Pitti Palace
Mansell-Anderson

274

140 ANTONIO DA SANGALLO THE YOUNGER 1485–1546 and MICHELANGELO BUONAROTTI 1475–1564
Rome: Palazzo Farnese
Begun 1534
Mansell–Anderson

141 HIERONYMUS BOSCH *c.* 1450–1516
Crowning with Thorns
c. 1500
Oil on wood 29 × 23¼ (73 × 59)
London, courtesy of the Trustees of the National Gallery

142 ALBRECHT DÜRER 1471–1528
The Great Fortune (Nemesis)
c. 1501–02
Copper engraving 13 × 9¼ (33 × 23)
London, courtesy of the Trustees of the British Museum

143 ALBRECHT DÜRER 1471–1528
Noli me tangere
1509–11
Woodcut 5 × 3¾ (13 × 10)
Nuremberg, Germanisches Nationalmuseum

144 ALBRECHT ALTDORFER *c.* 1480–1538
St George and the Dragon in a Wood
1510
Oil on panel 11 × 8¾ (28 × 22)
Munich, Bayerische Staatsgemäldesammlungen

145 MATTHIAS GRÜNEWALD *c.* 1470/80–1528
Crucifixion, closed outer movable wings of the *Isenheim Altarpiece*
1513–15
Panel 105⅞ × 120⅞ (269 × 307)
Colmar, Unterlinden Museum

146 HANS HOLBEIN THE YOUNGER 1497/8–1543
Portrait of *Georg Gisze*
1532
Tempera on oak, 37¾ × 33⅛ (96 × 86)
Berlin, Staatliche Museen, Gemäldegalerie Dahlem

147 LUCAS CRANACH 1472–1553
Henry the Pious, Duke of Saxony
1514
Oil on panel, transferred to canvas 72½ × 32½ (184 × 82)
Dresden, Gemäldegalerie
Deutsche Fotothek, Dresden

148 BERNARD STRIGEL *c.* 1460/61–1528
David returning with the Head of Goliath
c. 1500–06
Oil on panel 30¼ × 17¾ (77 × 45)
Munich, Bayerische Staatsgemäldesammlungen

149 PIETER BRUEGHEL THE ELDER 1525/30–69
Flemish Proverbs
1559
Oil on panel 46 × 64¼ (117 × 163)
Berlin, Staatliche Museen, Gemäldegalerie Dahlem

150 PIETER BRUEGHEL THE ELDER 1529/30–69
Landscape with Gallows
Signed and dated 1568
Oil on panel 18 × 20 (46 × 51)
Darmstadt, Hessiches Landesmuseum

151 JACOPO PONTORMO 1494–1556
The Visitation
1516
Fresco
Florence, Cloister of SS. Annunziata
Mansell–Alinari

152 MICHELANGELO BUONAROTTI 1475–1564
Florence, Italy: anteroom of the Laurentian Library
1526
Mansell–Alinari

153 FRANCESCO PARMIGIANINO 1503–40
Madonna with the Long Neck
1535
Oil on panel 85 × 52 (216 × 132)
Florence, Uffizi

154 BENVENUTO CELLINI 1500–71
Apollo and Hyacinth
1546
Marble h. 75¼ (191)
Florence, Museo Nazionale
Mansell–Alinari

155 ANDREA PALLADIO 1508–80
Vicenza, Italy: Palazzo Chiericati
1550–54
Mansell–Alinari

156 JACOPO ROBUSTI called TINTORETTO 1518–94
The Finding of the Body of St Mark
1562
Oil on canvas 166 × 124½ (422 × 316)
Venice, Accademia
Mansell–Alinari

275

157 GIORGIO VASARI 1511–74
Florence, Italy: exterior of the Uffizi
1559–74
Mansell–Alinari

158 GIOVANNI DA BOLOGNA 1529–1608
The Rape of the Sabines
1579–83
Marble h. 161$\frac{3}{5}$ (410)
Florence, Loggia dei Lanzi
Mansell–Alinari

159 PAOLO VERONESE 1528–88
Christ disputing with the Doctors
1560–70
Oil on canvas 92$\frac{7}{8}$ × 169$\frac{1}{4}$ (236 × 430)
Madrid, Prado
Mansell–Anderson

160 GIACOMO BAROZZI DA VIGNOLA 1507–73
and GIACOMO DELLA PORTA c. 1537–1602
Rome: façade of the Gesù
1573–84
Mansell–Anderson

161 MICHELANGELO BUONAROTTI 1475–1564
and GIACOMO DELLA PORTA c. 1537–1602
Rome: dome of St Peter's
1546–93
Mansell–Anderson

162 CARLO MADERNO 1556–1629
Rome: façade of Sta Susanna
1598–1603
Mansell–Anderson

163 ANNIBALE CARRACCI 1560–1609
Triumph of Bacchus and Ariadne
1597–1604
Fresco
Rome, Palazzo Farnese gallery ceiling
Mansell–Alinari

164 MICHELANGELO MERISI DA CARAVAGGIO
1573–1610
The Martyrdom of St Matthew
1597–1601
Oil on canvas 129 × 137 (328 × 348)
Rome, S. Luigi de' Francesi
Anderson

165 GUIDO RENI 1575–1642
Aurora
1613
Fresco
Rome, Casino Rospigliosi-Pallavicini ceiling
Mansell–Alinari

166 DOMENICHINO 1581–1641
Last Communion of St Jerome
1614
Oil on canvas 165 × 100$\frac{3}{4}$ (419 × 256)
Rome, Vatican Museums

167 GIANLORENZO BERNINI 1598–1680
David
1623
Marble
Rome, Villa Borghese
Mansell–Anderson

168 DANIELE CRESPI c. 1598–1630
The Meal of S. Carlo Borromeo
c. 1628
Oil on canvas
Milan, Sta Maria della Passione
Alinari

169 GIANLORENZO BERNINI 1598–1680
Bust of *Cardinal Scipione Borghese*
1632
Marble
Rome, Villa Borghese
Mansell–Alinari

170 ANDREA SACCHI 1599–1661
Vision of St Romuald
c. 1631–32
Oil on canvas 36 × 30 (92 × 77)
Rome, Vatican Museums
Mansell–Anderson

171 NICHOLAS POUSSIN 1594–1665
Et in Arcadia Ego
1638–39
Oil on canvas 33$\frac{1}{2}$ × 47$\frac{5}{8}$ (85 × 121)
Paris, Louvre
Giraudon

172 PIETRO BERETTINI DA CORTONA 1596–1669
Glorification of Urban VIII's Reign
1633–39
Fresco
Rome, Palazzo Barberini ceiling
Mansell–Anderson

173 SALVATOR ROSA 1615–73
Grotto with Waterfall
c. 1640
Oil on canvas 25$\frac{5}{8}$ × 19$\frac{1}{4}$ (65 × 49)
Florence Pitti
Mansell–Alinari

174 G.F. BARBIERI called IL GUERCINO 1591–1666
Vision of St Bruno
c. 1647
Oil on canvas 152$\frac{3}{4}$ × 92$\frac{1}{2}$ (388 × 235)
Bologna, Pinacoteca
Mansell–Alinari

175 FRANCESCO BORROMINI 1599–1667
Rome: interior of the dome of S. Ivo della
Sapienza
1642–50
Bildarchiv Foto Marburg

176 GIANLORENZO BERNINI 1598–1680
Rome: plan of S. Andrea al Quirinale
1658–70

177 FRANCESCO BORROMINI 1599–1667
Rome: plan of S. Carlo alle Quattro
Fontane
1638

178 GIANLORENZO BERNINI 1598–1680
The Ecstasy of St Teresa
1645–52
Coloured marble and gilt metal
Rome, Sta Maria della Vittoria
Anderson

179 GIANLORENZO BERNINI 1598–1680
Fountain of the Four Rivers
1648–51
Rome, Piazza Navona
Boudot-Lamotte

180 NICHOLAS POUSSIN 1594–1665
Orpheus and Eurydice
c. 1650
Oil on canvas $48\frac{7}{8} \times 78\frac{3}{4}$ (120 × 200)
Paris, Louvre
Giraudon

181 CLAUDE LORRAINE 1600–82
Aeneas Arriving at Delos
1671–72
Oil on canvas $39\frac{1}{4} \times 52\frac{3}{4}$ (100 × 134)
London, courtesy of the Trustees of the
National Gallery

182 Rome: aerial view of St Peter's showing
the colonnaded piazza by BERNINI
1656–57
Mansell-Alinari

183 CARLO RAINALDI 1611–91 and FRANCESCO
BORROMINI 1599–1667
Rome: Sta Agnese in Piazza Navona
1653–55
Mansell-Anderson

184 FRANCESCO BORROMINI 1599–1667
Rome: façade of S. Carlo alle Quattro
Fontane
1665–67
Anderson

185 EL GRECO (Domenikos Theotocopoulos)
1541–1614
Burial of Count Orgaz
1586
Oil on canvas $191\frac{7}{8} \times 141\frac{3}{4}$ (487 × 360)
Toledo, S. Tomé
Mas

186 FRANCISCO DE ZURBARÁN 1598–1664
Adoration of the Shepherds
1638
Oil on canvas $102\frac{3}{4} \times 68\frac{7}{8}$ (261 × 175)
Grenoble, Musée des Beaux-Arts

187 JUSEPE RIBERA 1591–1652
Boy with a Club Foot
c. 1642
Oil on canvas $64\frac{5}{8} \times 36\frac{1}{4}$ (134 × 92)
Paris, Louvre
Giraudon

188 EL GRECO (Domenikos Theotocopoulos)
1541–1614
Cardinal Don Fernando Niño de Guevara (The
Grand Inquisitor)
1600
Oil on canvas $67\frac{1}{4} \times 42\frac{1}{2}$ (171 × 108)
New York, Metropolitan Museum
Bequest of Mrs H.O. Havemeyer, 1929.
The H.O. Havemeyer Collection

189 FRANCISCO DE ZURBARÁN 1598–1664
St Bonaventura and St Thomas Aquinas
1629
Oil on canvas 89 × $100\frac{3}{4}$ (226 × 256)
Berlin, Staatliche Museen, Gemäldegalerie
Dahlem
Walter Steinkopf

190 DIEGO RODRIGUEZ DE SILVA VELAZQUEZ
1599–1660
Las Meniñas (Maids of Honour)
1656–57
Oil on canvas $125\frac{1}{2} \times 108\frac{7}{8}$ (320 × 277)
Madrid, Prado
Mas

191 DIEGO RODRIGUEZ DE SILVA VELAZQUEZ
1599–1660
The Fable of Arachne
1644–48
Oil on canvas $84\frac{5}{8} \times 113\frac{3}{4}$ (220 × 280)
Madrid, Prado
Mas

192 BARTOLOME ESTEBAN MURILLO 1617–82
The Marriage Feast of Cana
c. 1667–70
Oil on canvas $70\frac{1}{2} \times 92\frac{1}{2}$ (179 × 235)
The Barber Institute of Fine Arts, University of Birmingham

277

193 BARTOLOME ESTEBAN MURILLO 1617–82
Christ at the Pool of Bethesda
c. 1670–74
Oil on canvas 93¼ × 102¾ (237 × 261)
London, courtesy of the Trustees of the
National Gallery

194 SIR PETER PAUL RUBENS 1577–1640
The Deposition, central section (inside) of a
triptych
1611–14
Oil on canvas 165¾ × 122½ (421 × 311)
Antwerp Cathedral
A C L

195 REMBRANDT VAN RIJN 1606–69
Entombment
Completed 1639
Oil on canvas 37 × 27½ (92 × 69)
Munich, Bayerische Staatsgemäldesamm-
lungen

196 SIR PETER PAUL RUBENS 1577–1640
The Artist and his first wife, Isabella Brandt
(in the Honeysuckle Bower)
1612
Oil on canvas, stretched on oak 71⅝ × 54¾
(178 × 136)
Munich, Bayerische Staatsgemäldesamm-
lungen

197 REMBRANDT VAN RIJN 1606–69
The Artist and his first wife, Saskia
1637
Oil on canvas 63⅜ × 51⅝ (161 × 131)
Dresden, Staatliche Kunstsammlungen

198 FRANS HALS 1580/5–1666
Meeting of the Officers of the Cluveniers-doelen
1633
Oil on canvas 89½ × 132⅝ (227 × 337)
Haarlem, Frans Halsmuseum
A. Dingjan

199 FRANS HALS 1580/5–1666
'Malle Babbe' (The Witch of Haarlem)
c. 1630–33
Oil on canvas 29½ × 25¼ (75 × 64)
Berlin, Staatliche Museen, Gemäldegalerie
Dahlem
Walter Steinkopf

200 SIR PETER PAUL RUBENS 1577–1640
Rape of the Daughters of Leucippus
1619
Oil on canvas 88¾ × 83⅝ (222 × 209)
Munich, Bayerische Staatsgemäldesamm-
lungen

201 REMBRANDT VAN RIJN 1606–69
Self-portrait
c. 1663
Oil on canvas 45 × 37 (114 × 94)
The Greater London Council as Trustee of
the Iveagh Bequest, Kenwood

202 SIR PETER PAUL RUBENS 1577–1640
Château de Steen
1635–37
Oil on panel 54 × 92½ (134 × 236)
London, courtesy of the Trustees of the
National Gallery

203 GIOVANNI BATTISTA TIEPOLO 1696–1770
Two Magicians and a Boy from *Scherzi di
Fantasia* (no. 22)
1755–65
Engraving 5½ × 7⅛ (14 × 19)
London, courtesy of the Trustees of the
British Museum

204 GABRIEL GERMAIN BOFFRAND 1667–1754
Paris: Salon de la Princesse in the Hôtel de
Soubise
1738–40
John Webb

205 FRANÇOIS BOUCHER 1703–70
Madame de Pompadour
1758
Oil on canvas 13¾ × 17¼ (35 × 44)
Edinburgh, National Gallery of Scotland
Annan, Glasgow

206 THOMAS GAINSBOROUGH 1727–88
Mr and Mrs Robert Andrews
c. 1750
Oil on canvas 27½ × 47 (69 × 120)
London, courtesy of the Trustees of the
National Gallery

207 THOMAS GAINSBOROUGH 1727–88
Peasants going to Market
c. 1770
Oil on canvas 46⅞ × 57¼ (119 × 146)
The Greater London Council as Trustee of
the Iveagh Bequest, Kenwood

208 JEAN-ANTOINE WATTEAU 1684–1721
Embarkation from Cythera
1716–17
Oil on canvas 45 × 37 (114 × 94)
Paris, Louvre

209 JEAN-ANTOINE WATTEAU 1684–1721
L'enseigne de Gersaint (Signboard for the
Art-Dealer Gersaint)
1721
Oil on panel 54½ × 121¼ (138 × 308)
Berlin, Verwaltung der Staatlichen Schlös-
ser und Gärten

210 WILLIAM HOGARTH 1697–1764
Marriage à la Mode: The Contract
1743–45
Oil on canvas $27\frac{1}{2} \times 35\frac{3}{4}$ (70 × 91)
London, courtesy of the Trustees of the
National Gallery

211 JOHANN BALTHASAR NEUMANN 1687–1753
Interior of the Pilgrimage church of Vier-
zehnheiligen, Germany
1743–72
A. F. Kersting

212 JOHANN BALTHASAR NEUMANN 1687–1753
Plan of the Pilgrimage church of Vier-
zehnheiligen, Germany
1743–72

213 JACQUES-ANGE GABRIEL 1698–1782
Versailles, France: Le Petit Trianon
1762
Bildarchiv Foto Marburg

214 GIOVANNI BATTISTA PIRANESI 1720–78
Caprice from *Opere Varie*
1744–45
Etching $15\frac{1}{5} \times 22\frac{1}{2}$ (39 × 57)
London, courtesy of the Trustees of the
British Museum

215 Venice, Italy: Ballroom of the Palazzo
Labia
Fresco of the Banquet of Cleopatra by
TIEPOLO
c. 1745
Architectural setting painted by MENGOZZI-
COLONNA
Georgina Masson

216 GIOVANNI BATTISTA TIEPOLO 1696–1770
Wedding of Frederick Barbarossa
1751
Fresco
Würzburg, Residenz
Hirmer Fotoarchiv, Munich

217 BARON ANTOINE-JEAN GROS 1771–1835
Napoleon at the Bridge of Arcole (detail)
1796
Oil on canvas $28\frac{3}{4} \times 23\frac{3}{4}$ (72 × 59)
Paris, Louvre

218 BENJAMIN WEST 1738–1820
Death of General Wolfe
c. 1771
Oil on canvas $59\frac{1}{2} \times 84$ (151 × 213)
Ottawa, National Gallery of Canada

219 JOHN FLAXMAN 1755–1826
Monument to Agnes Cromwell
1798–1800
Marble
Chichester Cathedral
National Monuments Record

220 WILLIAM BLAKE 1757–1827
The Spiritual Form of Nelson
1807
Tempera on canvas $30 \times 24\frac{5}{8}$ (77 × 63)
London, courtesy of the Trustees of the
Tate Gallery

221 THOMAS BANKS 1735–1805
Death of Germanicus
1774
Marble
Holkham Hall, Norfolk, courtesy of the
Earl of Leicester
*Courtauld Institute of Art, University of
London*

222 JOSEPH WRIGHT OF DERBY 1734–97
Experiment on a Bird in the Air Pump
c. 1768
Oil on canvas 72 × 96 (193 × 244)
London, courtesy of the Trustees of the
Tate Gallery

223 EUGÈNE DELACROIX 1798–1863
Liberty at the Barricades
1830
Oil on canvas $102\frac{3}{8} \times 128$ (260 × 325)
Paris, Louvre

224 JACQUES-LOUIS DAVID 1748–1825
The Oath of the Horatii
1784
Oil on canvas 130 × 168 (330 × 427)
Paris, Louvre
Giraudon

225 FRANCISCO JOSÉ DE GOYA Y LUCIENTES
1746–1828
The Shootings of May 3, 1808
1814
Oil on canvas $104\frac{3}{4} \times 135\frac{7}{8}$ (266 × 345)
Madrid, Prado

226 THÉODORE GÉRICAULT 1792–1824
The Boxers
1818
Lithograph (second state) $13\frac{3}{4} \times 16\frac{1}{2}$ (35 × 42)
London, courtesy of the Trustees of the
British Museum

227 EUGÈNE DELACROIX 1798–1863
Portrait of George Sand
1838
Oil on canvas 32 × 22½ (81 × 57)
Copenhagen, Ordrupgaard Museum
Bulloz

228 JACQUES-LOUIS DAVID 1748–1825
Self-portrait at the age of forty-six in prison
1794
Oil on canvas 31⅞ × 25¼ (81 × 64)
Paris, Louvre
Bulloz

229 THÉODORE GÉRICAULT 1791–1824
Le Fou Assassin (A Madman)
1822–23
Oil on canvas 24 × 20⅛ (61 × 51)
Ghent, Musée des Beaux Arts
A C L

230 JEAN-AUGUSTE-DOMINIQUE INGRES 1780–
1867
Portrait of Monsieur Bertin
1832
Oil on canvas 45¾ × 37⅞ (116 × 95)
Paris, Louvre
Archives Photographiques

231 BARON ANTOINE-JEAN GROS 1771–1835
François I and Charles V arriving at St Denis
1811
Pen and wash drawing 41·3 × 25·8 (16¼ ×
9)
Paris, Louvre
Giraudon

232 EUGÈNE DELACROIX 1798–1863
The Abduction of Rebecca
1846
Oil on canvas 39⅜ × 32¼ (100 × 82)
New York, Metropolitan Museum of Art,
Wolfe Fund, 1903

233 JEAN-AUGUSTE-DOMINIQUE INGRES 1780–
1867
Oedipus and the Sphinx
Signed and dated 1808, reworked *c.* 1827
Oil on canvas 74⅜ × 56⅝ (189 × 144)
Paris, Louvre
Mansell-Alinari

234 FRANCISCO JOSÉ DE GOYA Y LUCIENTES
1746–1828
Colossus
c. 1818
Etching and aquatint 11¼ × 8¼ (30 × 21)
Madrid, Prado

235 Twickenham, England: The Holbein
Chamber of Strawberry Hill
c. 1750–70
Copyright Country Life

236 CLAUDE-NICHOLAS LEDOUX 1736–1806
Arc-et-Senans, France: Entrance portico to
the Salt Works of Chaux
1775–79
Peter Murray

237 SIR CHARLES BARRY 1795–1860
London: The Reform Club
1837
National Monuments Record

238 JAMES WARD 1769–1859
Gordale Scar, Yorkshire
1814
Oil on canvas 32 × 42 (82 × 107)
Bradford City Art Galley and Museums,
Cartwright Hall

239 HUBERT ROBERT 1733–1808
Le Pont du Gard
1787
Oil on canvas 95¼ × 95¼ (242 × 242)
Paris, Louvre

240 JOHN CONSTABLE 1776–1837
The Haywain
1821
Oil on canvas 51¼ × 72 (130 × 185)
London, courtesy of the Trustees of the
National Gallery

241 RICHARD WILSON 1713/14–82
Cader Idris
c. 1774
Oil on canvas 19⅝ × 28¾ (50 × 72)
London, courtesy of the Trustees of the
National Gallery

242 JOSEPH MALLORD WILLIAM TURNER 1775–
1851
Steamer in a Snowstorm
1842
Oil on canvas 36 × 48 (90 × 120)
London, courtesy of the Trustees of the
National Gallery

243 JEAN-FRANÇOIS MILLET 1814–75
The Woodcutter
c. 1855
Oil on canvas 15 × 11⅜ (38 × 29)
Paris, Louvre
Giraudon

244 FORD MADOX BROWN 1821–93
Work
1852–65
Oil on canvas 53 × 77⅛ (134 × 196)
Manchester City Art Gallery

245 HONORÉ DAUMIER 1808–79
Third Class Carriage
c. 1865–70
Oil on canvas 23⅜ × 36¼ (67 × 92)
Ottawa, National Gallery of Canada

246 JEAN DÉSIRÉ GUSTAVE COURBET 1819–77
Girls on the Bank of the Seine
1851
Oil on canvas 68⅛ × 80¾ (173 × 205)
Paris, Petit Palais
Archives Photographiques

247 PHILIP WEBB 1831–1915
Bexley Heath, England: The Red House
1859
National Monuments Record

248 EDGAR DEGAS 1834–1917
Absinthe
1876
Oil on canvas 36¼ × 26¾ (92 × 68)
Paris, Louvre
Giraudon

249 ÉDOUARD MANET 1832–83
Le déjeuner sur l'herbe
1863
Oil on canvas 83½ × 106¼ (211 × 270)
Paris, Louvre
Archives Photographiques

250 CLAUDE MONET 1840–1926
Poplars on the Epte
c. 1893
Oil on canvas 31¼ × 31¼ (79 × 79)
Edinburgh, National Gallery of Scotland
Annan, Glasgow

251 GEORGES SEURAT 1859–91
Afternoon on La Grande Jatte
1884–86
Oil on canvas 81 × 120⅜ (205 × 305)
Chicago, Art Institute, Helen Birch Bartlett
Memorial Collection

252 AUGUSTE RODIN 1840–1917
The Walking Man
1877
Bronze h. 88⅝ (225)
Washington, National Gallery of Art

253 AUGUSTE RODIN 1840–1917
The Burghers of Calais
1884–186
Bronze h. 82 (208)
Paris, Musée Rodin
Bulloz

254 EDVARD MUNCH 1863–1944
Anxiety
1896
Lithograph 16½ × 15 (42 × 38)
Oslo, Kommunes Kunstsamlinger Munch-
Museet

255 PAUL GAUGUIN 1848–1903
*Vision after the Sermon, or Jacob Wrestling
with the Angel*
1888
Oil on canvas 28¾ × 36¼ (73 × 92)
Edinburgh, National Gallery of Scotland
Annan, Glasgow

256 VINCENT VAN GOGH 1853–90
The Yellow Chair
1888–90
Oil on canvas 36⅛ × 28¾ (93 × 73)
London, courtesy of the Trustees of the
Tate Gallery

257 PAUL CÉZANNE 1839–1906
Still Life with Cupid
c. 1895
Paper mounted on panel 27½ × 22½ (70 ×
57)
London, Courtauld Institute Galleries
*Courtauld Institute of Art, University of
London*

258 HENRI ROUSSEAU 'LE DOUANIER' 1844–1910
The Sleeping Gipsy
1897
Oil on canvas 51 × 79 (130 × 201)
Collection the Museum of Modern Art,
New York, gift of Mrs Simon Guggenheim

259 GUSTAVE EIFFEL 1832–1923
Paris: view inside the Eiffel Tower
1889
Photograph by the author

260 LOUIS H. SULLIVAN 1856–1924
Chicago (Illinois), U.S.A.: Carson Pirie
Scott Store
1899–1904
Chicago Architectural Photographing Co.

261 FRANK LLOYD WRIGHT 1869–1959
River Forest (Illinois), U.S.A.: Winslow
House
1893
Reproduced from Manson: *Frank Lloyd
Wright to 1910: the First Golden Age*, Van
Nostrand Reinhold Company, a Division
of Litton Educational Publishing Inc., New
York 1958

281

262 ADOLF LOOS 1870–1933
Vienna: Steiner House (garden front)
1910
Dr Franz Stoedtner

263 WALTER GROPIUS 1883–1969 and ADOLF
MEYER 1881–1929
Cologne, Germany: south side of the model
factory built for the Werkbund Exhibition
1914
Dr Franz Stoedtner

264 ANTONIO GAUDÍ 1852–1926
Barcelona, Spain: Casa Batlló
1905–07
Mas

265 ERICH MENDELSOHN 1887–1953
Neubabelsberg near Potsdam, Germany:
Einstein Tower
1920–21
Dr Franz Stoedtner

266 GIACOMO BALLA 1871–1958
Leash in Motion
1912
Oil on canvas $35\frac{3}{4} \times 43\frac{3}{8}$ (96×110)
Albright Knox Gallery, Buffalo, N.Y.

267 CONSTANTIN BRANCUSI 1876–1957
Bird in Space
1924
Polished bronze on marble base
Philadelphia Museum of Art

268 PABLO PICASSO b. 1881
Les Demoiselles d'Avignon
1907
Oil on canvas 96×92 (244×234)
Collection the Museum of Modern Art,
New York

269 JUAN GRIS 1887–1927
Landscape near Céret
1913
Oil on canvas $36\frac{1}{4} \times 23\frac{5}{8}$ (92×60)
Stockholm, National Museum

270 FERNAND LÉGER 1881–1955
·*The Pink Tug*
1918
Oil on canvas $25\frac{5}{8} \times 36\frac{1}{4}$ (65×92)
Cologne, Walraf-Richartz Museum
Rheinisches Bildarchiv

271 UMBERTO BOCCIONI 1882–1916
Unique Forms of Continuity in Space
1913
Bronze h. $43\frac{1}{2}$ (110)
Milan, Galleria Civica d'Arte Moderna

272 FRANZ MARC 1880–1916
Blue Horses .
1913
Oil on canvas $41\frac{1}{4} \times 71\frac{1}{2}$ (104×181)
Minneapolis, Walker Art Center

273 WASSILY KANDINSKY 1886–1944
Deluge
1912
Oil on canvas $39\frac{3}{8} \times 41\frac{3}{8}$ (100×105)
Krefeld, Kaiser Wilhelm Museum

274 PIET MONDRIAN 1872–1944
Composition in Blue Grey and Pink
1913
Oil on canvas $34\frac{5}{8} \times 45\frac{5}{8}$ (88×115)
Otterlo, Rijksmuseum Kröller-Müller

275 GIORGIO DE' CHIRICO b. 1888
Nostalgia of the Infinite
1913–14? (Dated on painting 1911)
Oil on canvas $53\frac{1}{4} \times 25\frac{1}{2}$ (135×64)
Collection the Museum of Modern Art,
New York

276 MARCEL DUCHAMP 1887–1968
Bottle Rack (Ready-made)
1914
Iron h. $25\frac{1}{4}$ (64)
Original lost. From a photograph by Man
Ray

277 KURT SCHWITTERS 1887–1948
Merz 83, Drawing F
1920
Collage of cut paper wrappers, announce-
ments and tickets $5\frac{3}{4} \times 4\frac{1}{2}$ (14×11)
Collection the Museum of Modern Art,
New York, Katherine S. Dreier Bequest

278 SALVADOR DALI b. 1904
The Persistence of Memory
1931
Oil on canvas $9\frac{1}{2} \times 13$ (24×33)
Collection the Museum of Modern Art,
New York

279 MAX ERNST b. 1891
*Loplop introduces Members of the Surrealist
Group*
1930
Collage of pasted photographs and pencil
$19\frac{3}{4} \times 13\frac{1}{4}$ (45×34)
Collection the Museum of Modern Art,
New York

Index

Figures in italic refer to illustrations

Alberti, Leon Battista, 110, 112, 113, 148, 153, 204
 Palazzo Rucellai, 112, 113, 148; *116*
 Sta Maria Novella, 112, 119, 175; *115*
 S. Sebastiano, 120; *125*
 Ten Books of Architecture, 120
Aldobrandini Wedding, 34, 104, 165; *31*
Alexandria, 24
Altdorfer, Albrecht, 136
 St George and the Dragon, 136; *144*
Amiens Cathedral, 76, 77, 78, 79; *78, 80, 81*
 Vierge Dorée, 85, 90, 100, 104; *86*
Anastasius, Emperor, 52, 53, 122; *51*
d'Anjou, Yolande, 94
 Rohan Book of Hours; 94, 95, 104; *96*
Apotheosis of Homer, 9, 24, 39, 58; *19*
Ara Pacis, 30, 82, 208; *26*
Argive Twin, 10; *2*
Arles, 66, 71, 78
 St Trophîme, 71; *68*
Ars Morendi, 94
 Rohan Book of Hours, 94, 95, 104; *96*
Art Nouveau, 249, 250
Athens, 16
 Acropolis, 18
 Erechtheion, 18, 19; *12, 13*
 Parthenon, 15, 16, 17, 18, 19, 23, 24, 39, 224; *9, 10, 11*
 Centaur and Lapith, 130; *8*
 Three Goddesses, 125, 240; *6*
 Tower of the Winds, 24, 48, 52; *21*
Augustus, Emperor, 29, 41, 113; *24*
Auxerre Goddess, *1*

Baalbek, 43, 51, 167; *39*
Ballà, Giacomo, 251
 Leash in motion, 266
Banks, Thomas, 209, 212
 Death of Germanicus, 209, 212; *221*
Baroque art, 155–65, 168–91
Barry, Charles
 The Reform Club, 224; *237*
Bernini, Gianlorenzo, 160, 162, 168, 170, 172, 178, 180, 184, 188, 190, 197
 Cardinal Scipione Borghese, 162, 179; *169*

David, 160, 168, 180, 184; *167*
 Ecstasy of St Teresa, 168, 178, 197; *178*
 Fountain of the Four Rivers, 170; *179*
 S. Andrea, 168, 172; *176*
Berri, Duc de, 92
 Les Très Riches Heures, 94
Blake, William, 208, 214, 222
 The Spiritual Form of Nelson, 208, 214; *220*
Blaue Reiter, 256
Boccioni, Umberto, 251, 255
 Unique Forms of Continuity in Space, 271
Boffrand, Germain, 204
 Hôtel Soubise, 192, 199, 200, 204, 223; *204*
Bologna, Giovanni da, 153, 208, 250, 252
 Rape of the Sabines, 153; *158*
Borromini, Francesco, 167, 168
 Sta Agnese, 170, 172, 173, 175; *183*
 S. Carlo alle Quattro Fontane, 168, 175; *177, 184*
 S. Ivo della Sapienza, 167; *175*
Bosch, Hieronymus, 134, 139, 184
 Crowning with Thorns, 134; *141*
Botticelli, Sandro, 122, 124, 132, 136
 Birth of Venus, 122, 124, 132, 136; *129*
 Primavera, 122
Boucher, François, 197
 Madame de Pompadour, 192, 197; *205*
Bourges Cathedral, 75; *76*
Bramante, Donato, 126, 128, 153, 247, 250
 Tempietto, 126, 250; *133*
Brancusi, Constantin, 251, 255
 Bird, 251, 255; *267*
Braque, Georges, 252
Brown, Ford Madox, 232, 234, 240
 Work, 234; *244*
Brueghel, Pieter the Elder, 142, 143, 191, 225
 Flemish Proverbs, 142; *149*
 Landscape with Gallows, 143; *150*
Brunelleschi, Filippo, 106, 107, 108, 109, 113, 125, 173
 Florence Cathedral, 108, 173; *109*
 S. Lorenzo, 106, 107, 108, 125; *107*
 Sto Spirito, 107; *108*
Byzantine architecture, 48–50
 mosaics, 53–5, 56–60
Byzantium, *see* Istanbul

283

Cambio, Arnolfo di, 108
 Florence Cathedral, 108; *109*
 Sta Croce, 108
Caracalla, portrait bust, 41, 82, 162; *38*
Caravaggio, Michelangelo da, 157, 158, 179,
 186, 218
 Martyrdom of St Matthew, 157; *164*
Carracci, Annibale, 156, 157, 158, 196
 Triumph of Bacchus and Ariadne, 156; *163*
Cato and Portia, 29; *23*
Cellini, Benvenuto, 147, 153
 Apollo and Hyacinth, 147; *154*
Cézanne, Paul, 238, 244, 252, 255
 Still Life with Cupid, 244; *257*
Charioteer, The, 11, 13, 14; *3*
Chartres Cathedral, 73, 75, 76, 81, 82, 83, 84,
 87; *72, 77, 79*
Chicago, 247
 Carson, Pirie Scott Store, 247, 249; *260*
Chirico, Giorgio de, 261
 Nostalgia of the Infinite, *275*
Christ, the Light of the World, 58, 60; *56*
Christ on the Cross, 65; *65*
Claude Lorraine, 170, 171, 172, 190, 225, 226
 Aeneas arriving at Delos, *181*
Cluny, Abbey Church, 62, 63, 75, 87; *61*
Cologne, model factory, 247, 249; *263*
Compostela, Santiago, 66
Conques, 66, 73
 Ste Foy, 68, 69, 73; *70*
Constable, John, 227
 The Haywain, 228; *240*
Constantine the Great, 44; *41*
Cortona, Pietro da, 162, 165, 166
 Glorification of Urban VIII's Reign, 162, 165,
 167, 199; *172*
Courbet, Gustave, 232, 234, 237
 Girls on the Bank of the Seine 232; *246*
Cranach, Lucas, 140
 Henry the Pious, 140; *147*
Crespi, Daniele, 161, 179, 188
 Meal of S. Carlo Borromeo, 161; *168*
Cubism, 251–3

Dada Movement, 258–61
Dali, Salvador, 261, 262
 The Persistence of Memory, *278*
Daphni, 56, 65
 Monastery church, *Crucifixion*, 56, 57, 65;
 54
Daumier, Honoré, 232, 234, 237, 238
 Third Class Carriage, 234; *245*
David, Jacques-Louis, 207, 212, 213, 214, 216,
 217, 224, 234
 Oath of the Horatii, 212, 213; *224*
 Self-Portrait, 216; *228*

Degas, Edgar, 237, 238, 244
 Absinthe, 238; *248*
Delacroix, Eugène, 212, 213, 216, 218, 229
 Abduction of Rebecca, 220; *232*
 George Sand, 217; *227*
 Liberty at the Barricades, 212; *223*
Delphi, 11
Domenichino, 158, 165
 Last Communion of St Jerome, 158; *166*
Donatello, 113, 115, 121, 131, 142
 David, 113, 126; *117*
 Miracle of St Anthony, 114; *118*
Duccio, 104
Duchamp, Marcel, 258, 261
 Ready-made, 258, 261; *276*
Dürer, Albrecht, 134, 136, 137, 139, 142, 143
 The Great Fortune, 134; *142*
 Noli me tangere, 134; *143*
Durham Cathedral, 63, 69, 77, 78; *63*

Eiffel, Gustave,
 Eiffel Tower, 246, 247, 258; *259*
Ernst, Max, 261, 262
 *Loplop introduces a member of the Surrealist
 Group*, *279*
Eyck, Jan and Hubert van, 93, 95, 98, 118,
 128, 134, 137, 158
 The Ghent Altarpiece, 97, 98; *95*
 Rolin Madonna, 95, 96, 98; *97*

Flaxman, John, 208
 Monument to Agnes Cromwell, 208; *219*
Florence, 63, 98, 103, 104, 105, 112, 119, 132
 Baptistery, 108, 109; *109, 110*
 Campanile, 108; *109*
 Cathedral, 108, 173; *109*
 Laurentian Library, 144; *152*
 Palazzo Rucellai, 112, 133, 148; *116*
 Piazza del Duomo, 109
 Sta Croce, 98, 106, 107, 108; *102*;
 Peruzzi Chapel, 103
 S. Lorenzo, 106, 107, 108, 125; *107*
 Sta Maria del Carmine; Brancacci Chapel,
 108; *112*
 Sta Maria Novella, 112, 119, 175; *115*
 S. Miniato, 99, 112, 175; *62*
 Sto Spirito, 107; *108*
 Uffizi, 151; *157*

Gabriel, Jacques-Ange, 194, 200
 Le Petit Trianon, Versailles, *213*
Gainsborough, Thomas, 192, 194, 197, 201,
 225, 232
 Mr and Mrs Andrews, 92, 232; *206*
 Peasants going to Market, 194; *207*

284

Gaudí, Antonio, 249, 250
 Casa Batlló, 250; *264*
Gauguin, Paul, 238, 241, 242, 243, 250, 255
 Vision after the Sermon, 243; *255*
Géricault, Théodore, 214, 216, 229
 Boxers, 214; *226*
 A Madman, 217; *229*
Germigny-des-Prés, Theodulf's Oratory, 61.
 128; *59*
Gernrode, St Cyriakus, 62, 63, 78; *60*
Ghiberti, Lorenzo; 109, 110
 Baptistery Doors, Florence; *110*
Giorgione, 132, 136, 143, 166, 236
 Concert Champêtre, 132, 237; *138*
Giotto, 95, 96, 100, 101, 103, 104, 105, 110,
 136, 155
 Campanile, Florence, 108
 Noli me tangere, *103*
 Salome before Herod, 103; *104*
Goes, Hugo van der, 96, 140, 158
 Portinari Altarpiece, 97; *99*
Gothic architecture, 73–8, 86–8
 art, 90–8, 99–104
 Revival, 223–4
 sculpture, 73–5, 78–86, 90
Goya, Francisco de, 213, 222, 227, 229, 234,
 237
 Colossus, 222, 223, 227; *234*
 The Shootings of May 3, 1808, 213; *225*
Greco, El, 177, 178, 179, 187, 234, 252
 Burial of Count Orgaz, 177; *185*
 Cardinal Guevara, 178, 179; *188*
Greek architecture, 15–18; 27–8
 sculpture, 9–15, 18–27
Gris, Juan, 253
 Landscape near Céret, 253; *269*
Gropius, Walter, 247, 249
 model factory, Cologne, 247; *263*
Gros, Baron, 207, 217, 218
 Francis I and Charles V at St Denis, *231*
 Napoleon at the Bridge of Arcole, *217*
Grünewald, Matthias, 137, 139, 184, 242
 Isenheim Altarpiece, 137; *145*
Guercino, 167, 170, 213
 Vision of St Bruno, 166, 167, 190; *174*

Hals, Frans, 187, 188, 237
 'Malle Bobbe', 187, 188; *199*
 Meeting of the Officers of the Cluveniers-doelen, 187; *198*
Hogarth, William, 192, 194, 196, 197, 201,
 212
 Marriage à la Mode: the Contract, *210*
Holbein, Hans, 134, 140
 Georg Gisze, 140, 141; *146*

Impressionism, 236–41
Ingres, J.-A.-D., 216, 217, 221, 222, 224
 Monsieur Bertin, 217, 224; *230*
 Oedipus and the Sphinx, 221; *233*
Istanbul, Hagia Sophia, 48, 50, 51, 52, 63; *43,
 47, 50*

Kandinsky, Wassily, 256, 258
 Deluge, 256; *273*
Kells, Book of, 60, 61, 64, 69; *57*
kore, 10; *1*
kouros, 10; *2*

Landshut, 90
Laocoön, 26, 27, 160, 208; *20*
Le Corbusier, 247, 249
Ledoux, Claude-Nicolas, 224
 Salt Works of Chaux, 224; *236*
Léger, Fernand, 255
 The Pink Tug, 255; *270*
Leinberger, Hans, 90, 124, 136, 137, 178
 Virgin and Child, 90; *93*
Leonardo da Vinci, 125, 133, 153, 162
 Last Supper, 125, 153; *130*
Limbourg Brothers, 92, 111, 118
 Les Très Riches Heures du Duc de Berri, *94*
London, Reform Club, 224; *237*
Loos, Adolf, 249
 Steiner House, Vienna, 249; *262*
Lorenzetti, Pietro, 95, 96, 100, 104
 Deposition, *106*
Ludovisi Throne, 12, 15, 21, 81, 125; *5*

Maderno, Carlo, 155, 156, 172, 173
 Sta Susanna, Rome, 155, 173, 175, 247; *162*
Manet, Édouard, 236, 237
 Le Déjeuner sur l'herbe, 236; *249*
Mannerism, 144–53
Mantegna, Andrea, 122, 124, 131, 132, 136
 Virtue expelling the Vices, 124; *127*
Mantua, 120, 122
 S. Sebastiano, 120; *125*
Marc, Franz, 256
 Blue Horses, 256; *272*
Marcus Aurelius, Equestrian statue, 41, 53,
 122; *37*
Marienburg Castle, 88; *90*
Martini, Simone, 96, 100, 103, 104, 111
 Annunciation, *105*
Masaccio, 108, 109, 110, 112, 114, 125
 The Tribute Money, 108, 109; *111, 112*
Mendelsohn, Erich, 250
 Einstein Tower, 250; *265*

Meyer, Adolf, 247, 249
 model factory, Cologne, 247; *263*
Michelangelo, 126, 128, 130, 133, 142, 144,
 145, 147, 153, 160, 162, 173
 Anteroom of the Laurentian Library,
 Florence, 144; *152*
 Creation of Man, 128; *134*
 David, 126, 147, 160, 208; *131*
 Last Judgment, 208
 Palazzo Farnese, 133, 148; *140*
 Plan for St Peter's, 126, 172, 173; *132, 161*
Milan, Sta Maria delle Grazie, *Last Supper*, *130*
Millet, Jean-François, 232, 234
 The Woodcutter, 232; *243*
Moissac, St Pierre, 66, 68; *69*
Mondrian, Piet, 256, 258
 Composition in Blue, Grey and Pink, *274*
Monet, Claude, 238, 239
 Poplars on the Epte, 238; *250*
Monreale Cathedral, 57, 58
 Christ Pantocrator, 60; *55*
Munch, Edvard, 241, 242
 Anxiety, 241; *254*
Murillo, Bartolomé, 180, 183, 187, 204
 Christ at the Pool of Bethesda, 183; *193*
 Marriage Feast of Cana, 183, 187; *192*

Naumburg Cathedral, 84, 96, 100; *85*
Neo-classical art, 165–7
Neumann, Balthasar, 199
 Vierzehnheiligen, 192, 199, 200; *211, 212*
Nîmes,
 Maison Carrée, 32, 33, 43, 69, 71; *27*
 Temple of Diana, 40, 71; *36*

Octavia, portrait bust, 30, 114; *25*
Olympia, pediment group, 12, 13, 23; *4*
Orange, Triumphal Arch, 71

Padua, 101, 103, 124
 Arena Chapel, 101, 103
 Santo, High Altar, *118*
Palladio, Andrea, 148, 149, 201
 Villa Chiericati, 148, 153; *155*
Paris,
 Eiffel Tower, 246, 247, 258; *259*
 Hôtel Soubise, 192, 199, 200, 223; *204*
 Notre Dame, 81, 82, 102; *82*
 Sainte Chapelle, 86, 88; *87*
Parmigianino, Francesco, 146, 147, 149, 152,
 222
 Madonna with the long neck, 146; *153*
Pergamon, 24
 Propylon, Sanctuary of Athena, 27; *22*

Perugino, Pietro, 119, 120, 121
 Christ giving the keys to St Peter, *123*
Picasso, Pablo, 252
 Les Demoiselles d'Avignon, 252; *268*
Piero della Francesca, 115, 118, 124, 234
 Flagellation, *121*
Piranesi, Giovanni Battista, 192, 202, 203,
 220, 222
 Decorative Caprice, 192; *214*
Pisanello, Antonio, 111, 118
 The Vision of St Eustace, 111; *113*
Pisano, Giovanni, 96, 99, 104
 Pulpit in S. Andrea, Pistoia, *101*
Pistoia, 101
 S. Andrea, *101*
Pollaiuolo, Antonio and Piero, 118, 119, 124,
 130, 143, 172, 234
 Martyrdom of St Sebastian, *122*
Polyclitus, 14, 45, 130
 Doryphorus, *7*
Pompeii, *Idyllic landscape*, 36; *32*
Pont du Gard, 34
Pontormo, Jacopo, 144, 152, 157
 Visitation, 144; *151*
Porta, Giacomo, della, 153, 156
 Gesù Church, Rome, 153, 155, 175; *160*
 St Peter's, 153; *161*
Poussin, Nicolas, 165, 166, 170, 172, 190, 197,
 212, 225, 226, 246
 Et in Arcadia Ego, 165, 212; *171*
 Orpheus and Eurydice, 170; *180*
Prato, Sta Maria delle Carcere, 121; *124*
Praxiteles, 21, 22, 45, 85
 Cnidian Venus, 124; *15*
 Hermes with Dionysus, 22, 85; *16*
Pre-Raphaelite Brotherhood, 234

Raimondi, Marcantonio, 130, 236
 Massacre of the Innocents, 130; *136*
Rainaldi, Carlo,
 Sta Agnese in Piazza Navona, *183*
Raphael, 128, 130, 131, 133, 144, 156, 157,
 158, 165, 222, 234, 236
 Massacre of the Innocents, 130
 Philosophy, or The School of Athens, 128,
 130, 144, 181; *135*
Ravenna, 48
 S. Vitale, 48, 54, 55; *48, 53*
Registrum Gregorii, Master of, 64
 Annunciation, 64
Reims Cathedral, 76, 78, 82, 85, 86, 87, 100,
 104, 107, 168; *73, 74, 75, 84*
Rembrandt van Rijn, 184, 186, 216, 234
 The Artist and his Wife, 186; *197*
 Entombment, 186; *195*
 Self-Portrait, 191, 216; *201*

Renaissance architecture, 105–8, 112–13, 120, 126–7, 133
 art, Italian, 109–11, 115–20, 122–6, 131–3
 art, Northern, 134–43
 sculpture, 113–15, 121
Reni, Guido, 158, 160
 Aurora, 158; *165*
Ribera, Jusepe, 179
 Boy with a Club Foot, 179; *187*
Robert, Hubert, 225, 226
 Le Pont du Gard, 225; *239*
Rococo art, 192–205
Rodin, Auguste, 240, 241
 Burghers of Calais, 240; *253*
 Walking Man, 240; *252*
Rohan Book of Hours, 94, 104; *96*
Roman architecture, 32–4, 39–41, 43–4
 sculpture, 28–30, 34–39, 41–43, 44–45
Romanesque architecture, 61–4, 66, 69–71
 art, 60–1, 64–5, 69, 112, 243
 sculpture, 65–8
Romantic art, 215–22
Rome, 33, 112, 119, 132, 172
 Aldobrandini Wedding, 34, 104, 165; *31*
 Arch of Constantine, 44, 118, 149, 175; *40*
 Arch of Titus, 33, 34, 53, 158, 207; *28, 29*
 Colosseum, 34, 40; *30*
 Fountain of the Four Rivers, 170; *179*
 Gesù Church, 153, 155, 175; *160*
 Palazzo Barbarini, Cortona frescoes, 162, 165, 167, 199; *172*
 Palazzo Farnese, 133, 148, 162, 165, 224; *140, 163*
 Palazzo Rospigliosi-Palavicini, 158; *165*
 Pantheon, 39, 40, 43, 50, 126, 168; *34, 35*
 Sta Agnese, 170, 172, 173, 175; *183*
 S. Andrea al Quirinale, 168, 172; *176*
 S. Carlo alle Quattro Fontane, 168, 175; *177, 184*
 S. Ivo della Sapienza, 167; *175*
 St Peter's, 126, 128, 153, 172, 173; *132, 161, 182*
 Sta Pudenziana, mosaic, 53, 54, 64, 73; *52*
 Sta Sabina, 50, 62, 69, 77, 83, 106; *49*
 Sta Susanna, 155, 173, 175, 247; *162*
 Sistine Chapel, 119, 128, 162, 208; *134*
 Tempietto, 126, 250; *133*
 Trajan's Column, 37, 39; *33*
Rosa, Salvator, 166, 167, 170, 225
 Grotto with Waterfall, 166; *173*
Rouen, St Ouen, 86, 87, 152; *88, 89*
Rousseau, Henri, 244, 246
 The Sleeping Gipsy, 246; *258*
Rubens, Peter Paul, 184, 186, 188, 189, 190, 191, 201, 207, 220, 225
 Artist and his Wife, 186; *196*
 Château de Steen, 190; *202*
 Deposition, 184, 186, 188; *194*
 Rape of the Daughters of Leucippus, 200

Sacchi, Andrea, 165, 167, 180, 213
 Vision of St Romuald, 165, 190; *170*
St Denis, Abbey Church of, 61, 62; *58*
Sangallo, Antonio da, the younger,
 Palazzo Farnese, 133, 148; *140*
Sangallo, Giuliano da, 121
 Sta Maria delle Carcere, *124*
Sassetta, Stefano di Giovanni, 111, 112, 246
 Betrothal of St Francis to Poverty, *114*
Schwitters, Kurt, 258
 Merz 83, Drawing F, *277*
Scopus, 22, 23, 24
 Tomb of Mausolus, 22, 23, 24, 30, 90; *17, 18*
Seurat, Georges, 239, 240
 Afternoon on La Grande Jatte, *251*
Sidamara, 45
 sarcophagus, 52; *42*
Siena, 103, 104
Sienese School, 100, 111
Signorelli, Luca, 124, 234, 240
 Pan and other Gods, 124; *128*
Stele of Hegeso, 20, 27, 208, 212; *14*
Strasbourg Cathedral, 82, 90, 100
 Death of the Virgin, *83*
Strigel, Bernard, 141, 142, 143
 David, 141; *148*
Sullivan, Louis H., 247, 249
 Carson, Pirie Scott Store, 247, 249; *260*
Surrealism, 261–2

Tiepolo, Giovanni Battista, 192, 194, 202, 203, 204, 218, 222
 Banquet of Cleopatra, 194, 204; *215*
 Fantastic Caprice, 192, 202; *203*
 Wedding of Frederick Barbarossa, *216*
Tintoretto, 151, 152, 153
 Finding of the Body of St Mark, *156*
Titian, 132, 133, 156, 157, 166
 Bacchus and Ariadne, 132; *137*
 The Concert, 133; *139*
 Rape of Europa, 181
Toulouse, St Sernin, 63, 66, 75; *76*
Turner, J. M. W., 228, 229, 231
 Steamer in a Snowstorm, 228; *242*

Uccello, Paolo, 118, 130, 136, 234
 A Hunt, *120*
Ulm, 142

Vasari, Giorgio, 151, 152
 Uffizi, *157*
Velazquez, Diego, 180, 183, 237, 244
 Fable of Arachne, 181; *191*
 Las Meniñas, 180; *190*
Veneziano, Domenico, 115
 St Lucy Altarpiece, *119*
Venice, 119, 124, 131, 132
 Palazzo Labia, fresco, 194, 204; *215*
Veronese, Paolo, 152, 153, 183, 204
 Christ disputing with the Doctors, *159*
Verrocchio, Andrea del, 121
 Bartolommeo Colleone, *126*
Versailles, 200
 Le Petit Trianon, 194, 200; *213*
Vézelay, Ste Madeleine, 65, 66, 73; *66*
Vicenza, Villa Chiericati, 148, 153; *155*
Vienna, Steiner House, 249; *262*
Vierge Dorée, 85, 90, 100, 104; *86*
Vierzehnheiligen, 192, 199, 200; *211, 212*
Vignola, Gesù Church, Rome, 153; *160*
Vitruvius, 120, 136

Walpole, Horace, 223, 234
 Strawberry Hill, 223, 234; *235*
Ward, James, 227
 Gordale Scar, 227; *238*

Watteau, Jean-Antoine, 192, 194, 196, 197,
 201
 Embarkation from Cythera, *208*
 Signboard for the Art-dealer, Gersaint, *209*
Webb, Philip, 234, 235, 249
 The Red House, *247*
Wells Cathedral, 88, 96; *92*
Werden Crucifix, 65; *65*
West, Benjamin, 207, 212
 Death of General Wolfe, *218*
Weyden, Rogier van der, 95, 97, 104, 134,
 139, 212
 Deposition, 96, 97; *98*
 Francesco d'Este, 97; *100*
Wilson, Richard, 226, 229
 Cader Idris, 229; *241*
Winchester Bible, 69; *71*
Wright, Frank Lloyd, 247, 249
 Winslow House, 247; *261*
Wright, Joseph, 209, 212, 224
 Experiment with the Air-Pump, 209, *222*

York, Minister, 78, 84, 88; *91*

Zurbarán, Francisco de, 177, 180
 Adoration of the Shepherds, 177; *186*
 St Bonaventura and St Thomas Aquinas, *189*